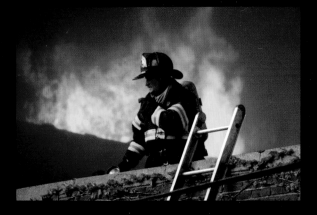

"Greater love hath no man than this,
that a man lay down his life for his friends."

–John 15:13

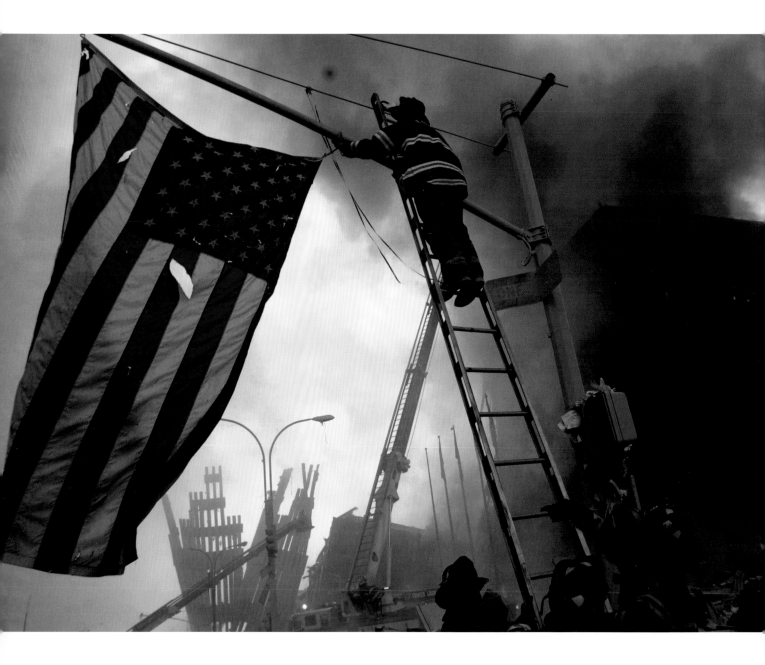

NEW YORK'S BRAVEST

Eight Decades of Photographs from the Daily News

edited by **Shawn O'Sullivan** essays by **Patrice O'Shaughnessy**

pH powerHouse Books
New York, NY

PICTURING HEROES

Patrice O'Shaughnessy

The love of the job is bigger than any company, or battalion, or division. It's bigger than the whole Fire Department. It is kindled within each firefighter. The worse the situation, the stronger they get. The more tragic the sacrifice, the more soaring their resolve.

They emerge from fire cradling a baby, or carrying an old man, faces blackened and sweat-streaked, helmets sheathed in ice in winter. They peer somberly above air masks—but their eyes twinkle just a little in reassuring boldness.

They crawl through smoky blackness, march through searing heat, perch at the top step of multi-story ladders, dive into the Hudson River at night, and slither into mangled cars. They rarely maintain contact with those they help; saving a life is part of the job. As one fire captain put it: "Pull them out, send them to the hospital…that was all that was really expected." And people accept it as a matter of course that if a fire broke out, there would be someone to come save them.

Firefighters are an indelible part of the city's fabric, bound by courage and a zest for life. Maybe that is because they have seen death in all its horrible forms, even before September 11. It was then that the world realized what most New Yorkers have always known: in ways great and small, day in and day out, they were—they are—the Bravest.

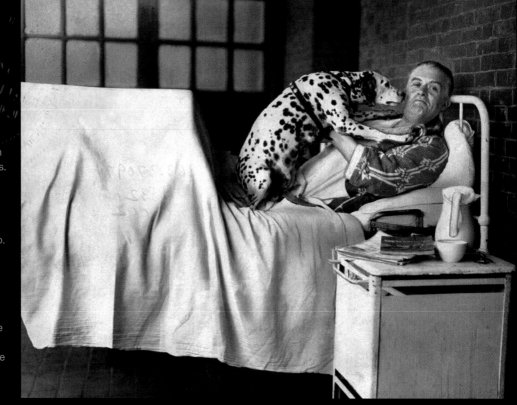

Dedication page: Firefighter at the scene of a three alarm fire in RIchmond Hill, Queens. Apr. 23, 2002
Willie Anderson

Previous page: Captain Michael Dugan of Ladder Co. 123 raises a tattered Old Glory, a symbol of fortitude and determination for fellow firefighters and all New Yorkers in the immediate hours and days following the unprecedented chaos and destruction resulting from the attack on the World Trade Center. Sept. 11, 2001
Andrew Savulich

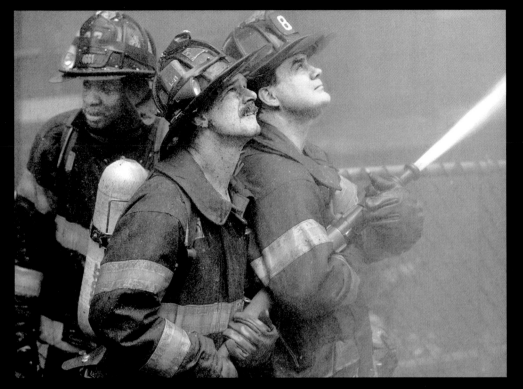

Opposite page: Cameramen are on hand at Bellevue Hospital to see Hook and Ladder No. 16's Pooch visiting her buddy Patrick Murphy, a fireman who fractured his legs slipping in the firehouse on East 67th St. while answering an alarm. Jun. 29, 1931
John Tresilian

Firefighters focus on two suspicious blazes at 521 and 525 West 133rd St., set within hours of each other. Dozens of people were evacuated. Oct. 15, 1995
Mike Albans

In 100 minutes on that day, the New York Fire Department suffered the greatest loss it has ever witnessed, sacrificing 343 of its brethren, most of whom were killed in the stairwells of the towers. Both towers were aflame, and undaunted, defiant, they entered the buildings and climbed. Some may have gotten as high as the 55th story, searching each floor on the way up to make sure no one was left behind in the massive evacuation. They were following the example of their patron saint, St. Florian, who, according to legend, boasted to the Romans attempting to burn him to death, "I will climb to heaven on the flames."

Daily News photographers were there as the twin towers came crashing down, and by the end of the day they had captured thousands of images of horror, heartbreak, and humanity. They stood fast to document the unfolding disaster, as people jumped from windows, concrete thundered down, and a dust cloud enveloped lower Manhattan. They preserved for all time glimpses of the greatest rescue effort in the nation's history, and the recovery of hundreds of the dead.

Sharing a special bond with the FDNY that began more than 80 years ago with the paper's inception as a pioneer of photojournalism, Daily News "shooters" have always been in the thick of things, telling firefighters' stories in pictures that make readers cry or gasp, and in better times, chuckle or smile in relief.

Behind many a hero there was a photographer dogging his steps. The life and death drama of fighting fires kept readers of "New York's Picture Newspaper" in thrall. Toting their cameras, photographers climbed tower ladders, balanced on ledges, and leaned over rooftops to capture the moment. In the early days, Daily News photographers took their pictures dressed in coats, ties, and hats (unlikely attire for a fire), and lugged big, boxy Speed Graphic cameras, the likeness of which became the logo of the paper. A new gadget pioneered by the News—the telephoto lens—allowed it to specialize in aerial photography, resulting in spectacular images of the city at various times of crisis. Today's shooters use high-speed digital cameras and laptop computers to transmit images from anyplace instantly. Whether chasing horse-drawn water vehicles or high-tech fire engines and ladder trucks, News photographers have chronicled the FDNY with drama and distinction.

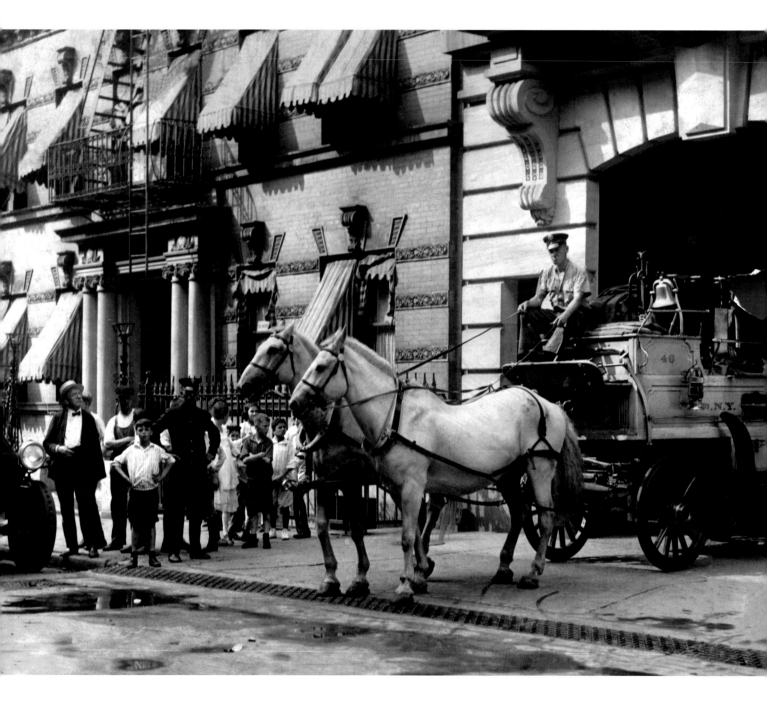

1920-1939

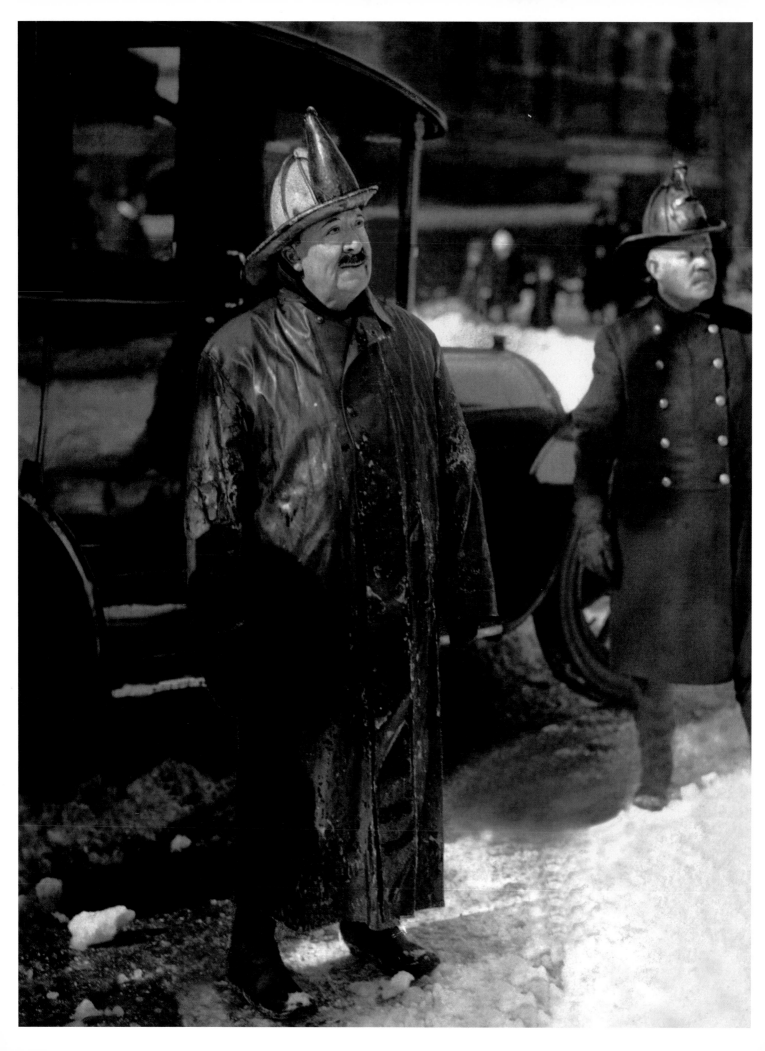

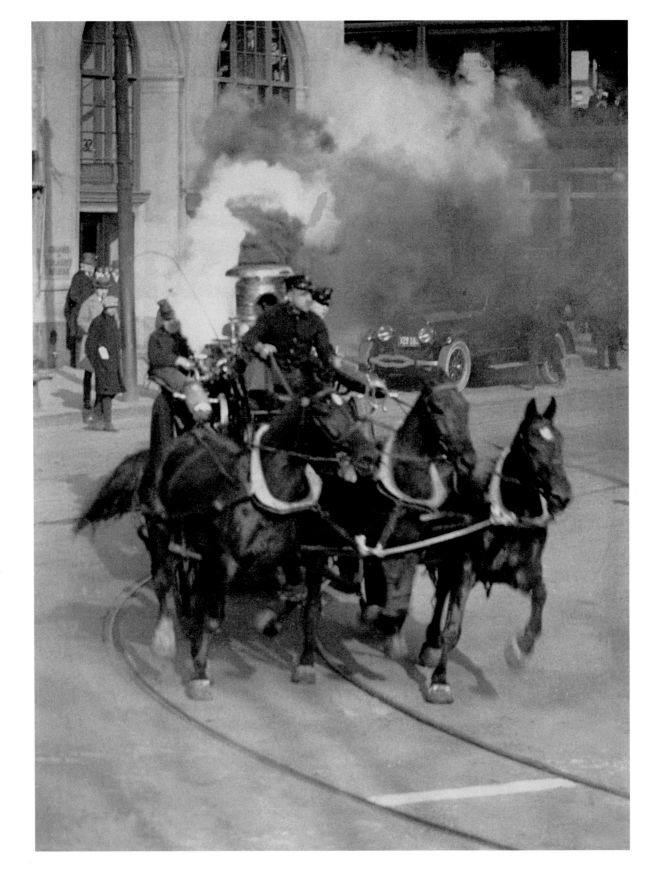

Previous page: Happy and
Fairfax, a favorite team of
Engine Co. 72, 66th St. & 12th
Ave. Waiting in the wings is
the motorized truck that will
replace them. Some of their
fans are on hand to bid them
farewell. Aug. 12,1920

Opposite page: Fireman
"Smokey Joe" Martin.

Above: Last horse-drawn fire
engine team in Brooklyn races
to its last call. Dec.,1922

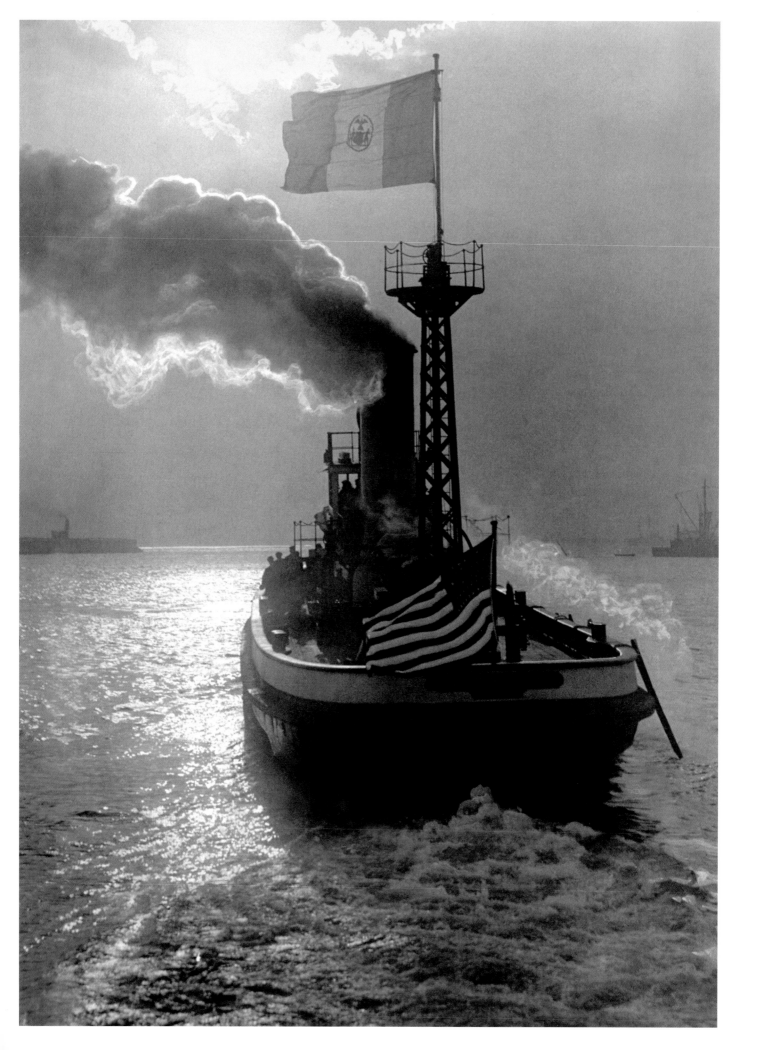

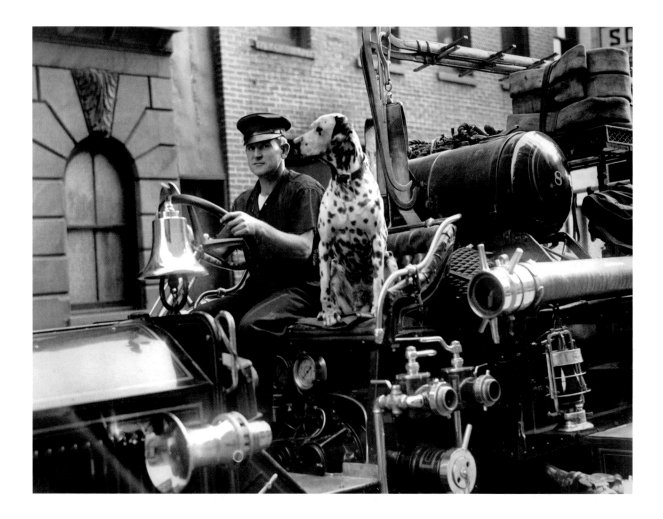

Opposite page: The fireboat
John Purroy Mitchel glides
away from the Battery after
ceremonies adding her to the
city's fleet. Named for a
reform mayor who died in a
U.S. Army Air Corps training
flight accident in 1918, the
fireboat became the queen of
the fleet until she was
decommissioned in 1966.
Dec. 27, 1921

Above: Fireman George Lorz
and Rex of Engine Co. 8 pre-
pare for action outside the
station house on East 51 St.
Sept. 22, 1929
Reidy

Next page: A five-alarm
blaze, detected just after the
last show let out from the
movie theater, wrecks the
six-story Lincoln Square
Arcade building at West 65th
St. and Broadway. A crowd
estimated to be 100,000
watched 350 firemen—the
biggest turnout in twenty
years—battle the windswept
fire, which injured dozens of
firemen and left scores of
evacuated residents without
homes. Jan. 30, 1931

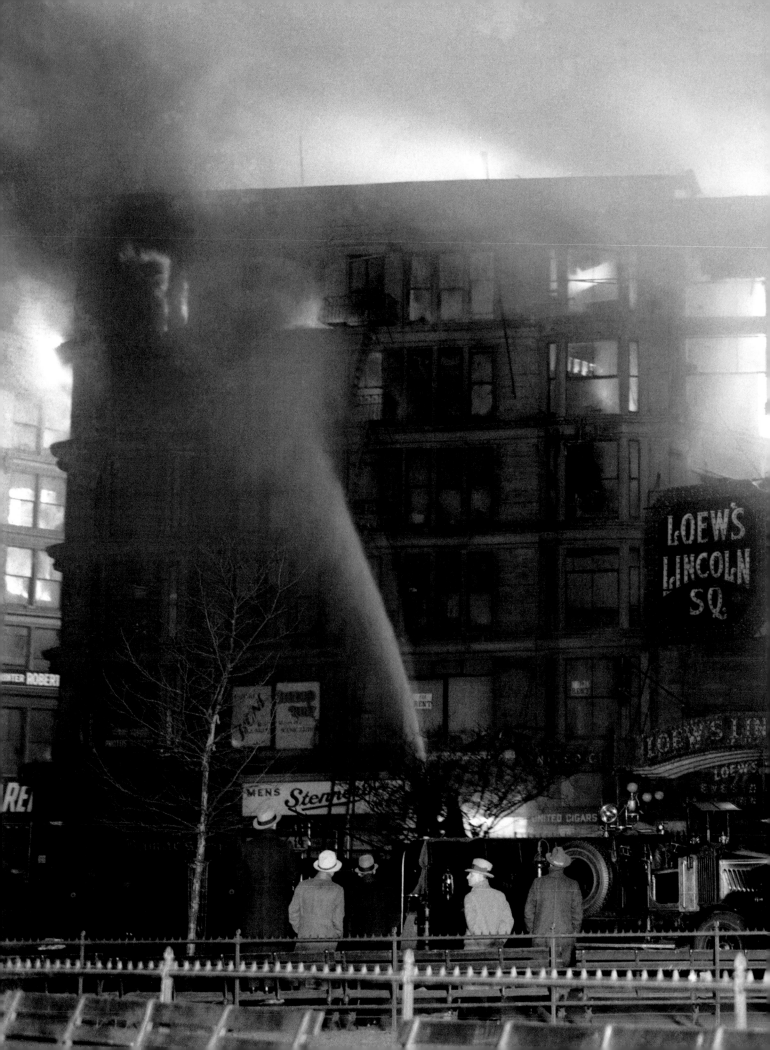

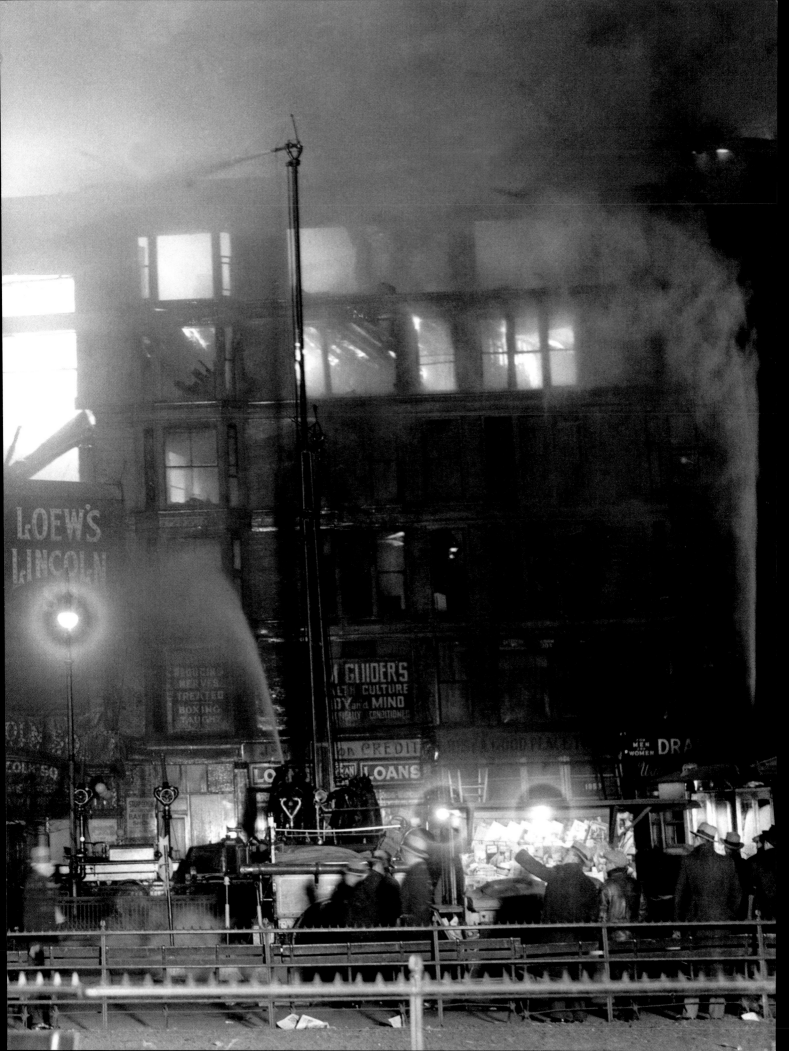

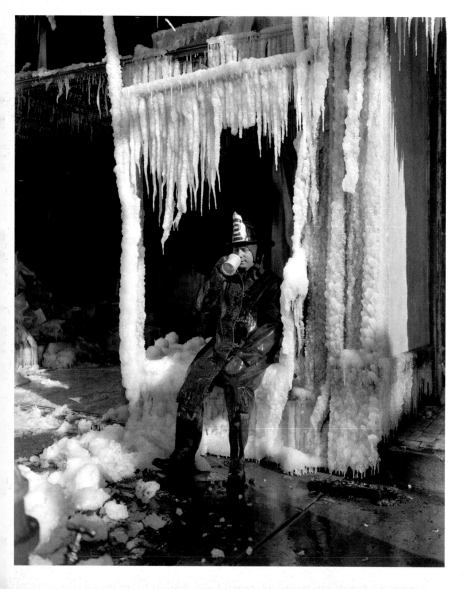

A weary fireman with a mug of coffee rests on an icy perch after battling a blaze in Port Chester. The fire damaged four buildings and routed 20 families from their homes; a dozen firefighters were injured. Feb.19, 1934

Opposite page: Lt. John M. Metz makes his way down a ladder after rescuing a young girl. Firemen saved 35 people trapped on the fourth and fifth floors of the burning tenement at 506 Brook Ave., the Bronx. Apr. 14, 1935

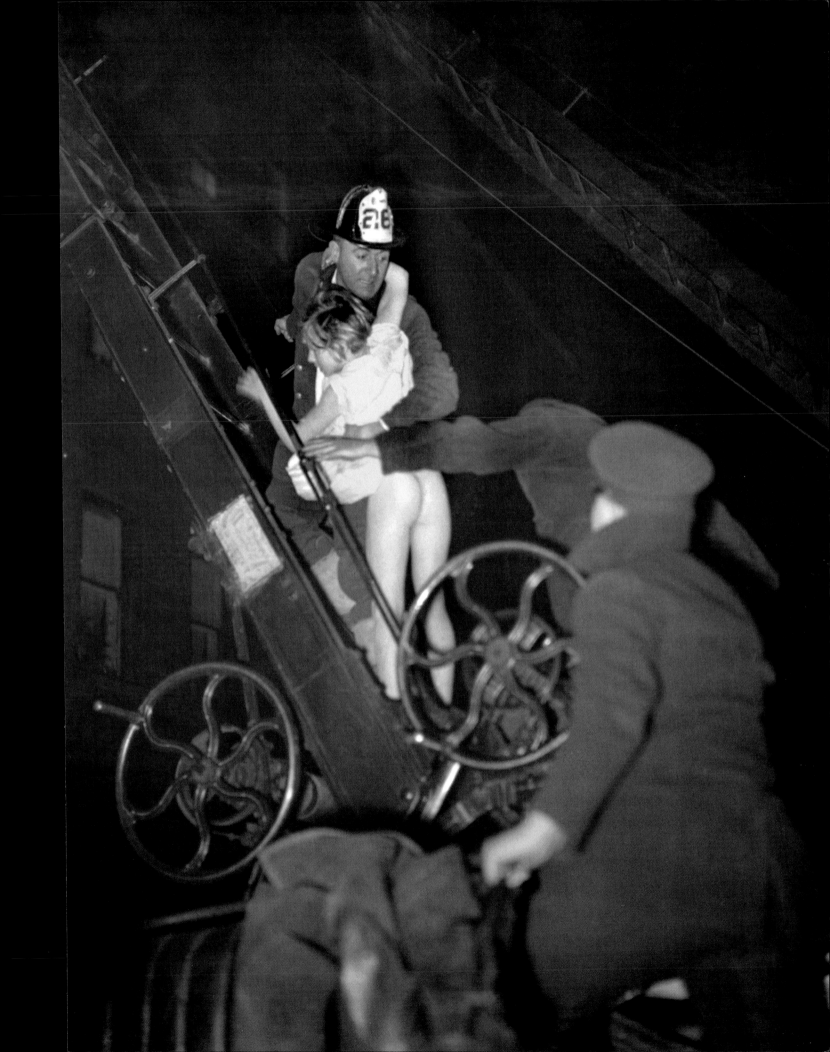

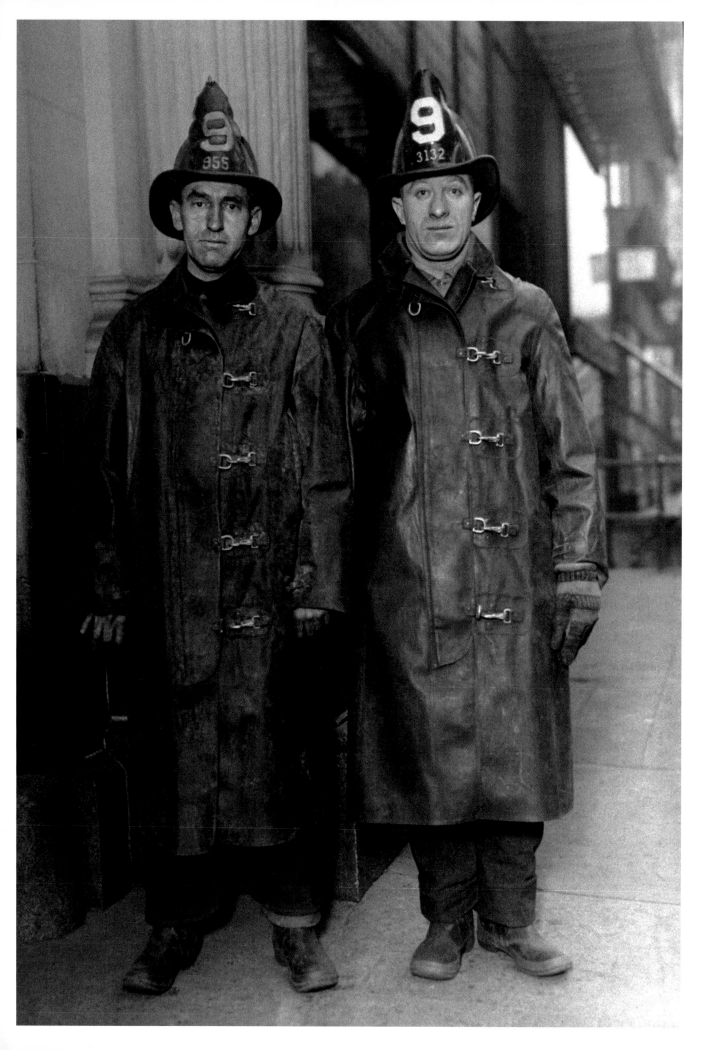

Opposite page: Firemen
Martin Daley and Herman
Klein. Jan. 28,1927
W. Willard

Above: Fireman Peter Daly of
Engine Co. 39 struggles for
life as his son, Peter Daly, Jr.
keeps vigil. Daly suffered a
fractured skull, third-degree
burns, and gas poisoning
resulting from two explosions
at the Ritz Tower Hotel, East
57th St. and Park Avenue.
The fire killed five firefighters
at the scene and injured
more than thirty others, three
of whom—including Daly—
later died. Aug. 1, 1932
Dowling

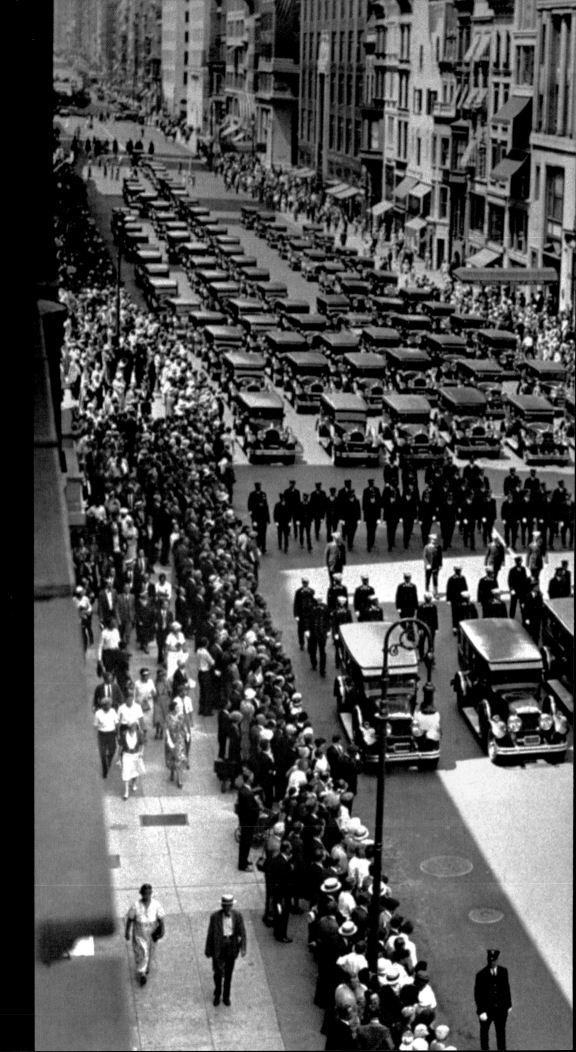

Fireman Peter Daly carried alongside his brothers, Lieutenants James Harnett and John Cosgrove, Firemen Thomas Finn, Louis Hardina, and William Pratt, in a funeral procession from St. Patrick's Cathedral up Fifth Avenue and then along East 57th St. past the Ritz Tower Hotel at Park Avenue (seen at right), three days after two explosions there killed eight firefighters. (Another fireman, James Greene, was buried the day before, and the last, Edward Maloney, died of his injuries several days later.) It was the worst loss of life in the Fire Department's history until October 1966.

"The life and death of a fireman are more noble than words can express. They live a life of constant courage, and when they die, their death is an inspiration because they have been willing to give their lives to combat a common enemy." —Monsignor Michael J. Lavelle, in his eulogy at St. Patrick's. Aug. 4, 1932
Dowling

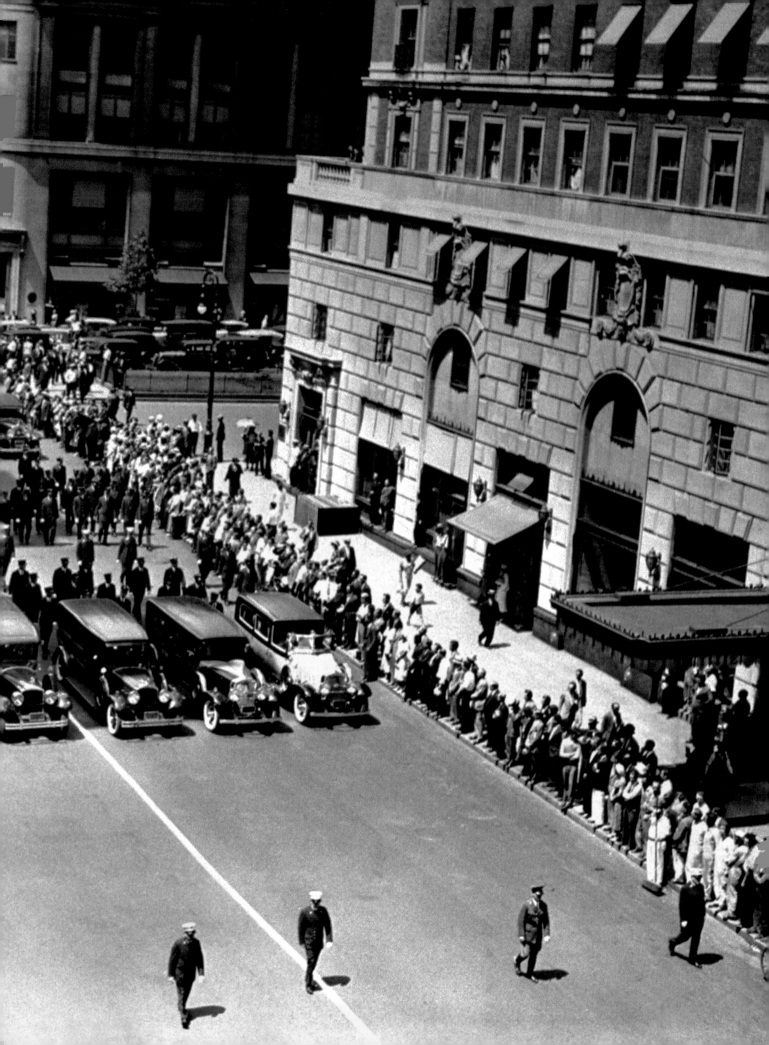

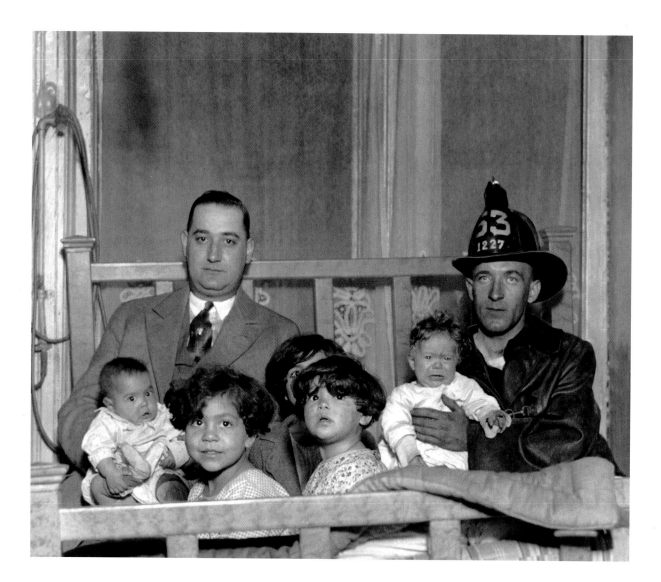

The five Russo children alive
after a pre-dawn fire thanks to
the heroism of Fireman James A.
Fitzsimmons, right, and
Detective Bernard Gunson.
Flames blocking the front door
at 1637 Lexington Avenue,
Gunson and two officers formed
a human ladder; Gunson
climbed atop the other two and
loosened a window's safety
bars, rescuing Rosie, 8, May, 5,
and Lucy, 3. Fitzsimmons arrived
with a real ladder and saved
twins Daniel and Madelaine, 8
months. May 30, 1928

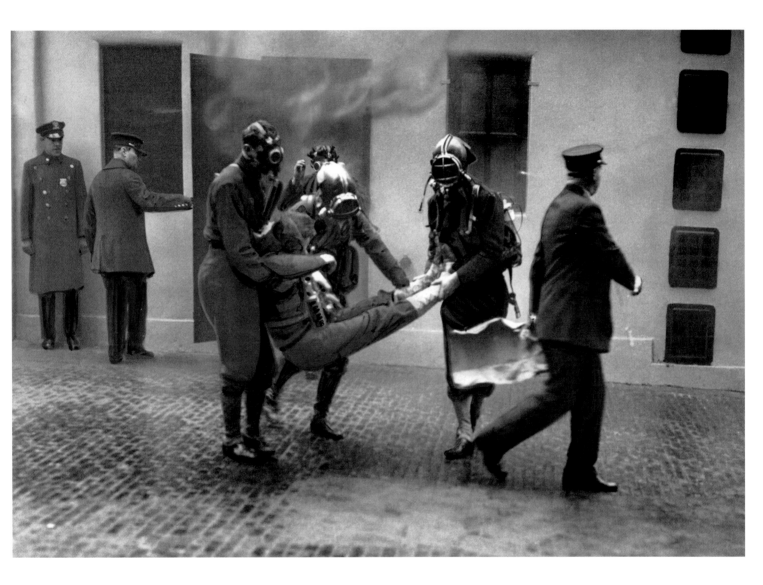

Rookies graduating from the
Fire Department's Drill School,
on East 68th St. near Lexington
Avenue, wear state-of-the-art
gas masks as they rescue
"victims" from a smoke-filled
chamber during a press
demonstration. Jan. 27,1934.
Brown

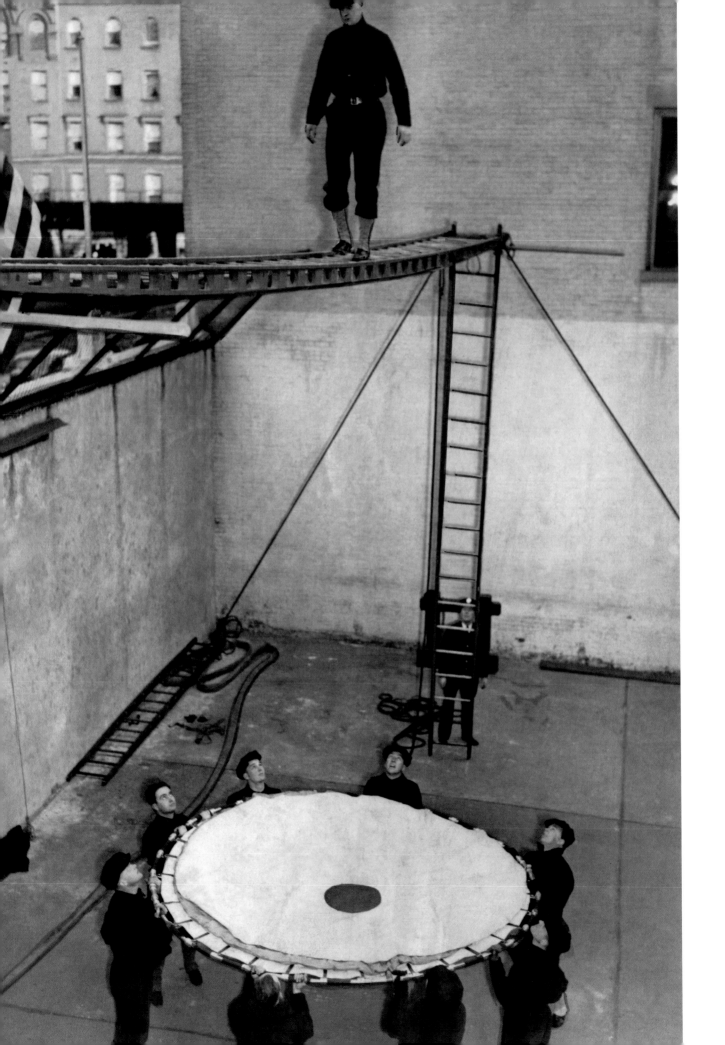

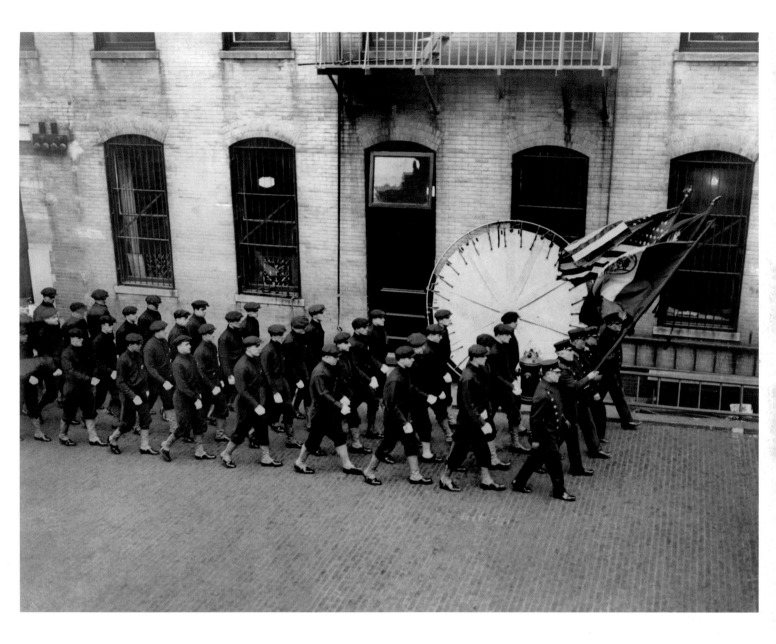

Opposite page: Rookie fireman
walks a bridge ladder while
classmates hold a safety net
underneath during a training
course for all budding firemen
at the department's School of
Instruction. Dec. 18, 1936
Zolotorofe

Above: The 86 probationary
firemen in this graduating
class parade in the drill yard
at the department's Drill
School. Jan. 27, 1934
Brown

Firefighters try in vain to save the top two floors of historic Webster Hall, at East 11th St. and Third Ave. The four-story building, dating to the 1860s, was for decades the leading site of Greenwich Village events: society parties, debutante balls, bohemian revels, and labor and political meetings. The three-alarm blaze was initially blamed on Communists because it began not long after a party given by *The New Masses,* a left-wing magazine. The building recovered from this fire, the third of five taking place there between 1902 and 1949. In the eighties, it was reborn as the original Ritz and then, in 1992, a nightclub named after its origins. Mar. 8, 1930
Bob Costa

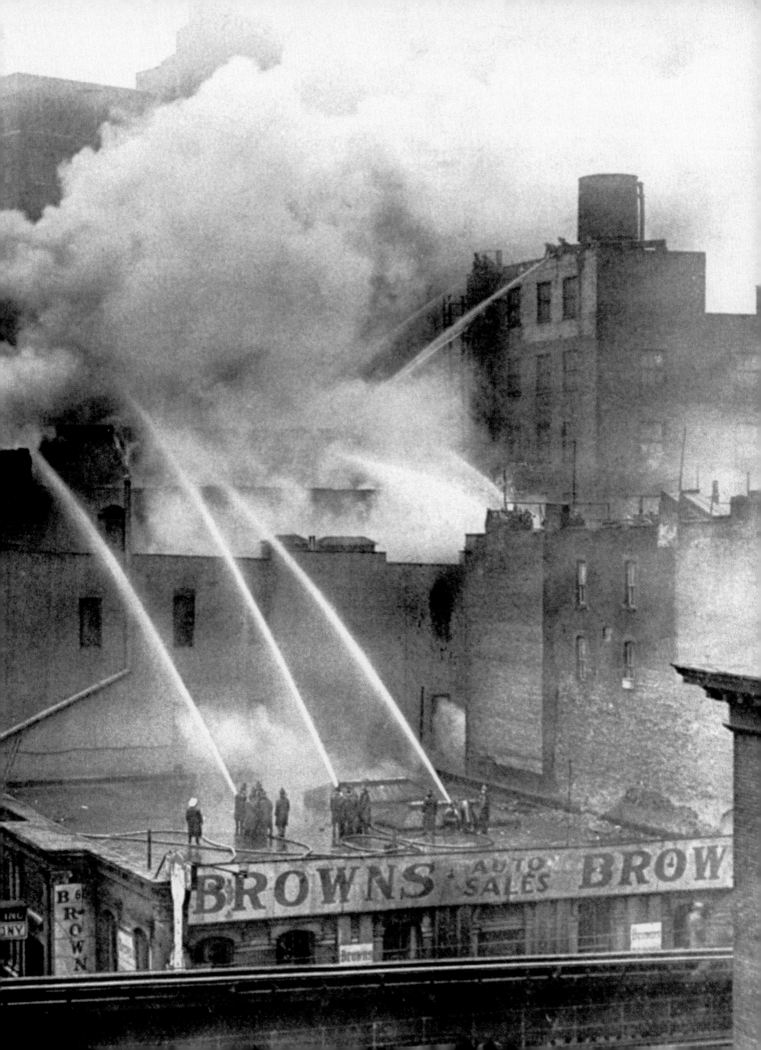

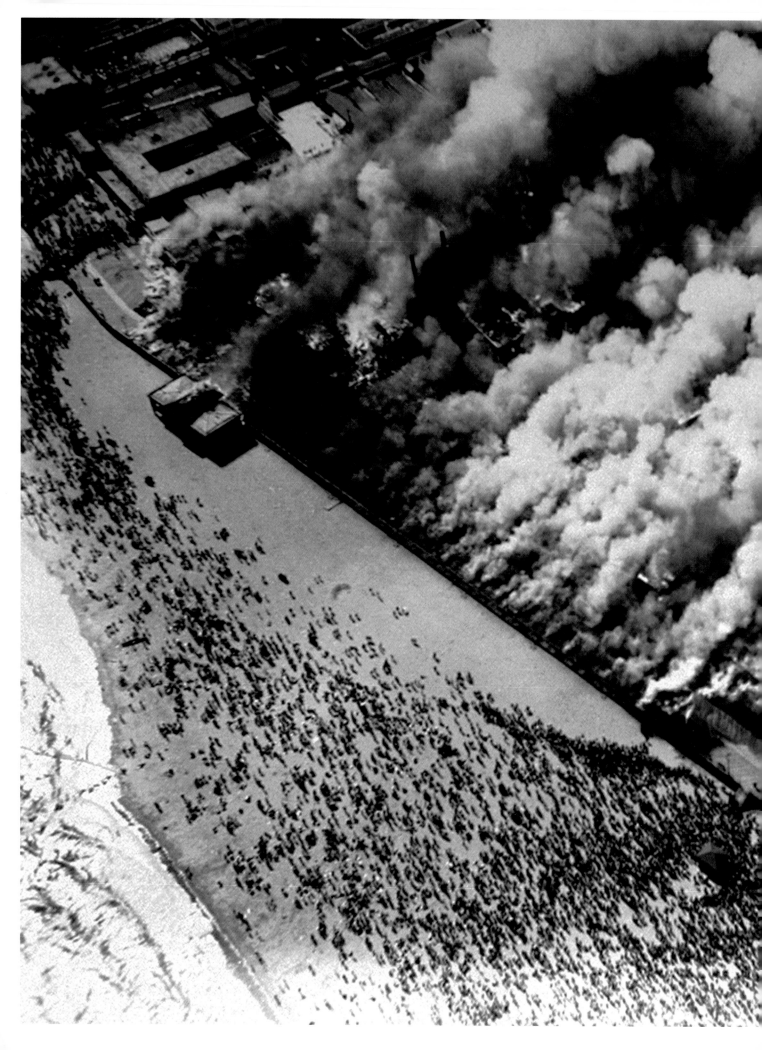

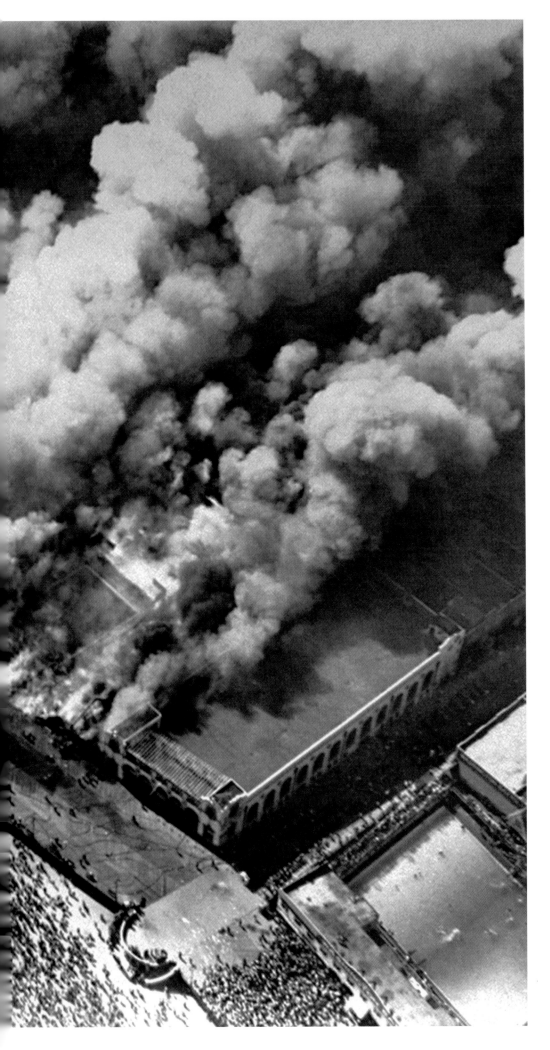

About 100,000 beachgoers watch four square blocks of Coney Island go up in flames. What began as a midafternoon rubbish fire set by some boys under the boardwalk destroyed a thousand feet of the wooden structure—along with apartment buildings, concession stands, and five bathing pavilions between Ocean and Surf Avenues, from West 21st to West 25th St. July 13, 1932
Herb McCory

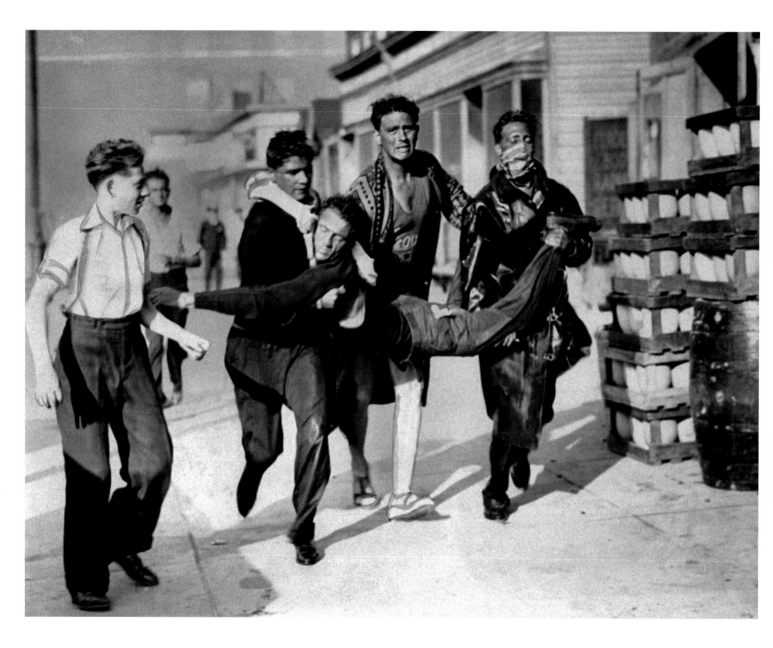

An unconscious volunteer
fireman is rushed to safety
during the devastating Coney
Island fire. In all, more than
two dozen firefighters were
hospitalized and about three
hundred other people were
treated; the $2 million fire
made up to five thousand
people homeless, many of
them left with nothing but the
bathing suits they were wear-
ing. July 13, 1932

Firemen carry a safety net to
the Gotham Hotel, Fifth Ave.
and 55th St., where one John
Warde was standing on a ledge,
seventeen floors up. Thousands
of spectators watched anxiously
for eleven hours as rescue
workers attempted to save the
distraught 26-year-old, but at
10:38 p.m., he fell to his death.
The sensational suicide inspired
a 1949 *New Yorker* magazine
article and later the fictionalized
1951 movie *Fourteen Hours*.
July 26, 1938
Seymour Wally

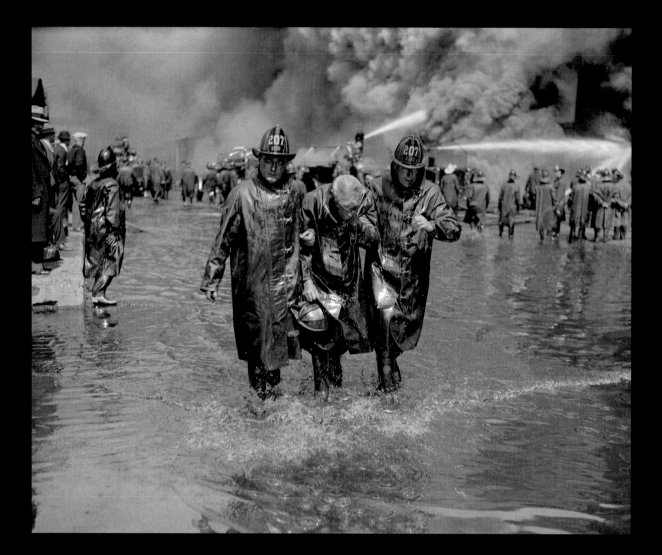

Above: Burned around his
eyes, Lt. Michael Moran of
Engine Co. 207 is led from
the scene of a six-alarm
blaze in a rubber and paper
warehouse at the foot of
Montague St., Brooklyn.
Dense clouds of smoke from
explosions and backdrafts
overcame not only 50 of the
350 firemen at the scene but
also more than 125 subway
passengers in the East River
tunnel and at the Wall Street
station more than a mile
away. Apr. 20, 1935

Opposite page: A new 125-
unit apartment building on
Shore Road at 97th St. in
Brooklyn goes up in flames
just before the scheduled
arrival of its first tenants. The
five-alarm fire, which took
250 firefighters nearly two
hours to control, was blamed
on arson linked to labor
problems involving a non-
union plastering contractor.
Mar. 30, 1935

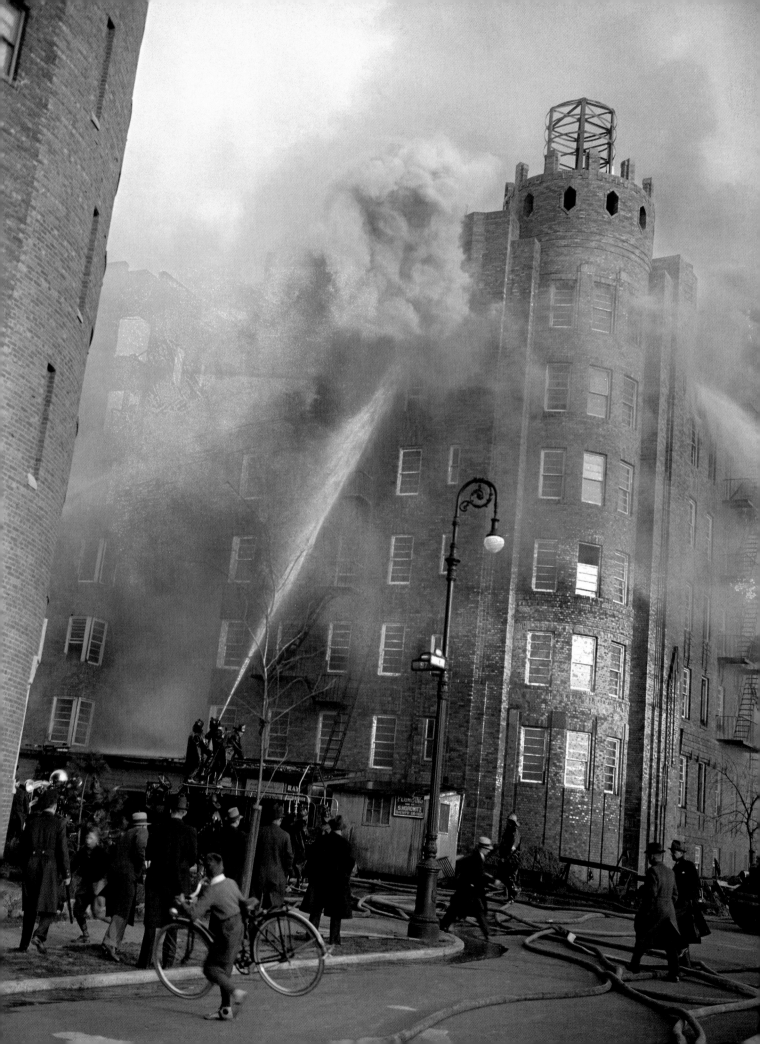

The Fire Department gives a demonstration at the Battery of twenty-nine new pieces of equipment, capable of pumping one hundred tons of water per minute. May, 1937.

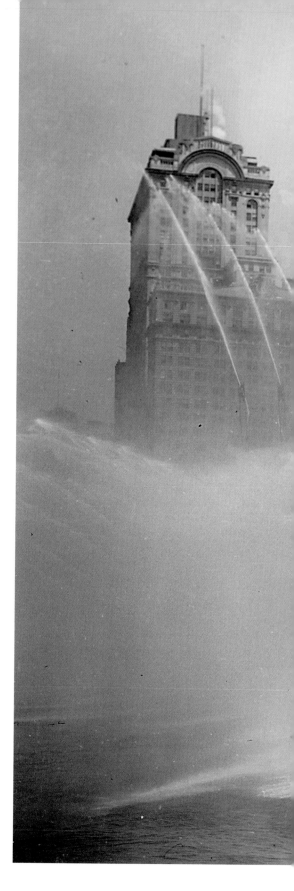

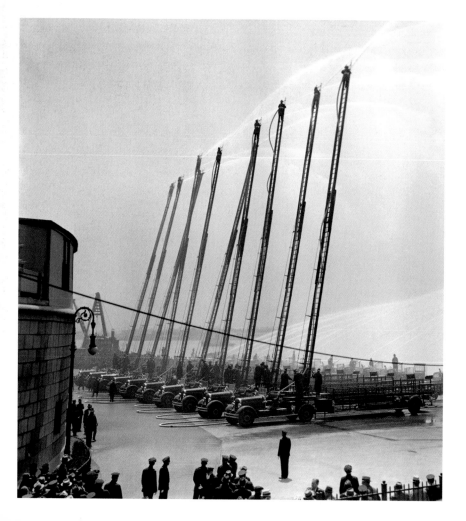

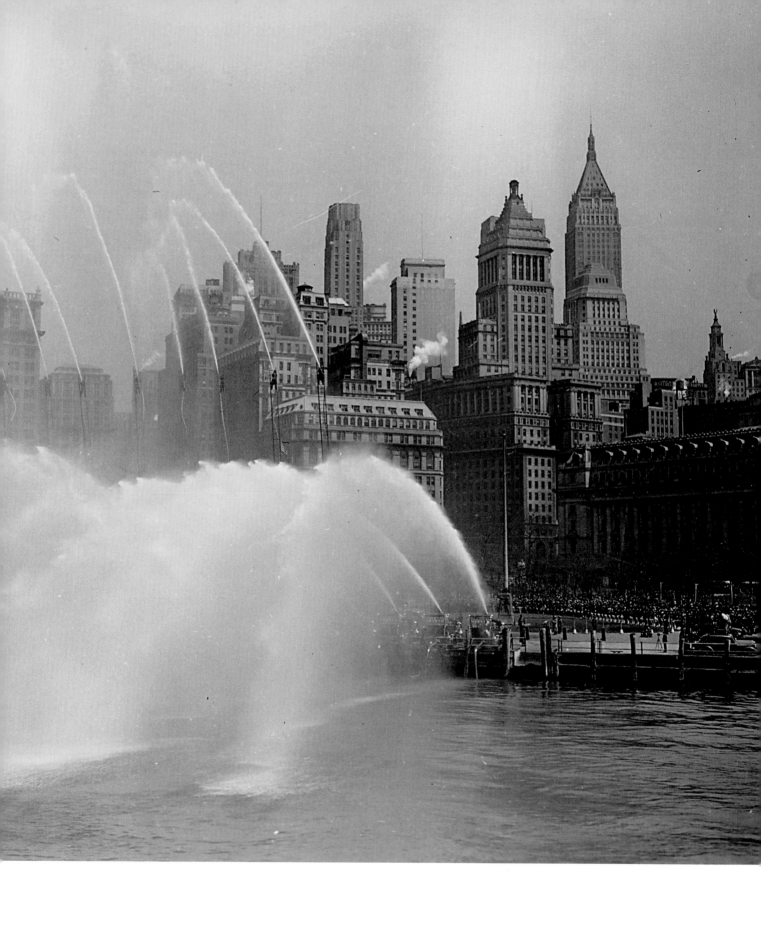

PROTECTING CHANGING CIT

Their stories are woven through the dynamic history of New York and its neighborhoods, enduring components in a landscape that never stops changing. There was a Fire Department even before there was a city of New York, hence the acronym FDNY, instead of NYFD.

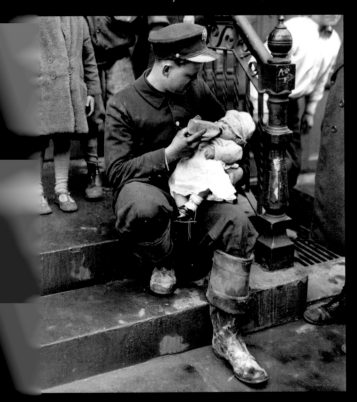

Fireman Arthur McCarthy plays nurse for Edna Lee Gabel at 417 W. 44th St. Her mother, May Gabel, was severely burned in a gas explosion at home. With her clothes on fire, she scooped up her baby and ran down the fire escape before collapsing. Mar. 18, 1930

The fire companies were originally brought together as a paid department in the last year of the Civil War. Thirty-three years later, in 1898, the City of Brooklyn and the territories of Staten Island Queens, and the Bronx joined Manhattan to become the New York City we know today.

Eighty years ago, as the city moved into the Roaring '20s and the Daily News became the standard of photojournalism, the majority of the Fire Department's members were Irish men—immigrants or first-generation Americans—who were a rough and-tumble lot, working 21 hours a day, seven days a week (later they would work 12-hour shifts for an 84-hour workweek).

They were burly men, many with thick handlebar mustaches of the period, who drove horse drawn vehicles carrying water pumpers. They were escorted by Dalmatians, the spotted breed used as carriage guardians. The dogs ran alongside the fire wagons, their barking serving as a siren to warn pedestrians out of the path of the rushing horses.

A picture of the final run of Happy and Fairfax, a team of white horses transporting Engine Company 72 through the Upper West Side of Manhattan, captures the flavor of the city in 1920 (page 6): the graceful architecture of the apartment building next to the firehouse, a gentleman in straw boater hat and bow tie, a band of scruffy children, and a gleaming motorized fire truck that would replace the horses. The last run by a horse-drawn FDNY vehicle was made in Brooklyn in December of 1922 (page 9).

As the Fire Department developed new technology, the News documented the progress such as the arrival in 1940 of the city's first rescue truck, used by Rescue Squad No. 1. It had a two-way radio telephone and a hydraulic lift to aid in building collapses. A 1944 photo shows a fireman wearing a large radio box on his back and speaking into a walkie-talkie, a new marvel that allowed him to communicate with firefighters on a building roof during a fire (page 45)

After World War II, when returning servicemen married and moved to the suburbs to raise families, city neighborhoods underwent a drastic change, and buildings deteriorated. In the 1960s, there were twice as many fires as there had been a decade earlier. Poverty, race riots, and civil unrest combined with absentee landlords to fuel arson in places like Harlem in Manhattan, and Brownsville and Bedford-Stuyvesant in Brooklyn. But the direst situation unfolded in the South Bronx, where entire blocks burned to the ground or were transformed by fire into eerie landscapes of blackened shells of buildings. Some fire companies in the city made as many as 8,000 runs a year in the early 1970s, when the number of fires topped 200,000 annually.

But a 1972 News photo shows how, caught in the midst of exhausting, terrifying moments of dense smoke and searing flame, firefighters never swayed from even small acts of compassion. It depicts a fireman at the top of a ladder making his way toward a singed cat cowering on a window ledge, paralyzed with fear and nowhere to go (page 84).

Many dramatic News photos were taken of firefighters atop 50-foot ladders, which came into use in the mid-'60s, and of the water force of the new Superpumper rig, which pumped more than 8,000 gallons per minute.

This era was a tough one for the FDNY; the fires seemed ceaseless, and at some scenes firefighters were pelted with bottles and other projectiles. Police cars often accompanied the fire rigs, which now contained cabs to give firemen a protective cover. In 1975, there were nearly 400,000 fire alarms, according to FDNY records. In 1978, Fire Commissioner Augustus Beekman said the city was undergoing a 20th-century version of the Burning of Rome.

In 1982, Brenda Berkman won a federal lawsuit and became the first woman to join New York's Bravest; she rose through the ranks to become the third female captain in department history in May 2002. By this time, there were still only 25 women in a department of 11,500.

FDNY Paramedic rescues child from a three-alarm blaze in which 41 people were injured on Garden St. in the Bronx. Dec. 15, 1996
David Handschuh

The firefighters' equipment improved during the 1980s and 1990s, with an emphasis on protective gear. Instead of the rubber raincoats and filter masks they once wore, firefighters today don bunker gear—thick, heavy, flame-retardant pants and coats issued only after a long, arduous crusade by firefighters themselves.

Fifteen years ago, fire companies began receiving emergency medical training and started responding to medical emergencies, particularly heart attacks. In 1997, the city's Emergency Medical Service was folded into the FDNY; this division now numbers 3,100 personnel.

Today, the men and women who fight fires or transport victims in ambulances have to deal with the 21st-century blight of terrorism, preparing for bombings, the spread of toxic substances, and chemical warfare—threats their forebears never dreamed of encountering.

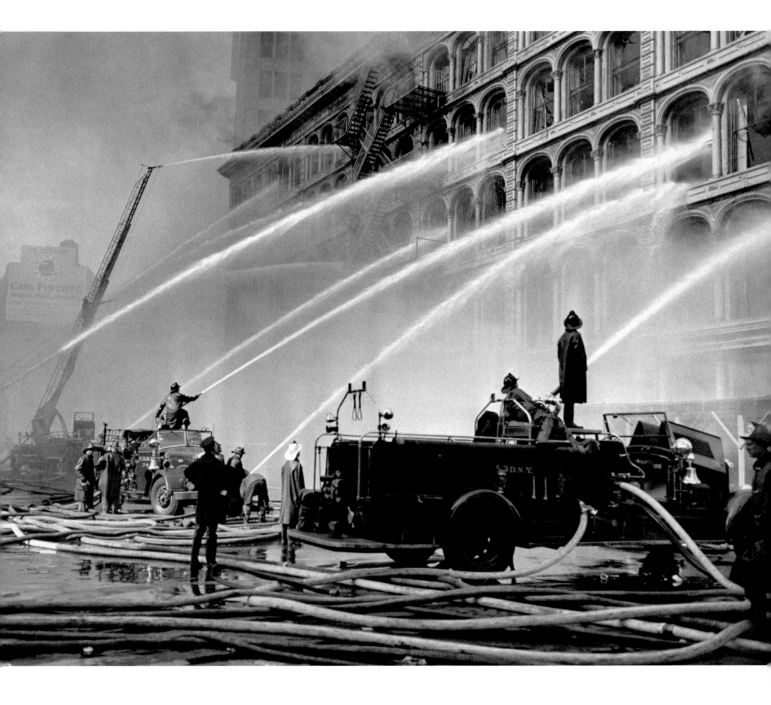

1940-1959

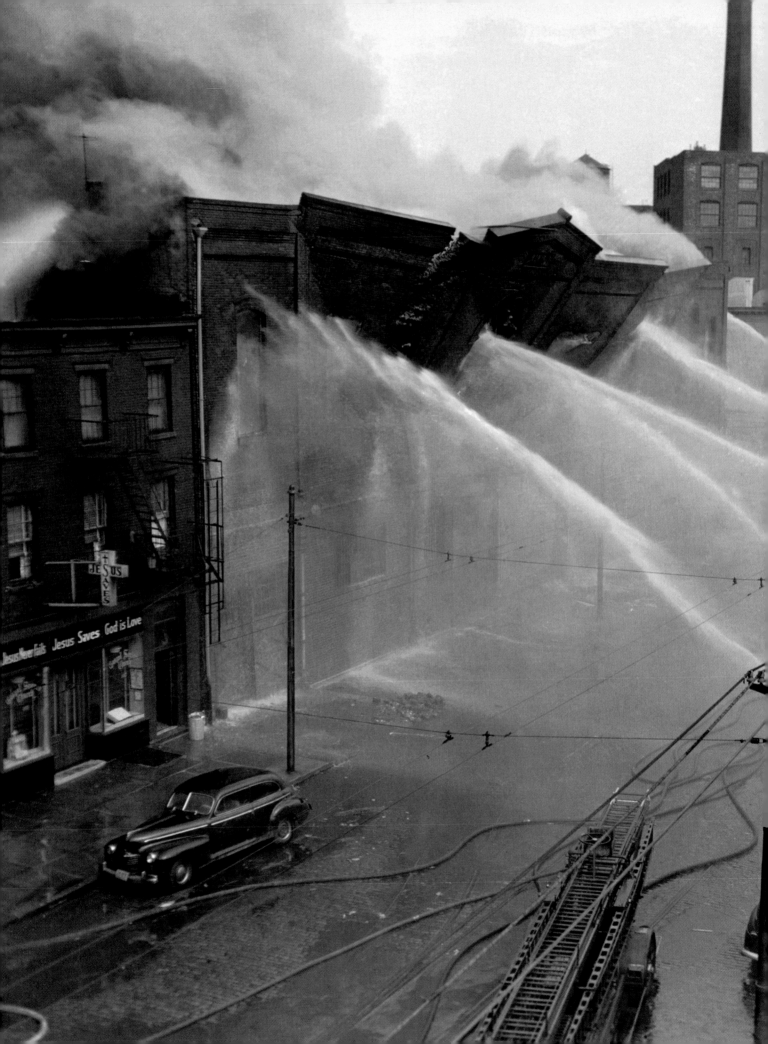

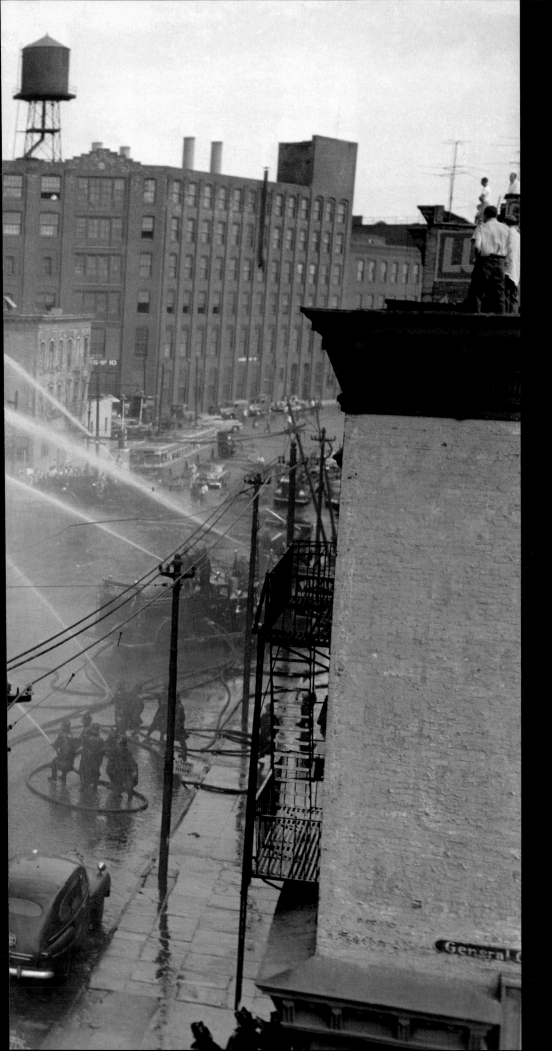

Previous page: Firefighters midway through a two-day battle to control a five-alarm fire in the vacant John Wanamaker Department Store, an historic 89-year-old cast-iron structure (scheduled for demolition to make way for apartments) at East 9th St. and 4th Ave. It took 600 firemen pouring millions of gallons of water onto the fire to control it. More than 220 firefighters required medical treatment, including 20 who were hospitalized. Up to eight feet of water flooded nearby subway tunnels; service on the Broadway and Lexington Avenue lines were curtailed for days, and vehicular traffic was also affected in an area of several square blocks. July 14-15, 1956
Art Whittaker

The facade of 749 Broadway, near 8th St., topples after the collapse of the fourth floor, pinning 13 firemen during a four-alarm fire on New Year's Eve. Six men were rescued immediately, but it took 12 hours to rescue the last of the trapped firemen, Mike Bennett, from the debris. Miraculously, no one was killed. Dec. 31, 1946
Art Whittaker

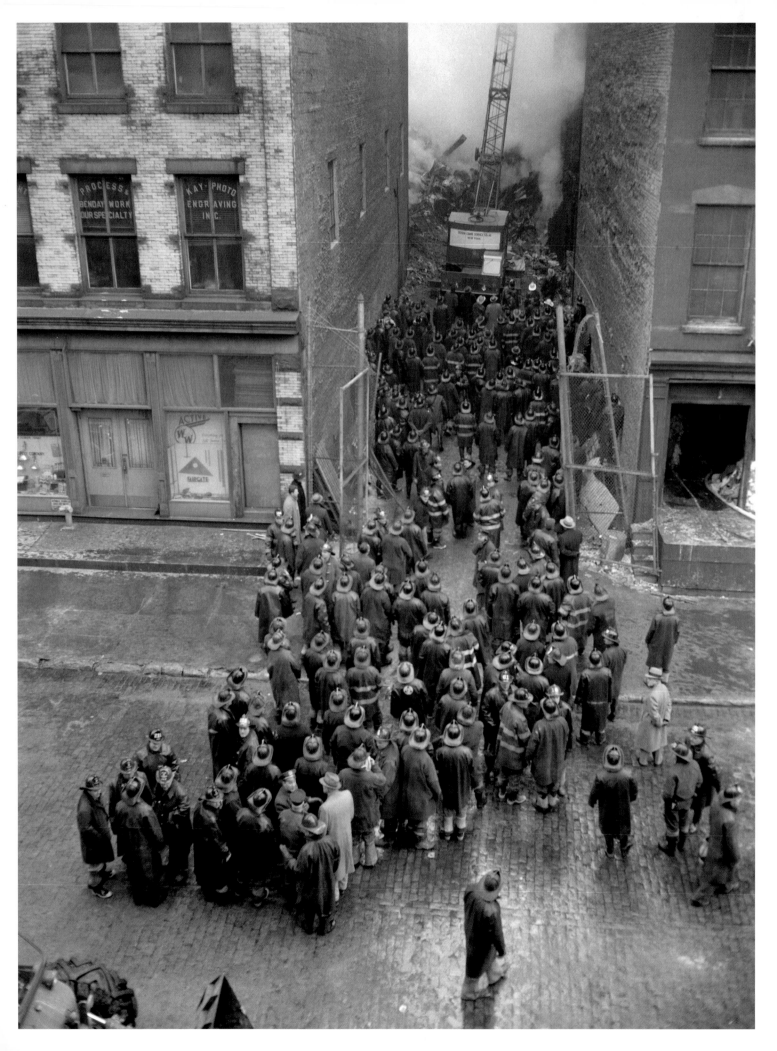

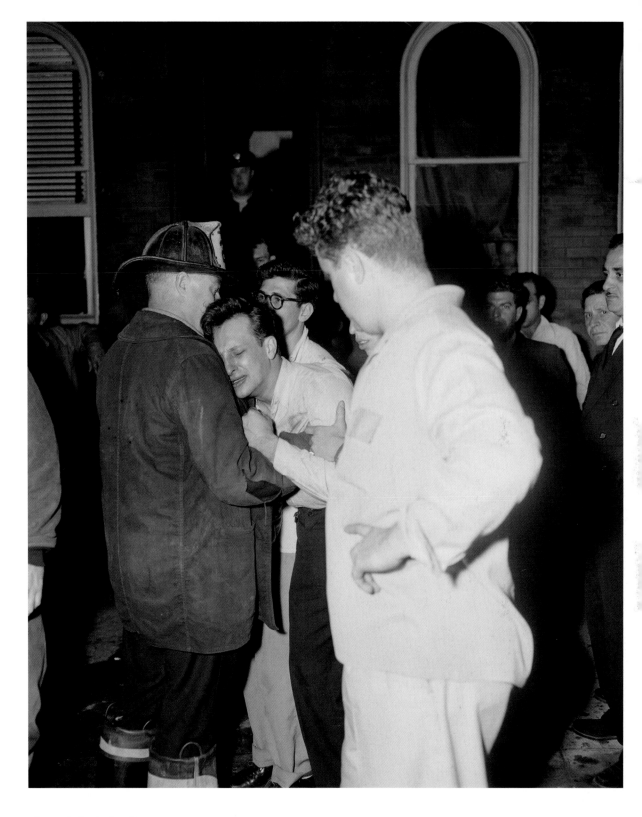

Opposite page: A crowd of volunteer firemen waits to search for missing brethren trapped after the collapse of the top floors of a burning loft building at 137 Wooster St. In all, 750 firemen, including 500 off-duty volunteers, took part in the rescue effort, which proved to be in vain. It was not until four days later that the last of the six bodies—of Firemen William G. Schmidt and Bernard Blumenthal, Fire Patrolmen Michael McGee, Michael Tracy, James Devine, and Louis Brusati—was pulled from the rubble. Feb. 15, 1958
Art Whittaker

Above: Robert Roeber, 25, breaks down after learning that all three of his children—Carol Ann, 4; Patricia, 2; and Robert Jr., 4 months—died in their sleep from smoke inhalation in a fire at their house, 15 Thames St., Brooklyn. Roeber and his wife had put the children to bed just before midnight and then had gone out for a short trip to buy some sandwiches. Sept. 30, 1950
Bob Costello

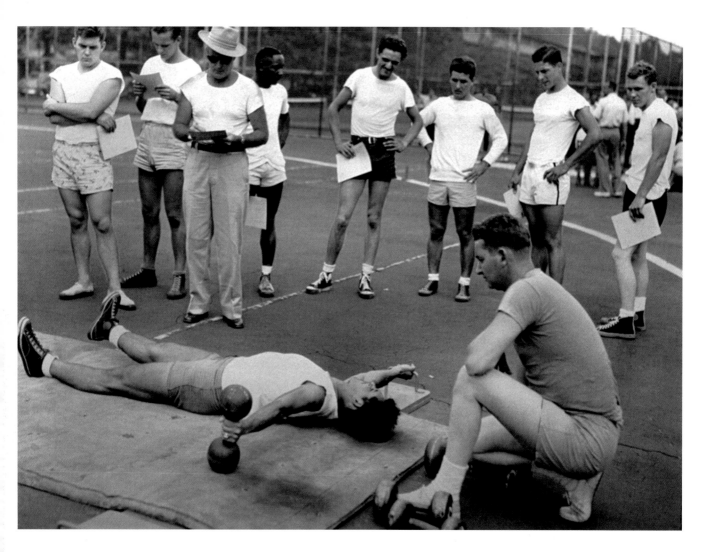

Above: One of the 7,200 candidates for vacancies in the Fire Department attempting "pectoral weightlifting" at Van Cortlandt Park, the Bronx. The broad jump was another element of the department's physical fitness test. They are the first group to be called up by the Fire Department in two years. Aug. 18, 1948

Ossie Leviness

Opposite page: Supported only by safety belts around their waists, some of the 72 Fire Department rookies use individual scaling ladders, hooked onto windowsills, as they undergo training at the Fire Department's school on E. 68th St. Sept. 24, 1946

Gruber

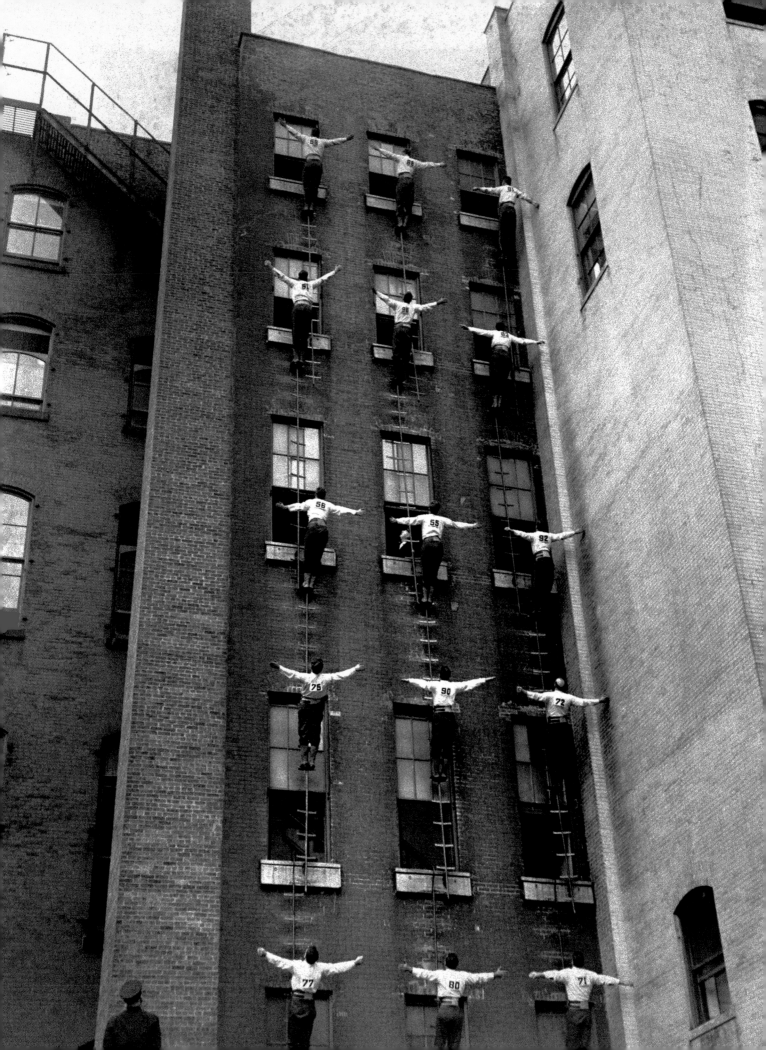

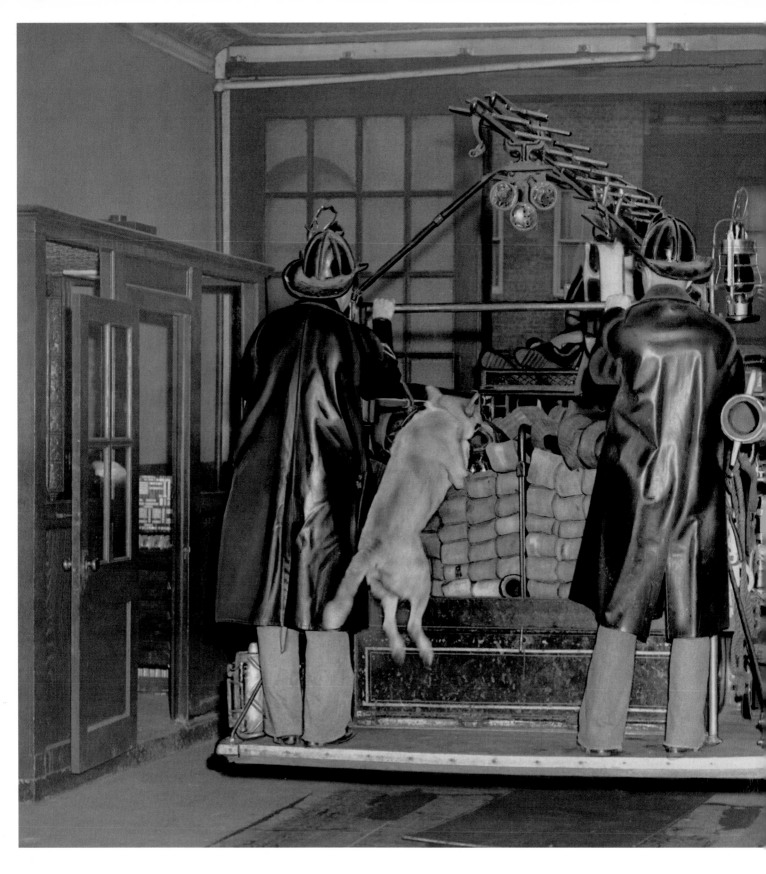

Above: When the alarm sounds, Buster jumps into his special spot on the hose truck for the run. He rides between Firemen Tim Flannagan and Joseph Bradley. At a fire he helps by pulling out the lengths of hose. He's been firefighting since just a pup. Oct. 21,1948

Al Willard

Opposite page: Fireman William Fleck of Rescue Squad 5 uses a walkie-talkie to relay commands from Asst. Chief John J. McCarthy to firemen on the roof of 1511 Sheridan Ave., the Bronx, the scene of a three-alarm fire. This was the FDNY debut of the newfangled "portable radio-telephone device," which firemen called "the pack." Mar. 27, 1944

Ossie Leviness

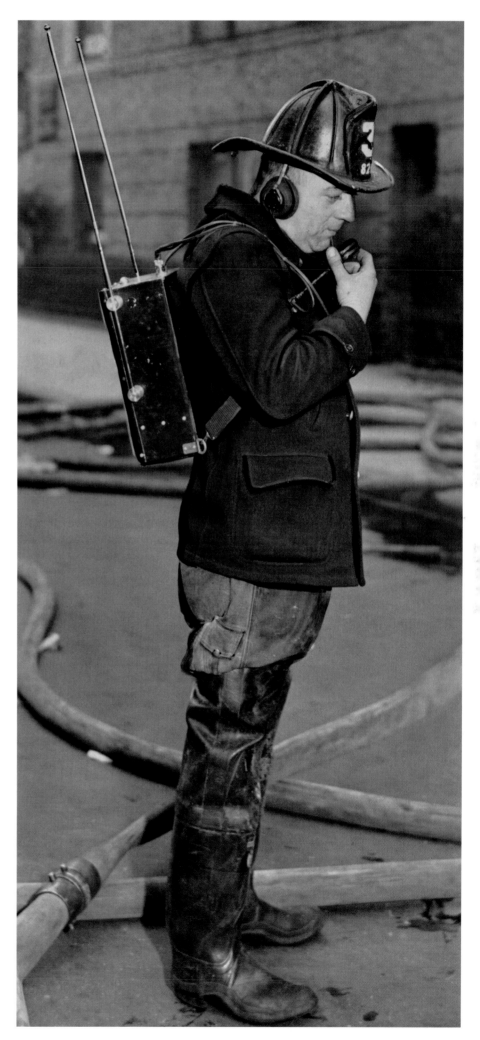

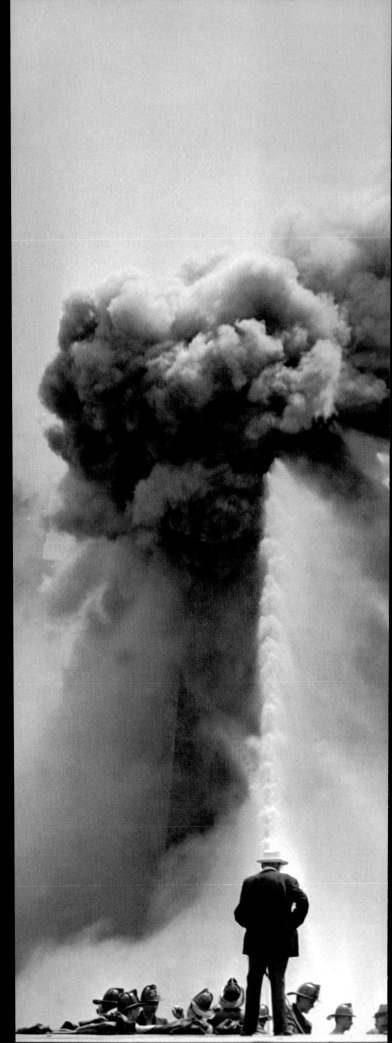

One of the smokiest fires in years results as hordes of firemen direct tons of water at the seven-story Great Atlantic Paper Co. warehouse at 591 Washington St. The five-alarm fire took four hours to control and left 75 firemen hurt while causing $1 million in damage. June 20, 1942

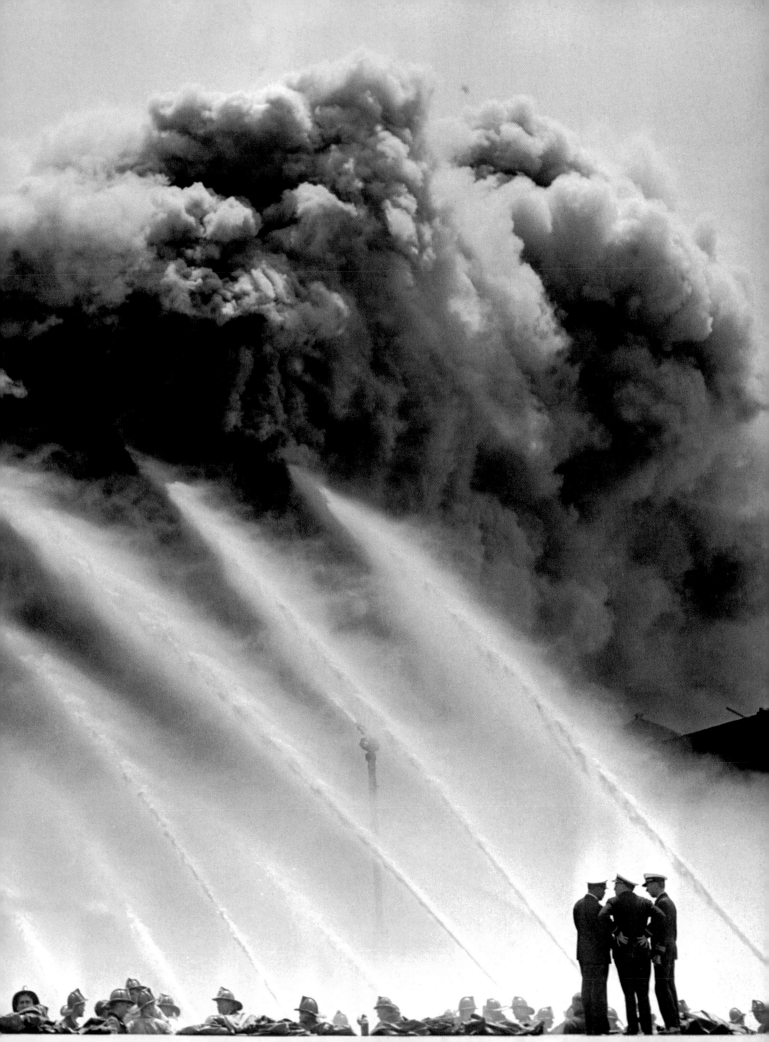

Nineteen firemen were felled during the five-alarm blaze at the old Wanamaker Building at Broadway and East 9th St. Here, an injured firefighter is given a drink by a nurse in the department's ambulance. July 15, 1956
Bill Quinn

Below: Second Deputy Fire Commissioner Dr. Harry M. Archer inspects the new fire ambulance at Engine Co. 56, 120 West 83rd St. At a cost of $20,000, it is the most fully equipped of its kind in the world. Nov. 16,1949
John Peodincuk

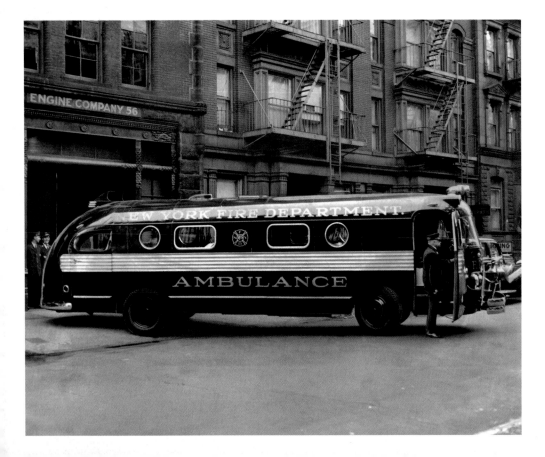

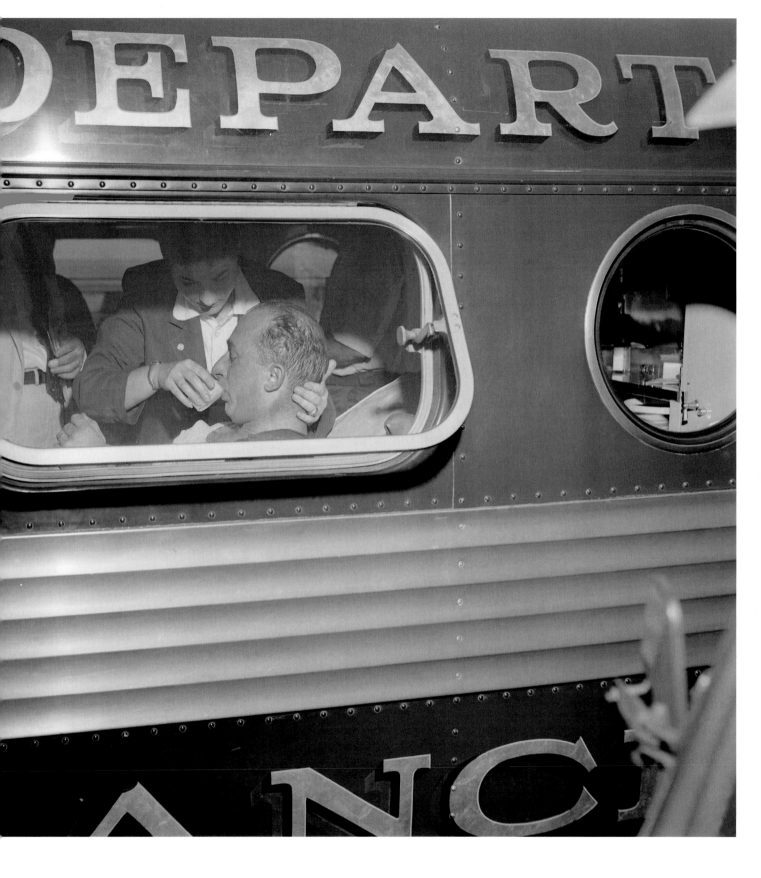

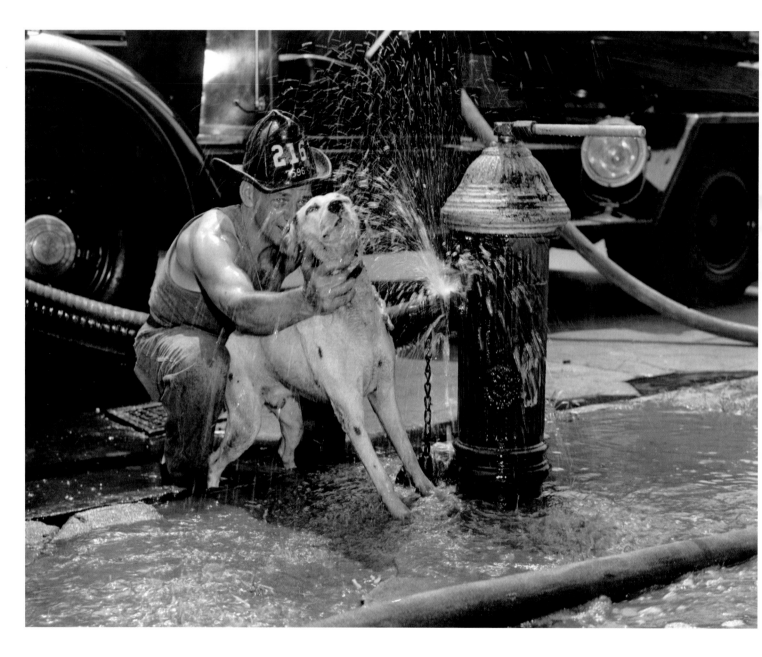

John Hanley of Engine Co. 216
with Peppy, the station's mas-
cot, cool off at the scene of a
two-alarm fire at 249 Floyd St.,
Brooklyn. Flames drove ten
families into the street, but no
one was injured. Aug. 13, 1953
Judd Mehlman

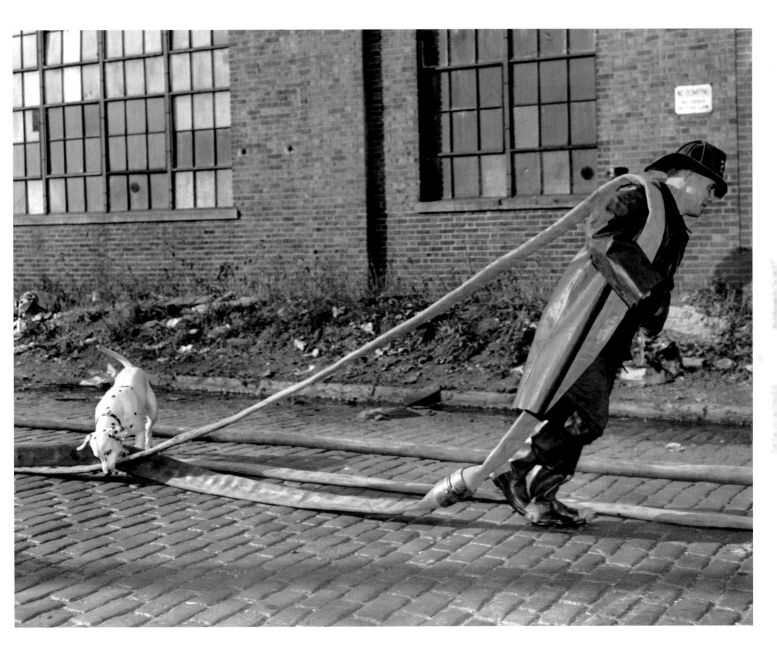

Peppy earns his keep by
helping fireman Bill Smith pull
a hose at the scene of a
three-alarm blaze at Norman
and Morgan Ave.s, Brooklyn.
Nov. 16, 1951
Tom Gallagher

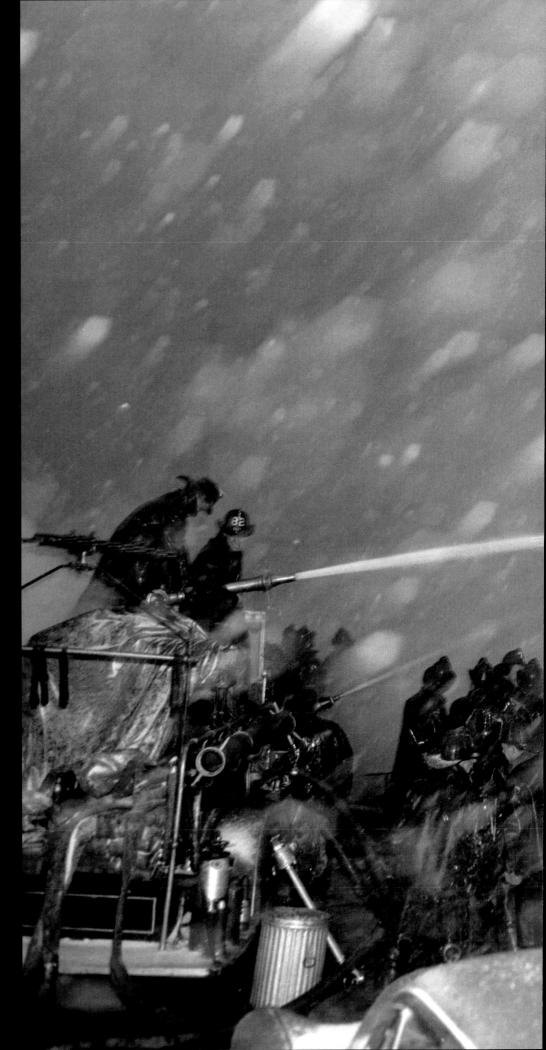

A four-alarm fire ruined the New Year's Eve celebrations of many, including these firemen, who not only had to battle the blaze, but the blizzard as well. Dec. 31, 1959
Ossie Leviness

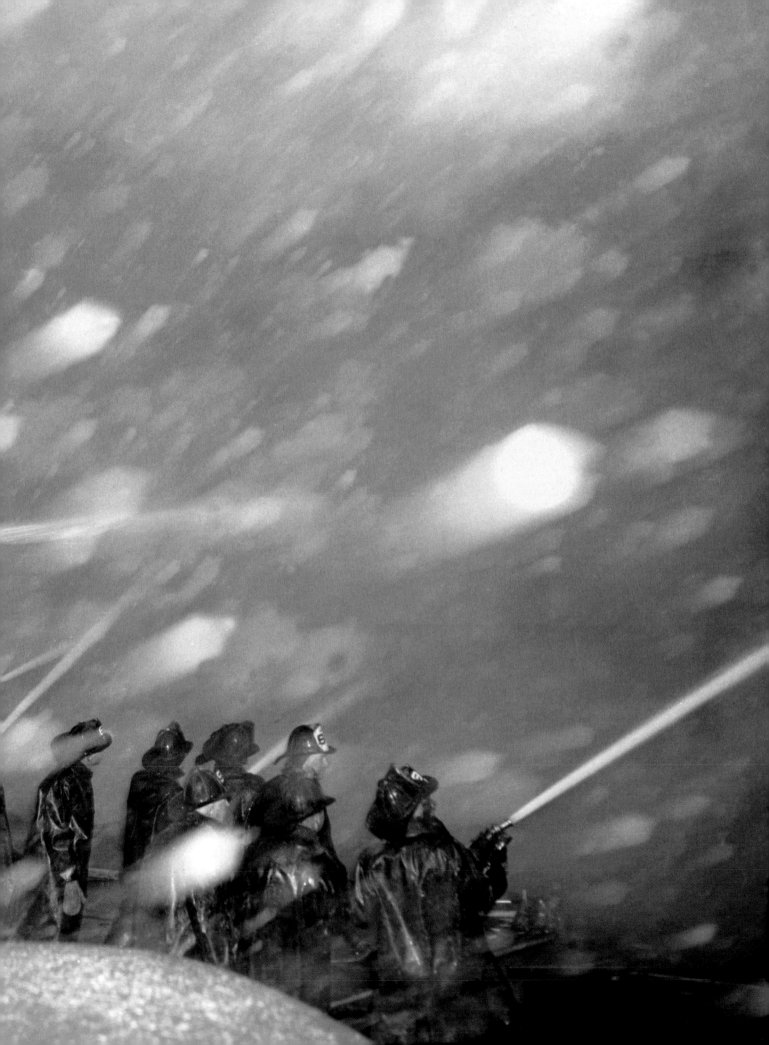

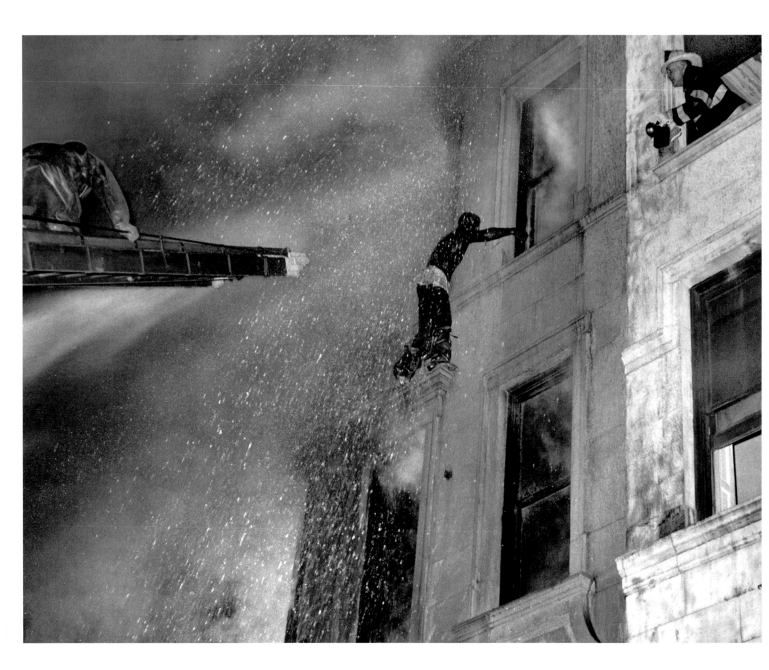

In this award-winning photograph, firemen
pour freezing water on Robert Rogers, 32, to
douse the fire on his clothing and in his hair as
he clings to the 4-inch ledge on the fourth floor
at 108 West 64th St. before dawn. Rogers
became trapped when a fire began in the
abandoned building he had entered to get out
of the cold. Soon afterward, Fireman George
Franco of Hook and Ladder Co. 25, seen here
at left climbing a 45-foot aerial ladder, made
the hazardous rescue by grabbing Rogers
through the curtain of icy water. Jan. 17, 1959

Bob Koller

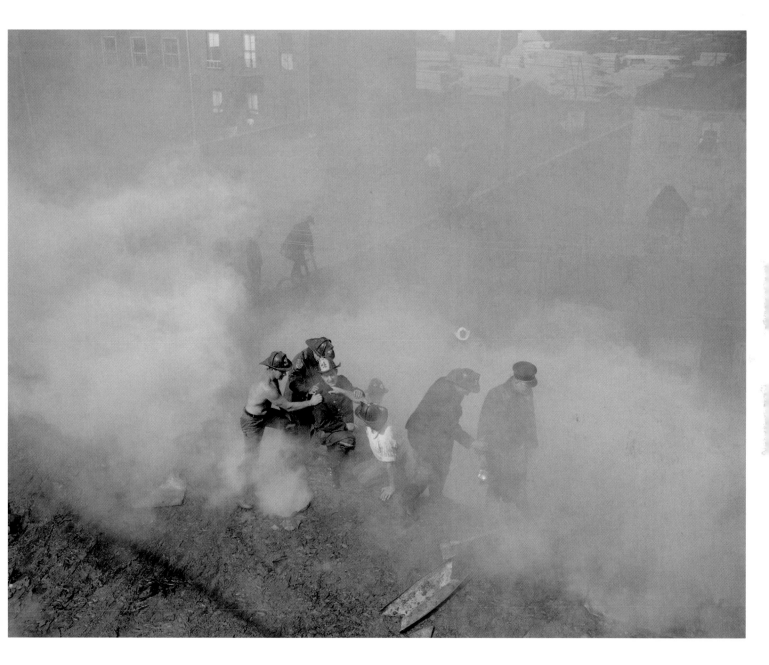

Lt. Carl Morchauser (center) is
pulled out of a hole in the roof
by his buddies. The roof gave
way under his feet, causing
him to fall halfway through as
the blaze in the film storage
plant at Huron and West St.s
in Brooklyn raged around him.
June 12, 1950
Victor Twyman

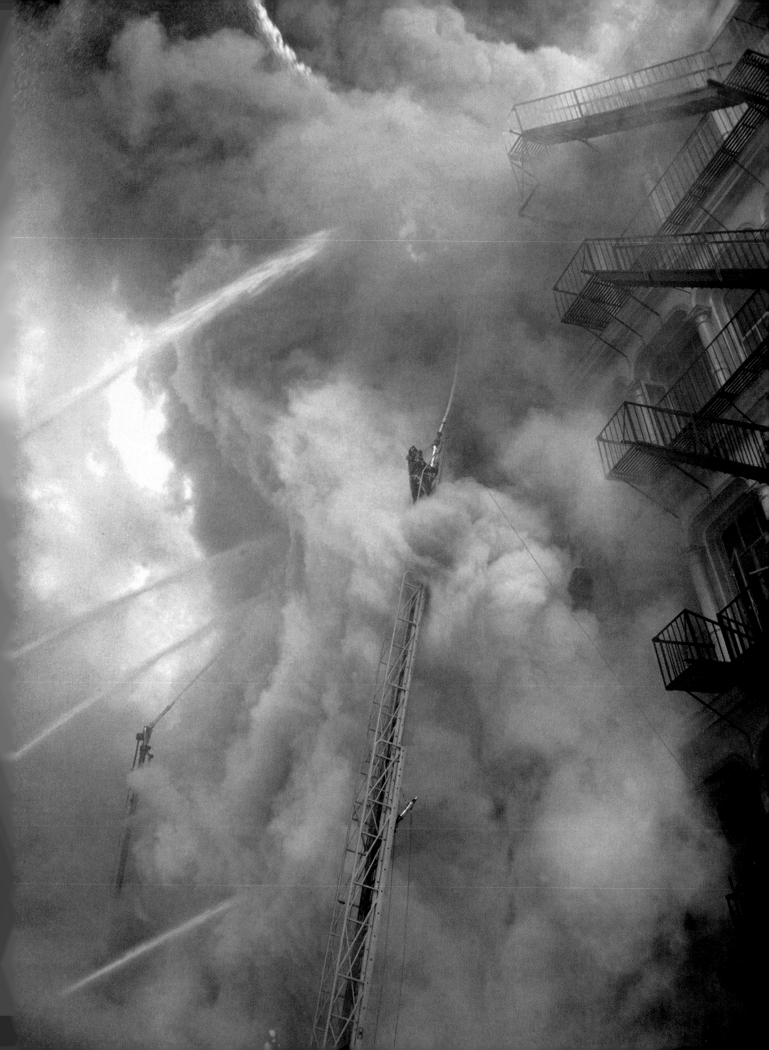

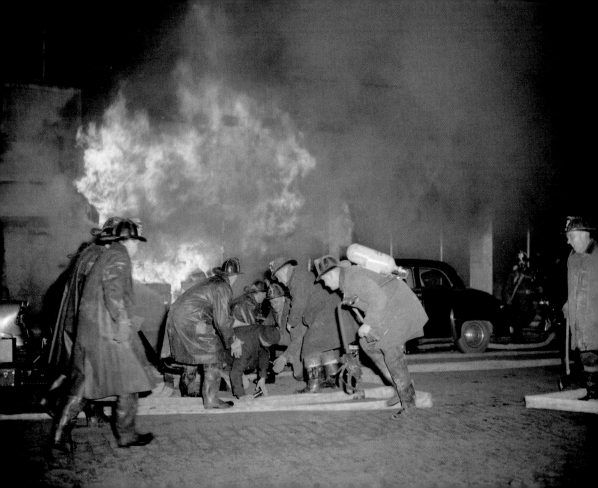

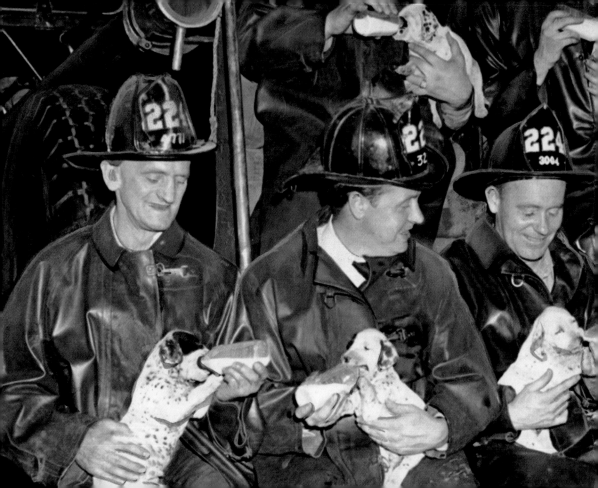

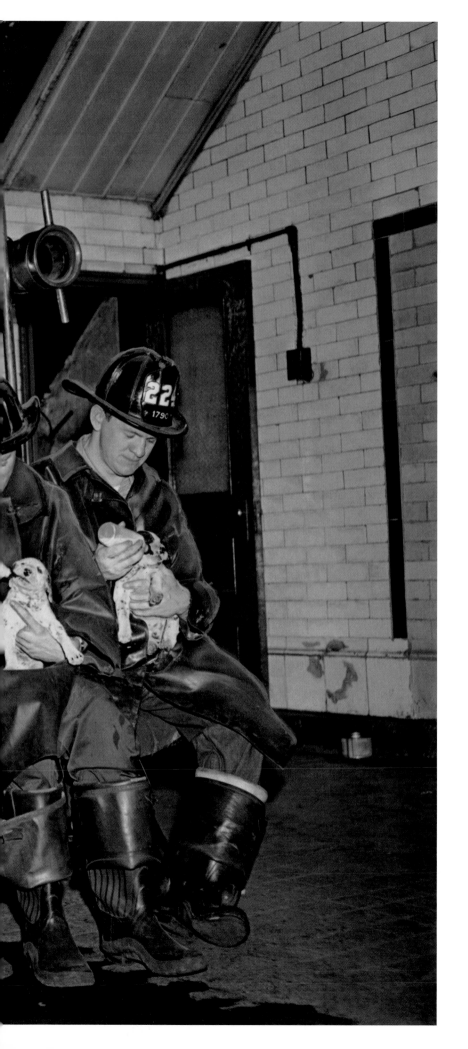

Seven firemen of Engine Co. 224, at 274 Hicks St. in Brooklyn, help wean fire- house mascot Nellie's seven pups. June 7, 1948
Paul Bernius

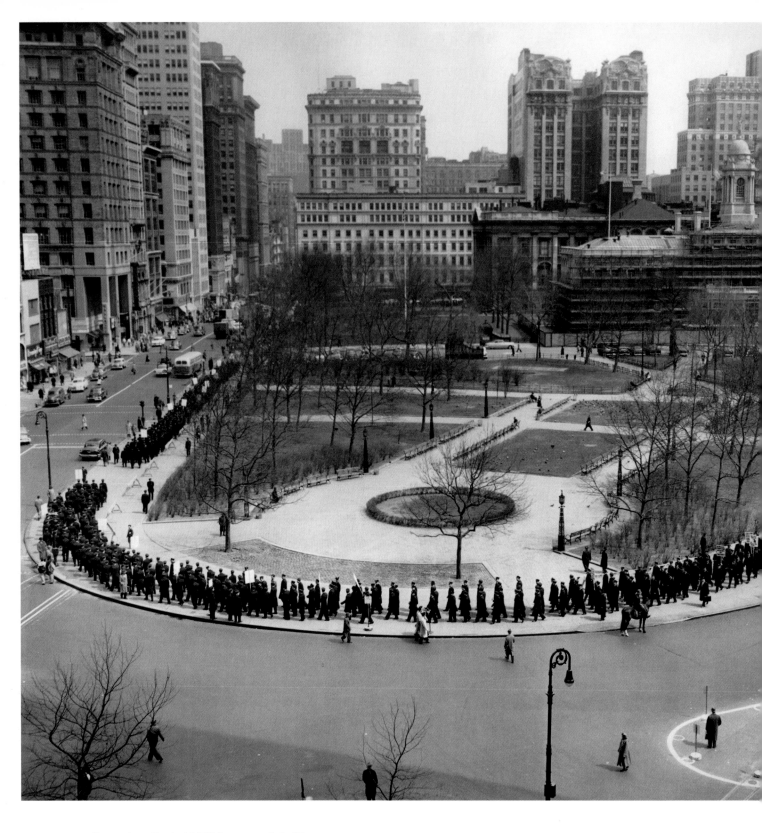

Above: An estimated 6,000 firemen encircle City
Hall and City Hall Park as they march in support
of their union's demand for a pay raise, from
$5,315 to $7,000 per year. The head of the
Uniformed Firemen's Association cited the deaths
of six firemen a week earlier in his statement to
the city's Board of Estimate about the need to
better reward the courage and sacrifice of fire-
fighters. That night, incensed by signs criticizing
Mayor Wagner, Fire Commissioner Edward
Cavanagh Jr. issued a departmental order against
picketing by firemen in uniform. May 11, 1956
George Mattson

Opposite page: Some 500 firemen march
in freezing temperatures to demand a
$1,000-per-year pay raise by July. They
were picketing outside the Municipal
Building, site of the Manhattan borough
president's office. Jan. 29, 1952,
Ed Clarity

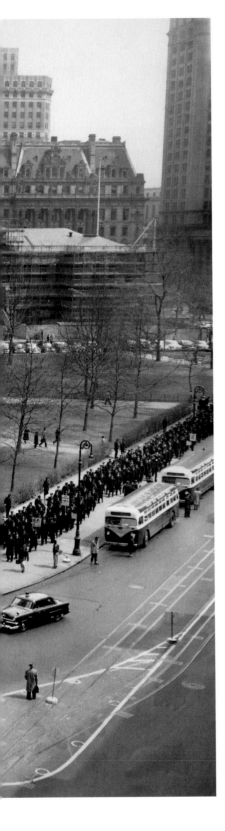
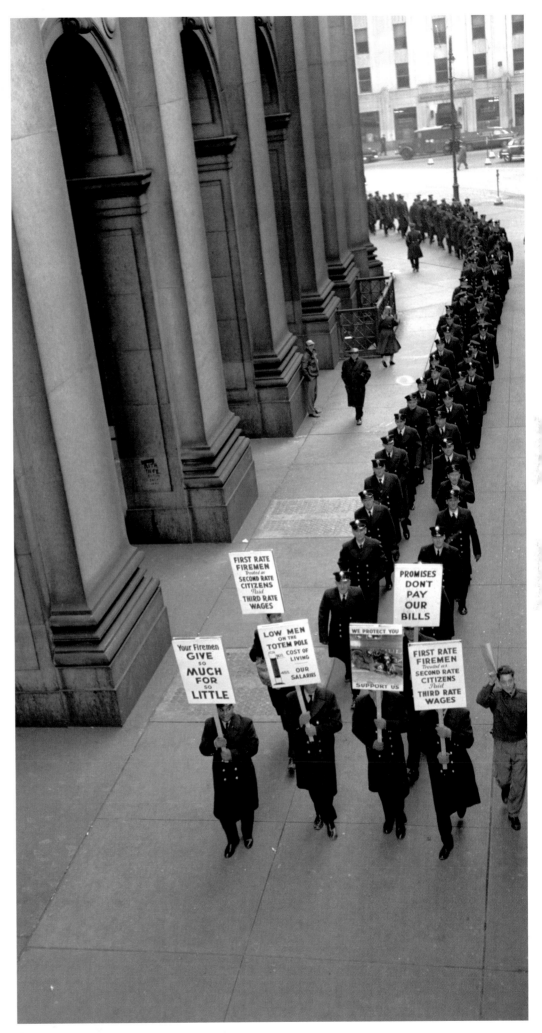

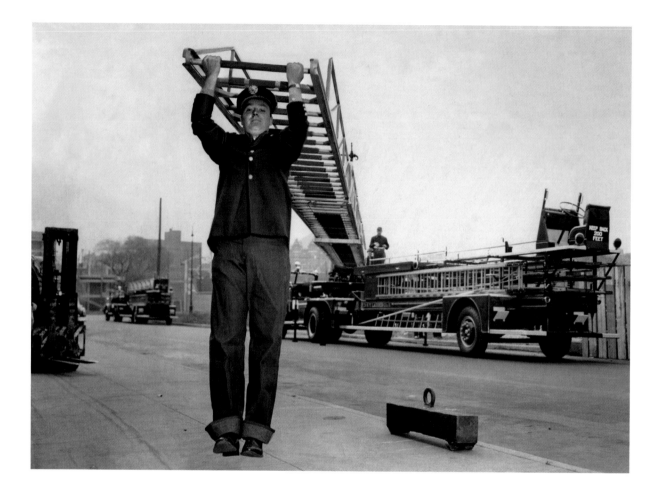

Above: Fireman Dan J. Sullivan
of Hook and Ladder Co. 109 in
Bay Ridge, Brooklyn hangs
from the end of an extension
ladder during departmental
equipment testing. Trucks and
ladders are tested under vari-
ous conditions to see if they
meet FDNY standards. Here
the ladder is retracted in a lev-
el position, possibly for use to
rescue people who have fallen
through ice. Oct. 21, 1953

Charles Payne

Opposite page: During City
Hall ceremonies to mark
Firemen's Day, Fireman
Lawrence Monichelli leaps fifty
feet onto a canvas net—and
has the wind knocked out of
him. Various demonstrations
of firefighting followed a
parade up Broadway by 4,000
firemen and 70 pieces of
apparatus. Mar. 31, 1954

Frank Hurley

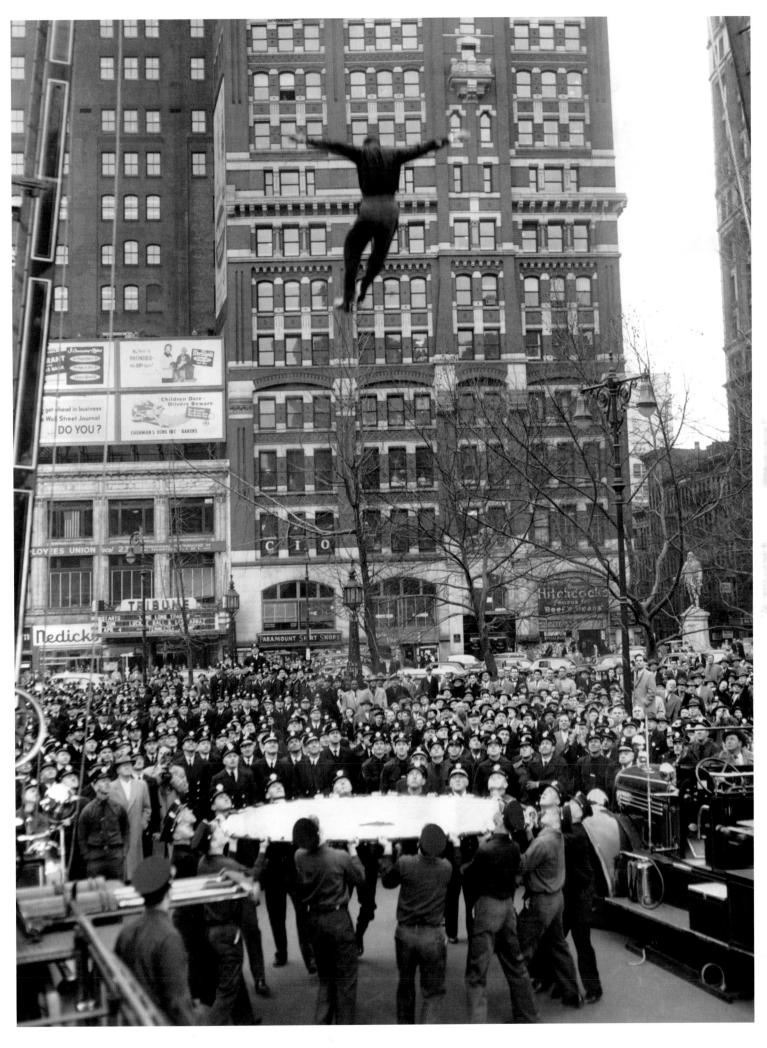

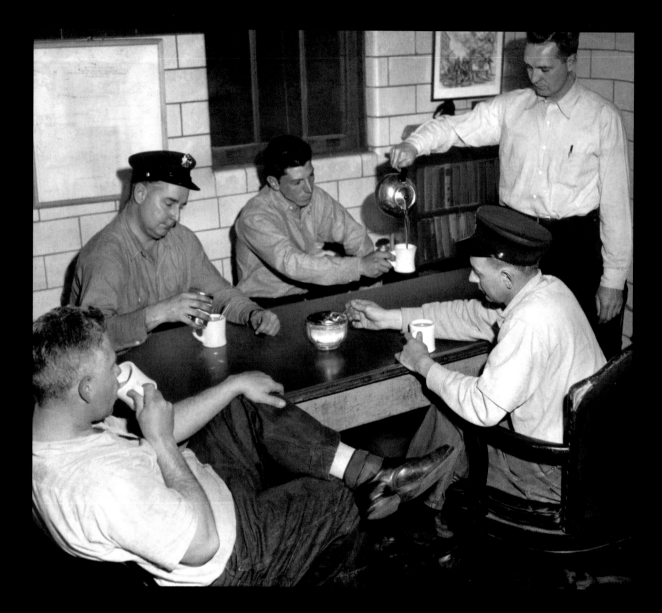

After a run, firefighters of Engine Co. 21 on East 40th St. return to the always-brewing pot of coffee. Shown seated are Edwin Tordik, Harold Fagan, Thomas DeMarchi, and Edward Lukasiewicz, as Edwin Stevens pours. Apr. 16, 1954

Gordon Rynders

Fire Capt. Stephen A. Downs
stands behind Firefighters
Dudley Maurice and Edward
M. McQuillan, who have just
been awarded scholarships to
New York University's
Washington Square College of
Arts and Science. Oct. 2, 1955

65

Below: Widows and children of firemen who died in the service of duty receive posthumous awards from Mayor O'Dwyer at City Hall. Shown (left to right) are Mrs. James Gillis and her children James and Mary; Mrs. Daniel Krauss; Mrs. Frank Moorehead with son Thomas; Mrs. Michael Berkery; Mrs. Walter Jensen with son Peter; Mayor O'Dwyer; and John C. Cran, President of the Uniformed Firemen's Association June 17, 1947
Evelyn Straus

Opposite page: Five caskets—for Lt. John Molloy and Firemen Edward Carroll, Frederick Hellauer, William Hoolan, and Charles Infosino—line the Communion rail in St. Patrick's Cathedral as Cardinal Francis Spellman celebrates the Pontifical Mass of Requiem. The five, along with Fireman Arthur Hanson, were killed five days earlier during a five-alarm fire at an artificial flower factory on 3rd Ave. near 175th St, in the Bronx, when a heavy iron canopy, an old movie marquee, collapsed on the firefighters and brought down the wall behind it. Mayor Robert Wagner, Fire Commissioner Edward Cavanagh, Jr., and 6,000 firemen, nearly half of the Fire Department, and 1,000 others from as far away as Detroit and Washington, D.C., paid tribute with a slow march down 5th Ave. to the cathedral behind five caissons, while over 100,000 people looked on. The tragedy left nineteen children fatherless. May 5, 1956
John Duprey

Next page: The worst riverfront fire in New York City's history to that time engulfs the Grace Line's Pier 57, between West 15th and 16th St.s. Firemen on land and in fireboats worked ceaselessly for 20 hours, and then remained for days afterward to control the eight-alarm fire, which destroyed the 1,000-foot pier and 400 tons of cargo. A new, $12 million pier opened there in 1955. Sept. 30, 1947
Gordon Rynders

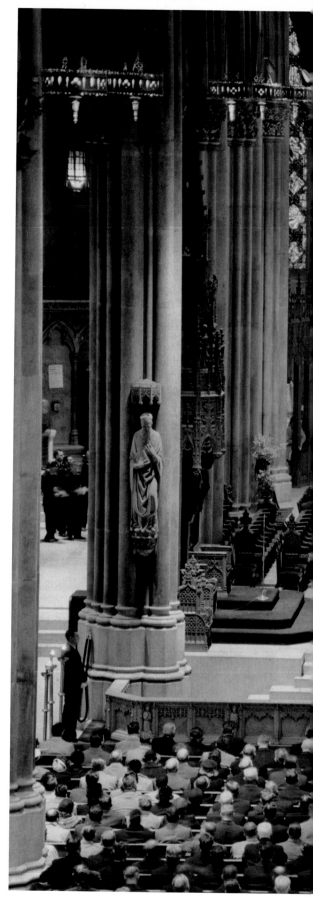

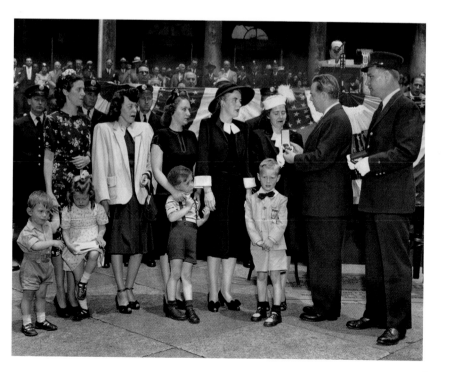

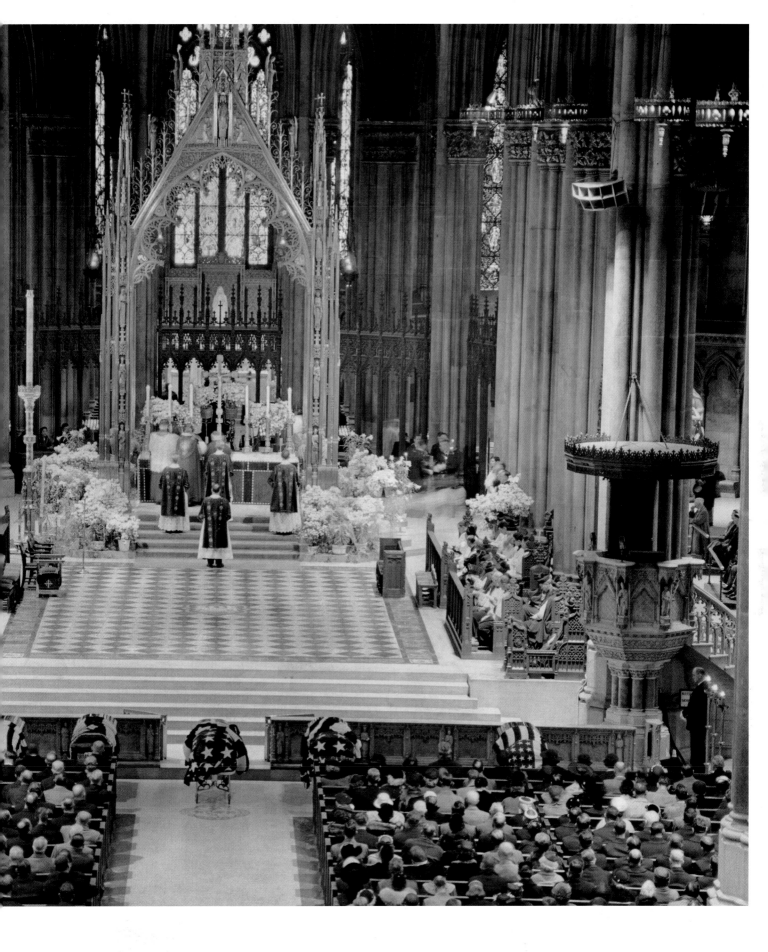

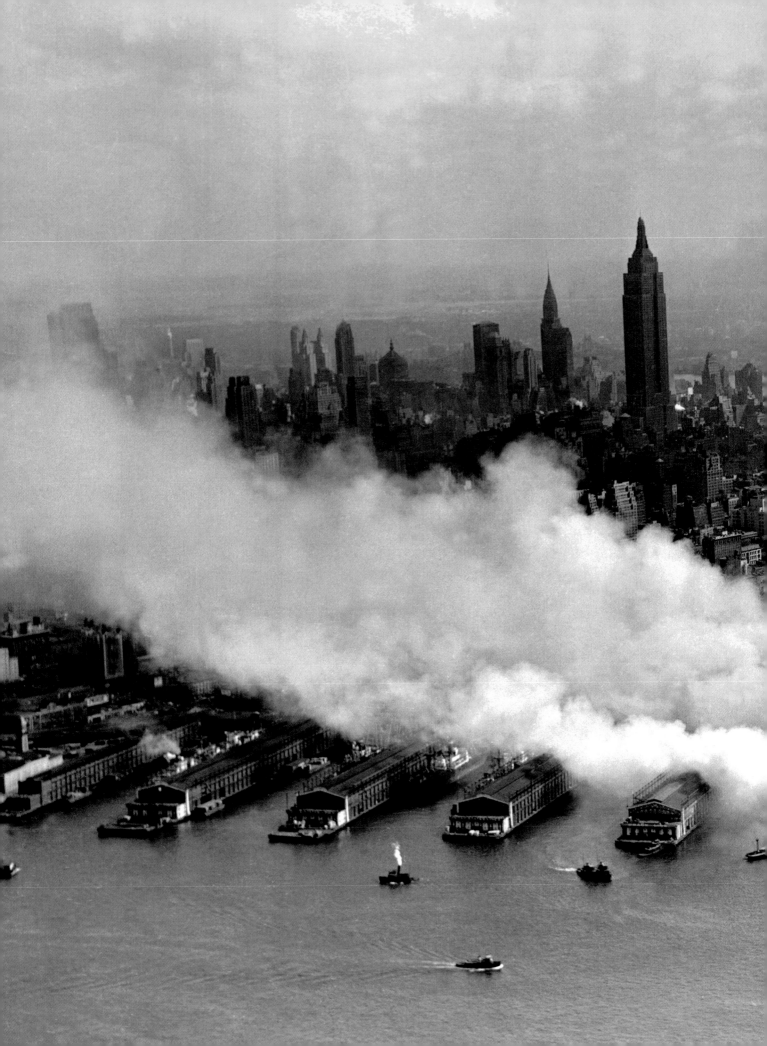

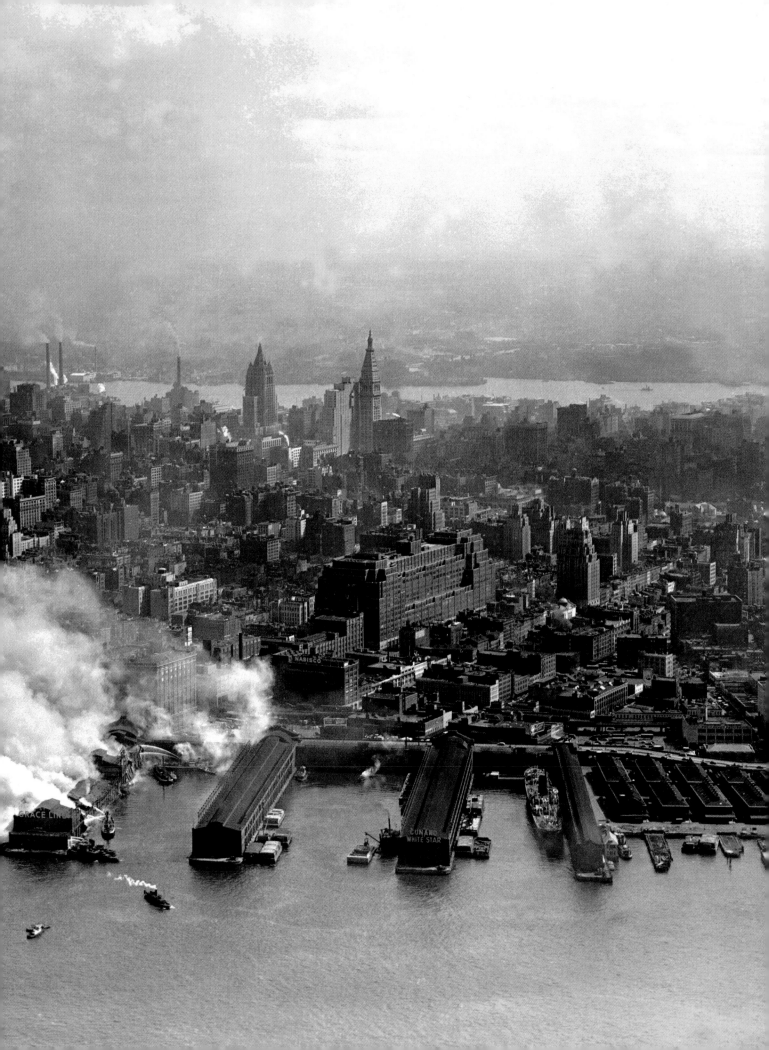

UNCOMMON VALO

In a city of eight million people—with every backdrop from skyscrapers to squatters' hovels, bridges to beachfront shacks, subways to highways—the potential is high for all types of fires, accidents, and disasters, mayhem, and chaos.

New York firefighters have handled them all, with daring exploits and nonchalant heroics They've kept loss of life at a minimum, often at the price of their own. After a rescue, most of them will say they really didn't think about the danger. Not until much later, when their families hear what happened—and their kids call them heroes—does it sink in.

Daily News' photographs have chronicled the triumph and heartache of one of the world's most dangerous jobs: the strain of fighting a fire on a steaming summer day; the pain of a soaking wet firefighter in sub-zero darkness; the stoic grimace of a firefighter with a shattered leg; the satisfied grin of a savior stepping off the ladder and handing a breathing child to a paramedic.

The News recognized, in its earliest days, the everyday acts of bravery that didn't make Page One by establishing the Hero of the Month Award for firefighters and police officers who went above and beyond the call of duty. With its tradition of courage and boldness, the FDNY's mettle has been tested many times, from spectacular fires and plane crashes to building collapses and subway wrecks.

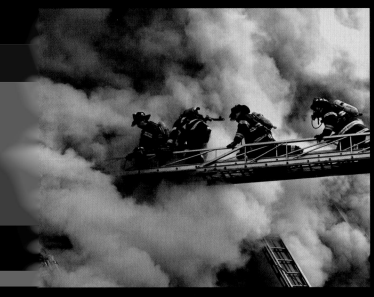

Firefighters race along ladders to rescue fellow firefighter Kevin Quinn, temporarily trapped—but soon brought to safety—at a four-alarm blaze that destroyed several stores on West 125th St. Nov. 21, 1996
David Handschuh

On December 16, 1960 death came from the sky as two planes collided in the fog over New York Harbor. One plane fell to the ground in Staten Island, killing all 44 passengers and crew, and the other plummeted into an idyllic Brooklyn neighborhood. Fire consumed ten buildings in Park Slope, and five on the ground were killed. It was a seven-alarm fire fought in the frigid air of snow-piled streets(page 74).

One February 26, 1993, eight years before the World Trade Center was destroyed terrorists detonated a powerful explosives packed truck in the basement garage of the twin towers, knocking out electrical systems and crippling ventilation ducts, turning elevator shafts into chimneys. It was the biggest fire alarm in the city's history. Six people were killed, and more than 1,000 injured.

Firefighters climbed up the towers, reaching all floors to evacuate workers. Firefighter Kevin Shea fell into the gaping crater blown open by the bomb as he groped in the smoke in search of victims. His legs were shattered in the fall, and he was lifted out in a basket by other firefighters. Two years earlier, Shea had rescued a man from the 12th floor of a burning building by rap

Risk-taking is the routine on the job; the public has come to accept that its brave firefighters can perform extraordinary tasks, so it is always a shock when a firefighter loses to the "red devil."

On August 1, 1932, a fire erupted at the Ritz Hotel on Park Avenue. Starting in the cellar, fumes from paints and other chemicals soon caused an explosion that tore through the 40-story building. Eight firefighters died. A News photo of a funeral for them showed a procession of hearses passing thousands of firefighters paying their respects (page 18).

Before the collapse of the twin towers, the darkest day for the FDNY was October 18, 1966, when 12 firefighters were killed in a fire at the Wonder Drug Store on East 23rd St. in Manhattan. Two chiefs, two lieutenants, and six firefighters plunged into the flaming cellar when the floor collapsed under them. Two other firefighters were killed by falling debris (page 96).

On Aug. 2, 1978 a roof collapsed during an arson fire at a Walbaum's in Brooklyn, sending six firefighters tumbling into a pyre.

Death is always there.

Waiting.

A few months before September 11, the FDNY suffered one of its most heartrending days. On June 17, 2001, three firefighters were killed when an explosion in a Queens hardware store buried them under an avalanche of rubble. It started as a routine fire in the basement of the Long Island General Supply Co., Astoria Blvd. But solvents, paints, and chemicals heated up and caused a huge blast in the block-long store. It went to five alarms. The three men killed—

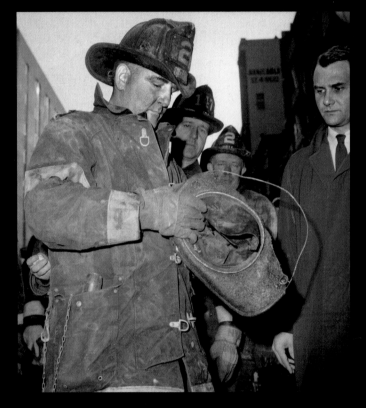

Fireman Ronald Foote looks at what remains of a helmet belonging to one of the 12 firefighters killed when the ground floor of a burning building at 6 East 23rd St. collapsed and they plunged into the basement. It was the worst loss of life in the history of the FDNY at that time. Oct. 18, 1966
Jim Hughes

Brian Fahey, Harry Ford and John Downing—left behind eight children among them. The fire occurred on Father's Day.

On November 12, 2001—still reeling from the loss of its 343 members just 60 days earlier—the FDNY responded to the crash of Dominican Republic-bound Flight 587 in Belle Harbor on the Rockaways Peninsula. The neighborhood had lost so many with the collapse of the twin towers—those who worked in them, and those who lost their lives trying to rescue them—and now the wreckage containing 260 souls from the jet lay on the streets; five people were killed in their homes. Flames raged as the fire quickly engulfed houses. Off-duty firefighters who lived in the area rushed to join the responding companies. They quickly doused the blazes, preventing a greater loss of life on the ground. "It's like the World Trade Center all over again," said a firefighter who lives in the Rockaways. "I've seen no survivors, just bodies."

They sifted through this new scene of death and smoking rubble, and then many of them headed back to Ground Zero to resume the quest to recover those entombed by that disaster.

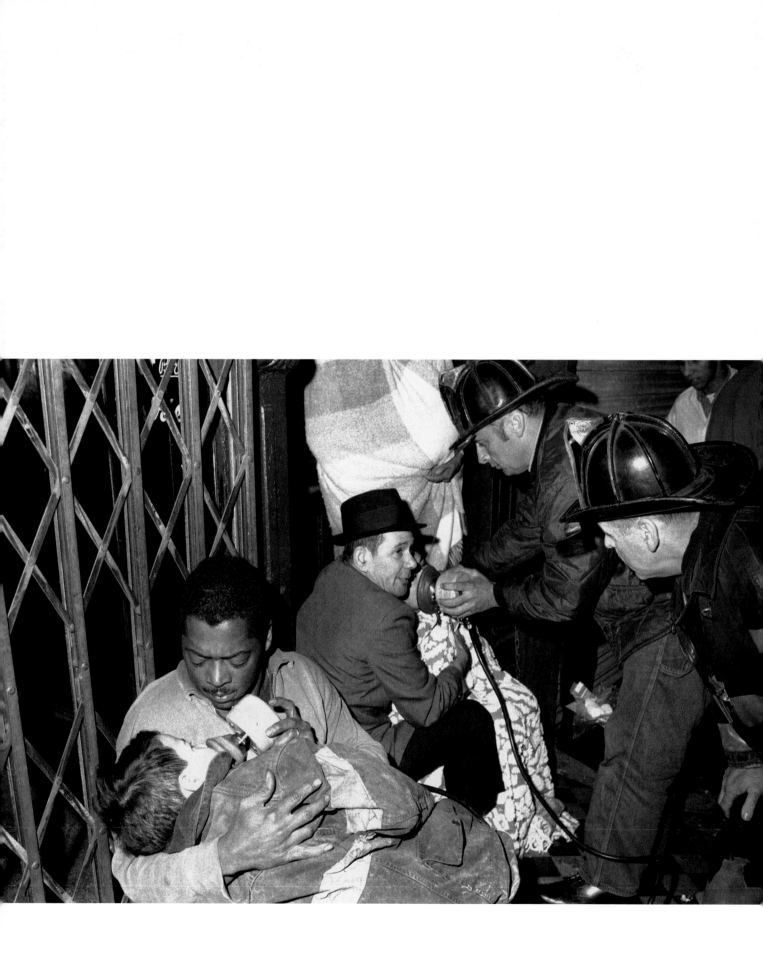

1960-1979

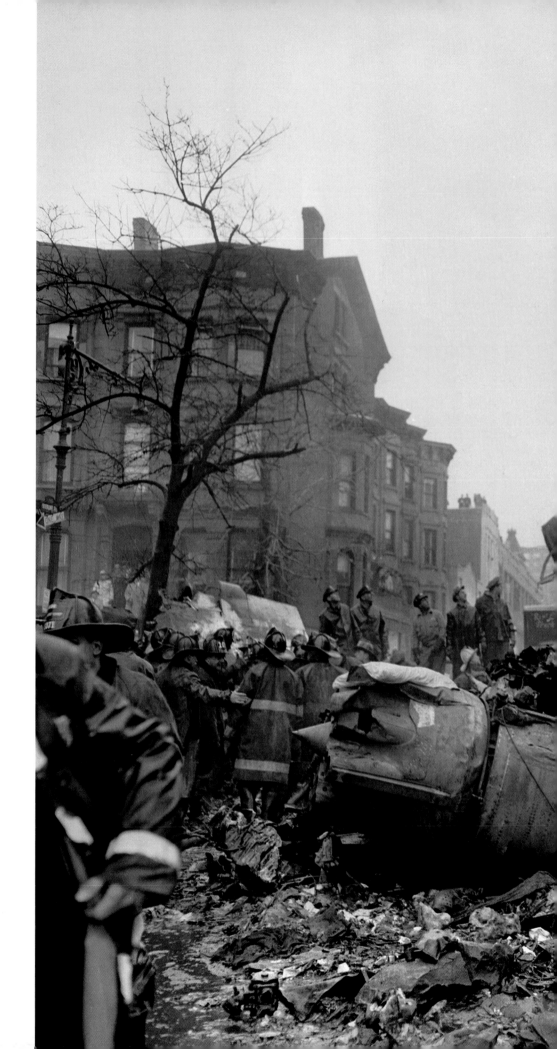

Previous page: Fireman
Waverly Howard provides
oxygen to one of the young
evacuees of a fire at 43
Clinton St., which began in
an upholstery store and
spread to the apartments
over it. Seven of the rescued
tenants were treated for
smoke inhalation. At the
scene of the fire, police
arrested Robert O'Connor,
22, accused of setting the
pre-dawn fire after accosting
two young women passing
by and threatening them with
a knife. May 16, 1970
Dan Godfrey

One of the jet engines from
the crashed United Airlines
DC-8 lies next to a gutted car
at 7th Ave. and Sterling
Place, Brooklyn. The plane
collided with a TWA Super
Constellation over New York
during a snowstorm. All 116
passengers and 12 crew of
both planes died, as well as
five people on the ground.
The accident, which was the
worst in aviation history at
that time, began a seven-
alarm fire, left a crater fifty
feet in diameter, wrecked
eleven buildings, and left
more than 200 homeless.
Dec. 16, 1960
Leonard Detrick

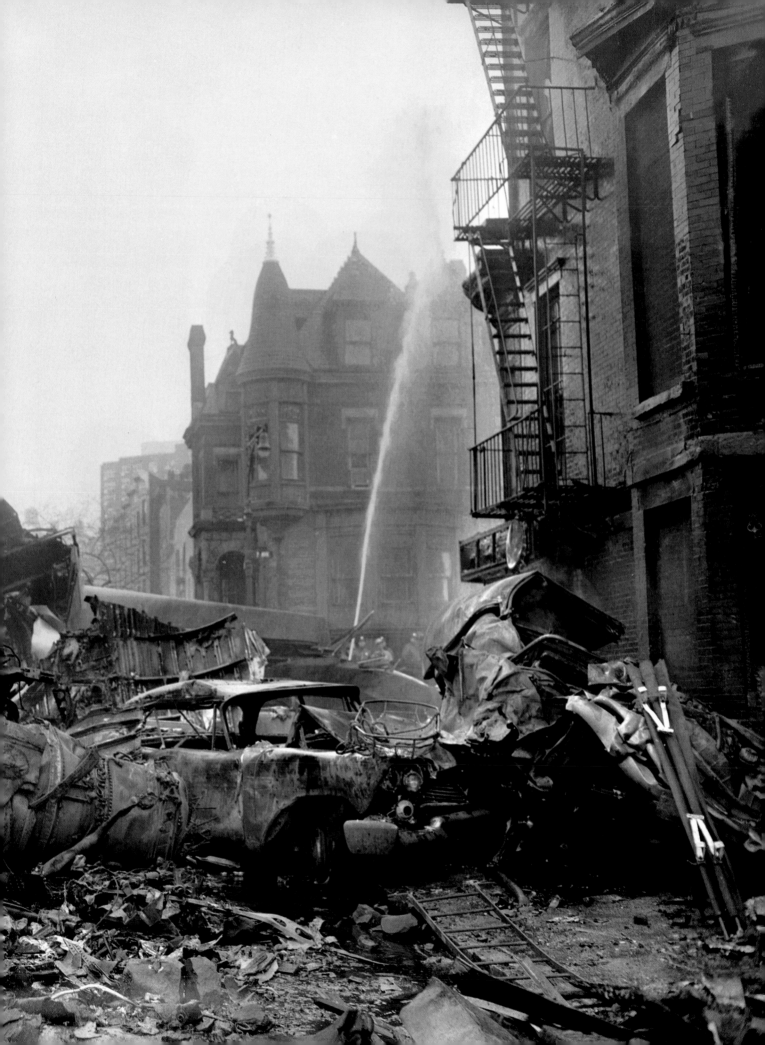

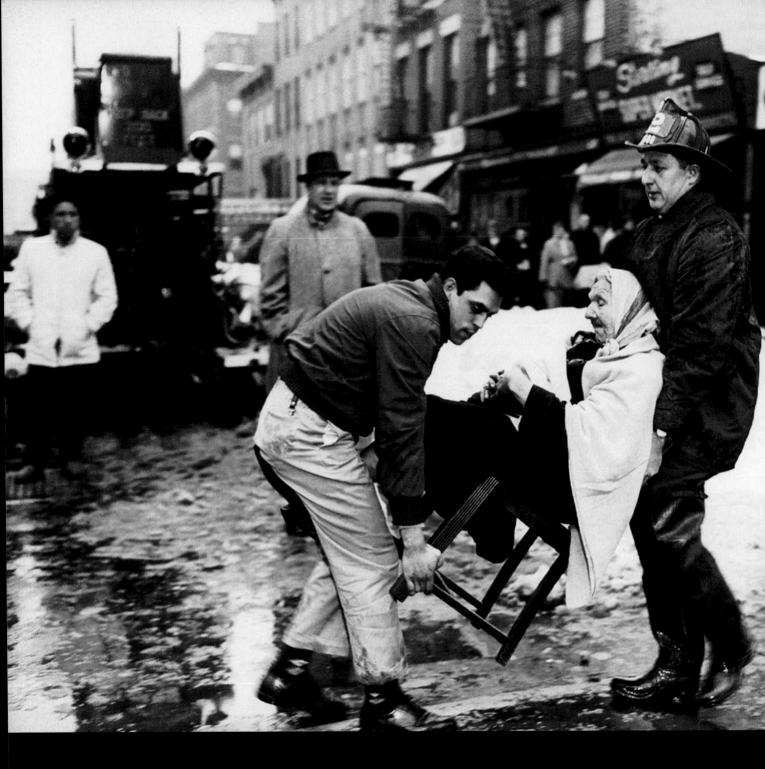

An elderly woman is carried to safety at the site of the Park Slope, Brooklyn crash of one of two planes that collided in midair. Dec. 16, 1960
Judd Mehlman

Below: Firefighter Michael Maye (former Golden Gloves champion and later president of the Uniformed Firefighters Association) tries in vain to revive two-month-old Cynthia Alvarado after an apartment fire at 940 East 165th St. Her two-year-old brother, Carlos, being carried by Firefighter Jack Mayne, also died. Nov. 29, 1964
Alan Aaronson

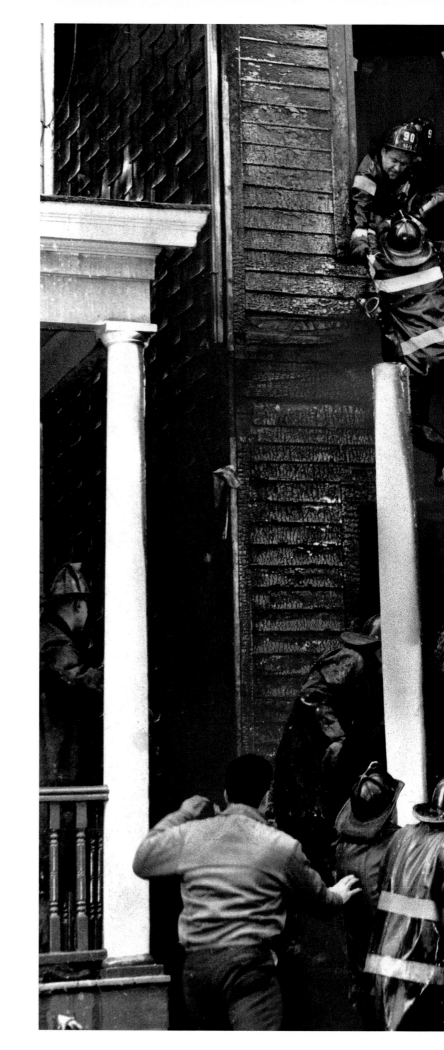

Fireman Anthony Tavolacci
grabs a window ledge at 78
East 236th St. in the Bronx
just as the porch roof buckles
under him; buddies pulled
him up through the window.
Several firemen were trapped
on the roof; and six were
injured. Sept. 22, 1962

Ossie Leviness

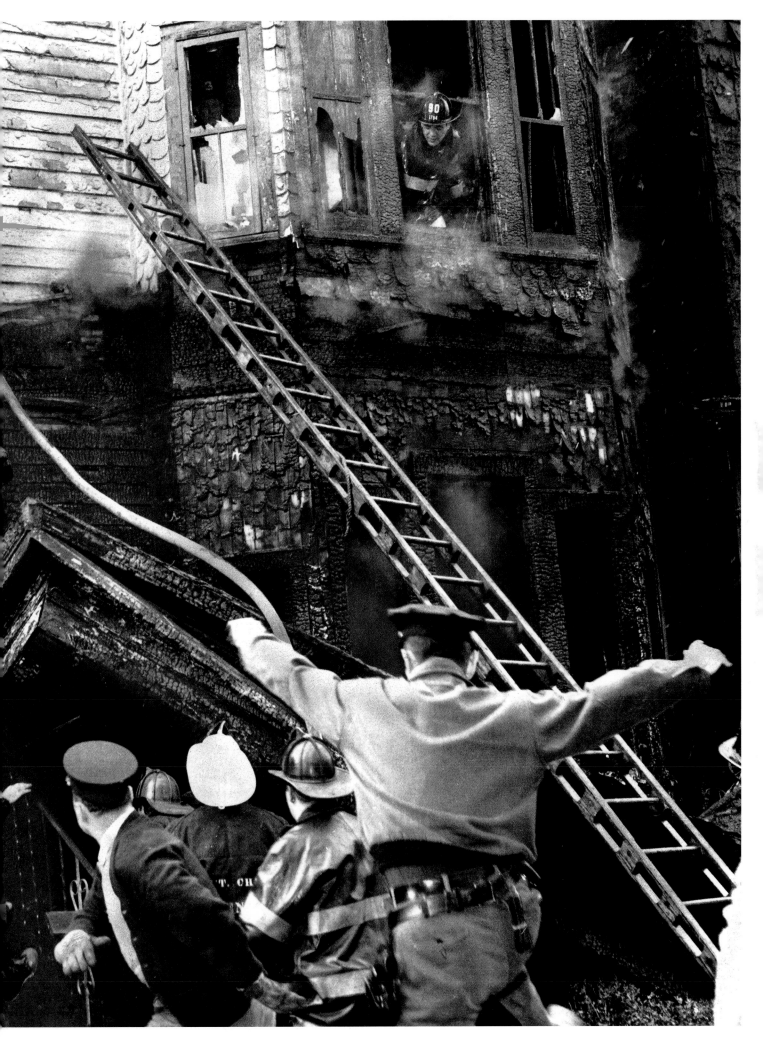

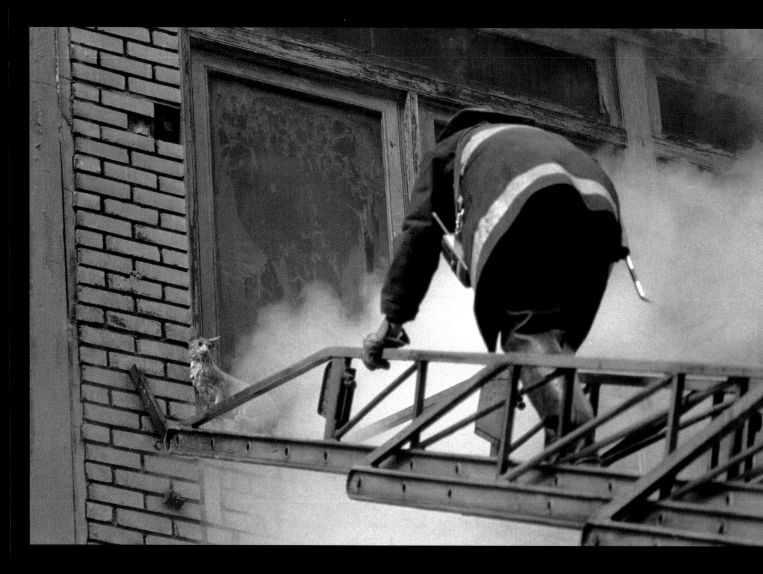

Lt. Caesar Sanservero of
Ladder Co. 4 rescues a wet
and very unhappy cat after a
noon-hour fire at 458 7th
Ave., near West 35th St. The
lunchtime crowd spotted the
cat and frantically screamed
for the firemen evacuating
residents to save it.
Sanservero climbed to the
rescue, reuniting it with its
owner to the cheers of the
crowd, after the company
made sure all the humans
were safe. Jan. 10, 1972

Keith Torrie

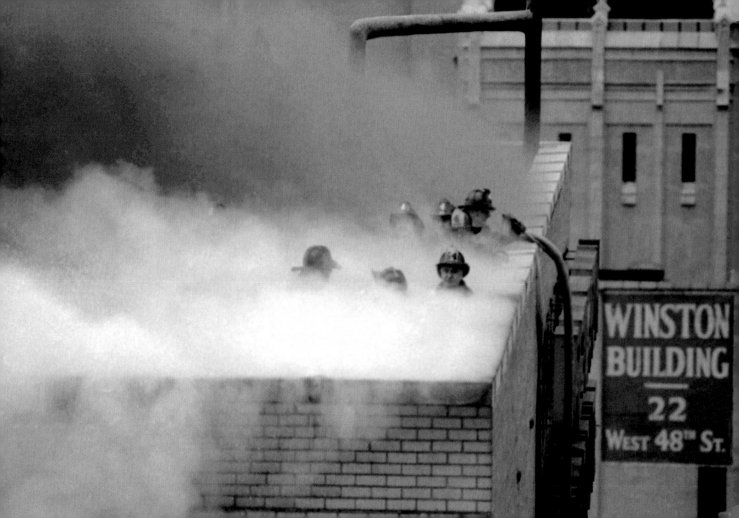

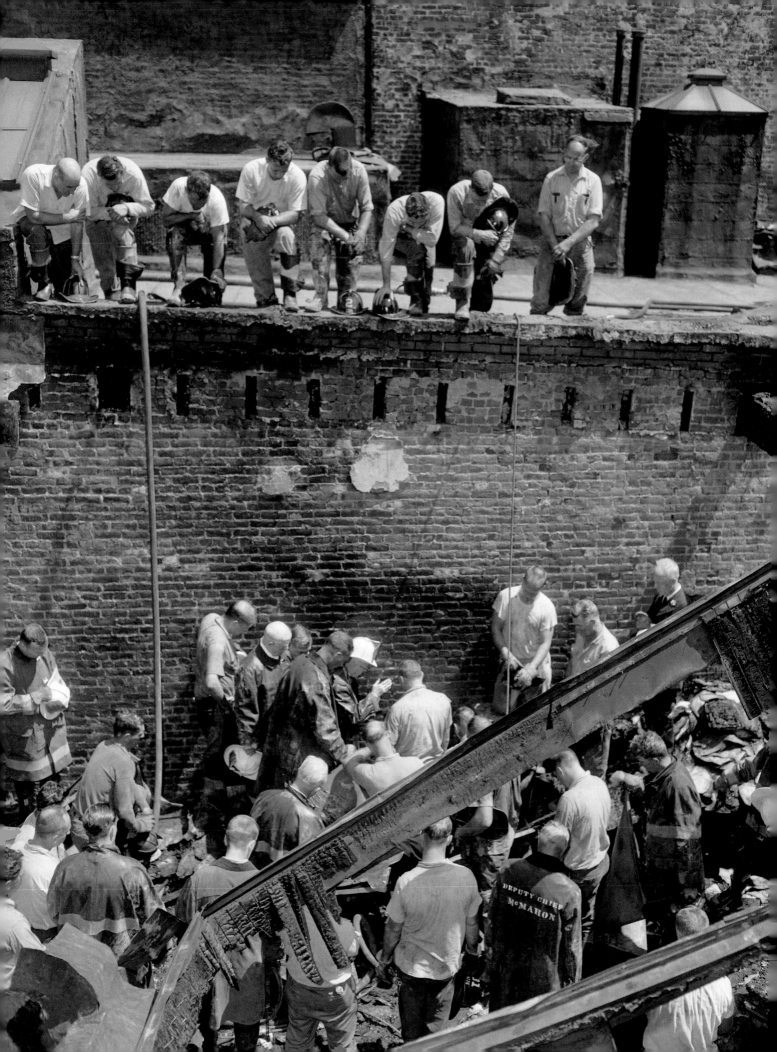

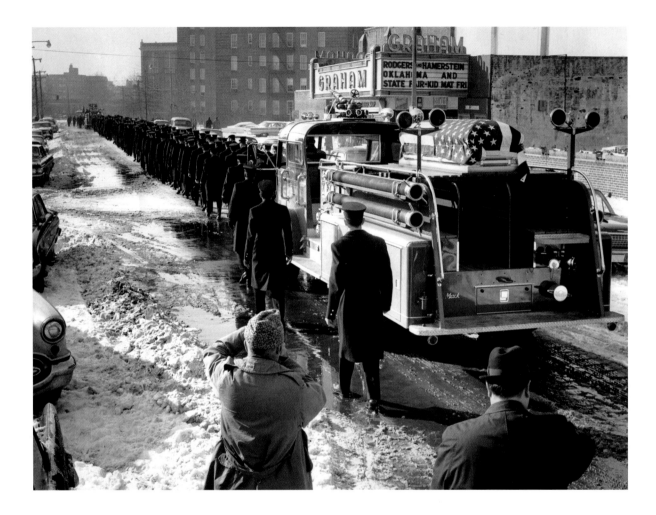

Opposite page: Father John Keegan, a Fire Department chaplain (seen wearing a white helmet), administers last rites to Fireman John C. Farragher, 38, of Rescue Squad 1 after his body was uncovered in the wreckage of a building at 390 Broadway, near White St. He was buried under debris when the rear of the roof collapsed as he battled the four-alarm fire the night before. Sixteen others were injured. Farragher, who left a wife and three young children, had been cited in 1960 for helping to rescue 22 trapped workers in a fire on the air-craft carrier Constellation at the Brooklyn Navy Yard. July 13, 1962
Bob Costello

Above: Firemen escort the engine bearing the casket of Fireman James J. Johnston. Johnston, 26, of Engine Co. 310, died of smoke inhalation while trying to rescue a family of three during a fire at 2452 Bedford Ave., Flatbush. Johnston left behind a wife and two young children. Dec. 25, 1963
Charles Payne

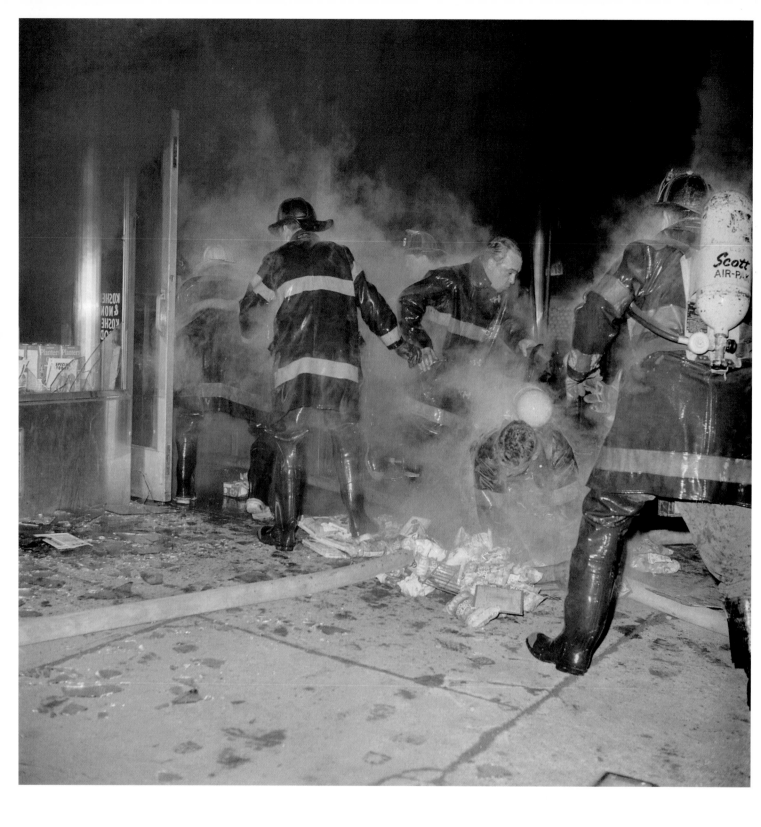

His clothes smoldering from
intense heat, Lt. John Roche
falls to the ground outside
the supermarket fire at 2034
Davidson Ave. in the Bronx
while Fireman John O'Malley
runs out into the street. Both
suffered second-degree
burns when flames flashed
back at them as they closed
in. Jan. 9, 1965

Alan Aaronson

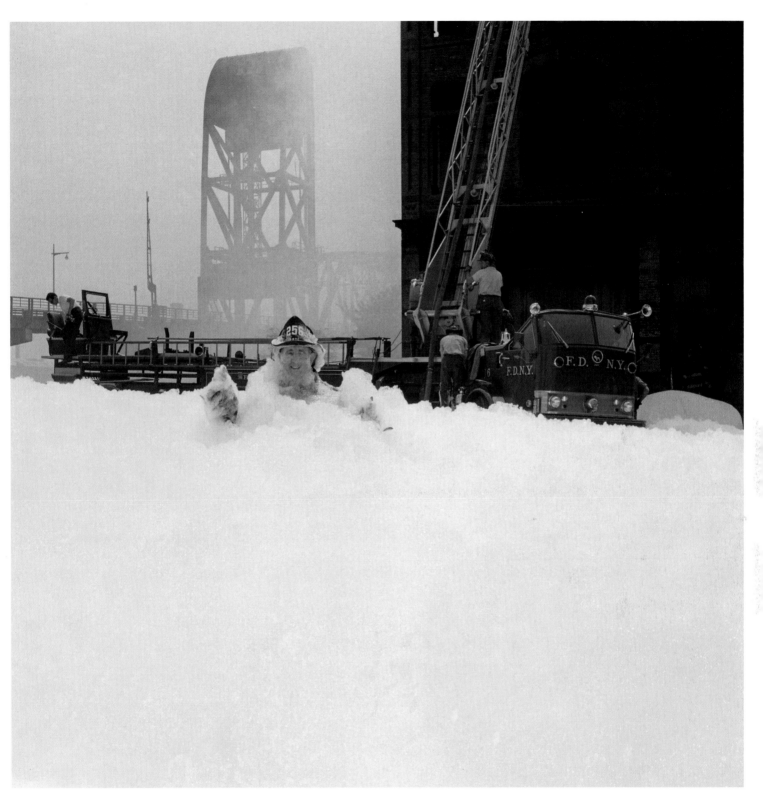

Fireman Albert Rosato wades
out of a sea of foam on
Welfare Island. The area was
flooded with the white stuff
when firefighting equipment
using the foam went awry
and frothed over while fire-
men were practicing on an
old firehouse. July 19, 1961
Jack Tresilian

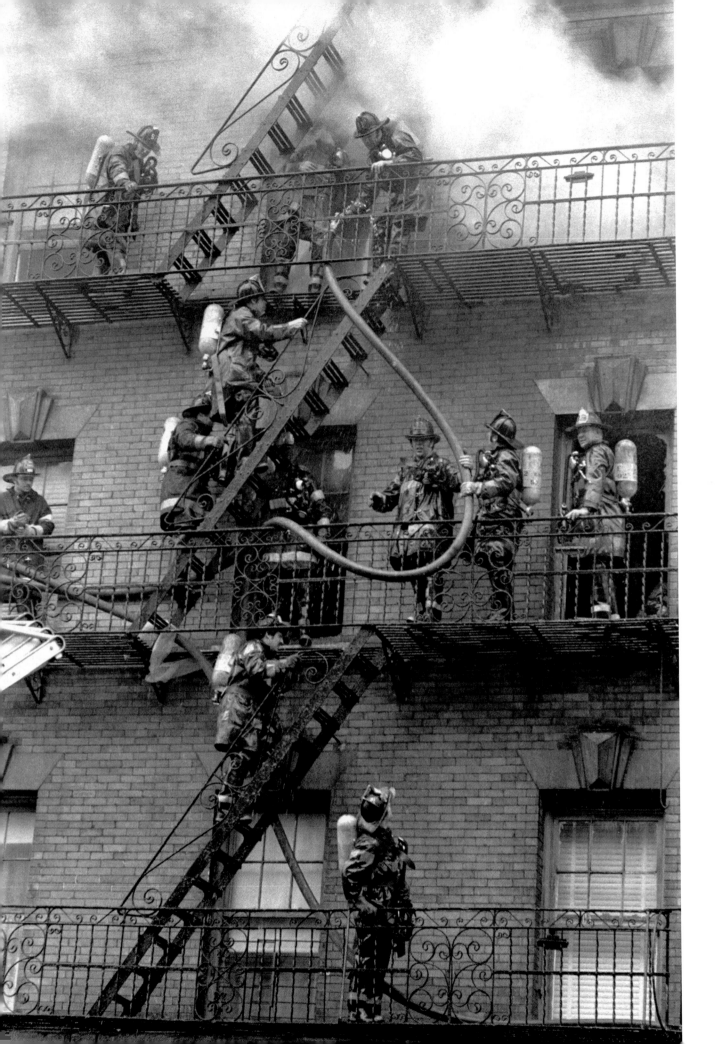

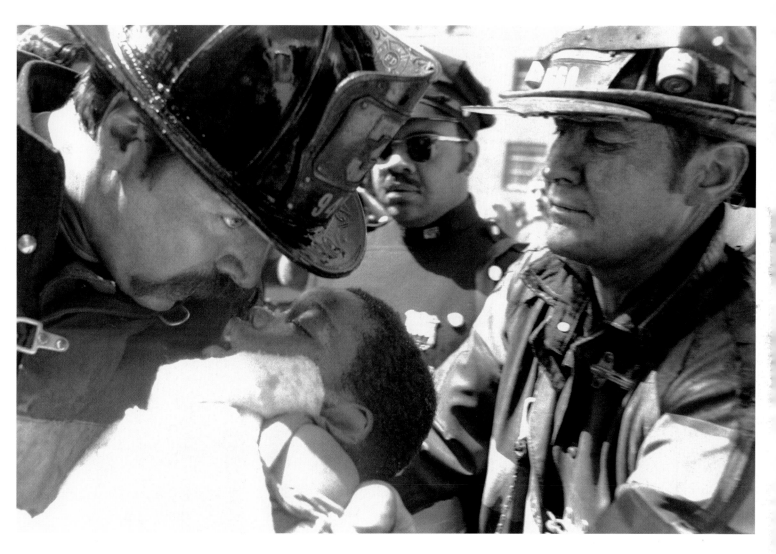

Opposite page: Firefighters manage to lug a huge hose up the fire escape at 901 Ogden Ave. in the Bronx, not long after the smokey fire broke out. Mar. 5, 1974
Tom Cunningham

Above: A firefighter gives mouth-to-mouth resuscitation in a futile effort to save one of three brothers found in a blazing tenement at 312 Willis Ave., the Bronx. The fire, spreading quickly, gutted the five story building. The boys died en route to the hospital. Apr. 3, 1970
Dennis Caruso

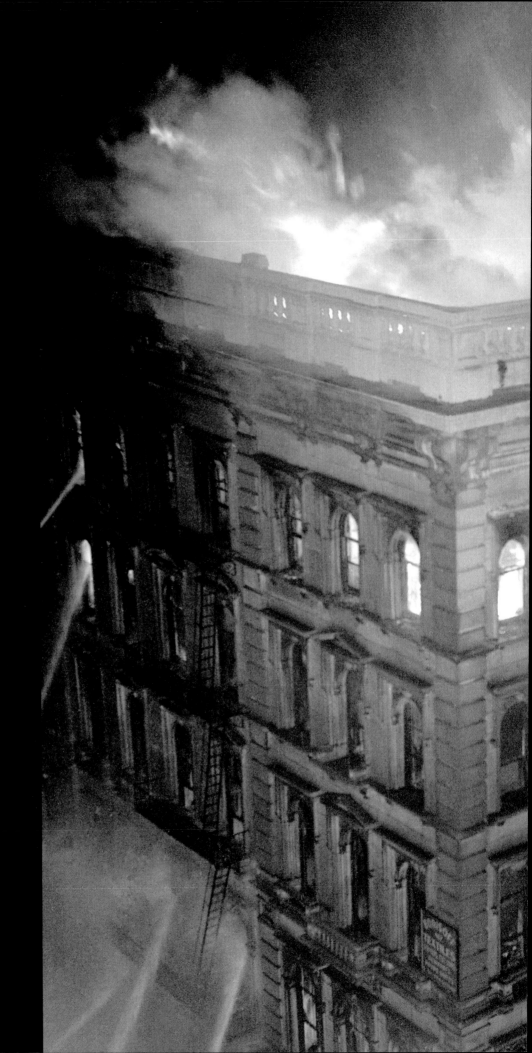

Flames erupt from a five-
story fabric warehouse at
the corner of Broadway and
Grand St. as firemen battle
the nine-alarm blaze, which
soon spread to three other
buildings. More than 500
men were thrown into battle.
Nov. 12, 1960
Frank Russo

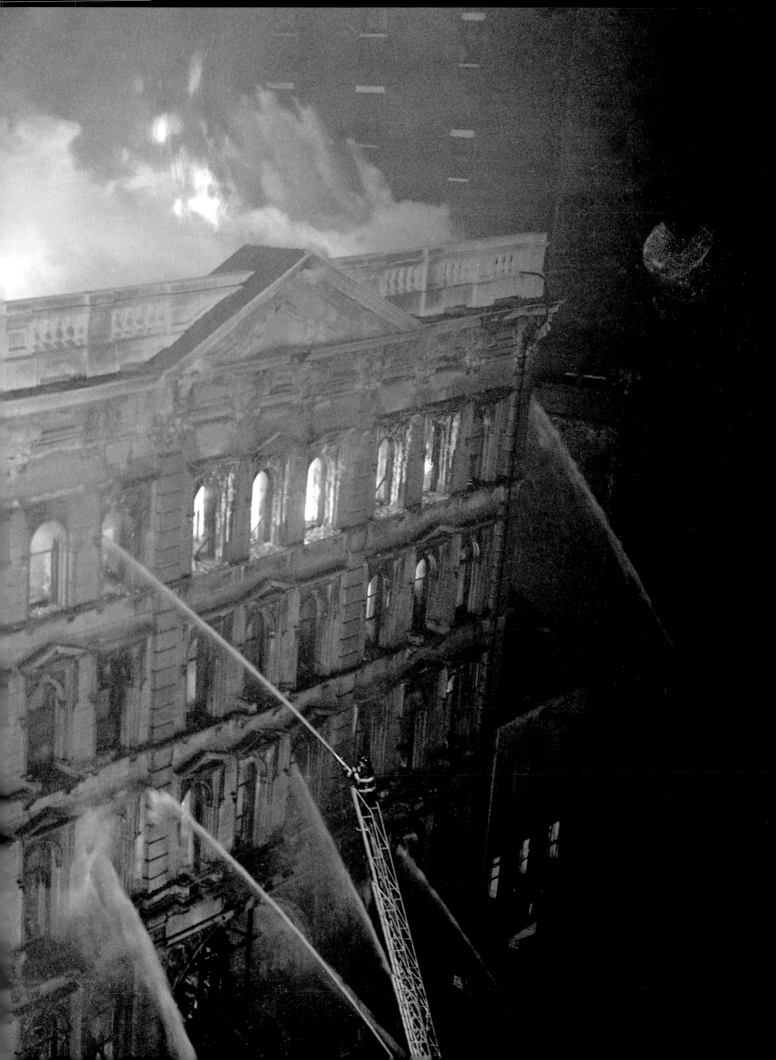

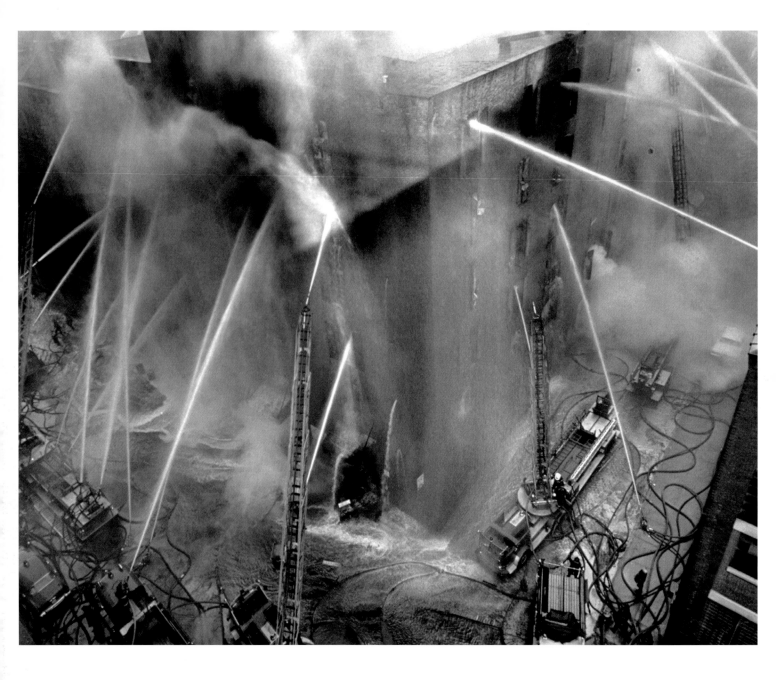

Above: Fireman fight an eight-alarm blaze at a Brooklyn warehouse near the Manhattan Bridge. More than $1 million in merchandise belonging to Manhattan-area department stores was destroyed. Mar. 7, 1964

Frank Hurley

Opposite page: Police and firemen run for cover as a section of the 119-year-old University Hotel at 673 Broadway collapses in a huge cloud of dust. Twenty of them were injured, though authorities managed to evacuate the building before the collapse at 5 p.m. A search through the rubble turned up the body of an elderly man two days later. Aug. 3, 1973

Anthony Casale

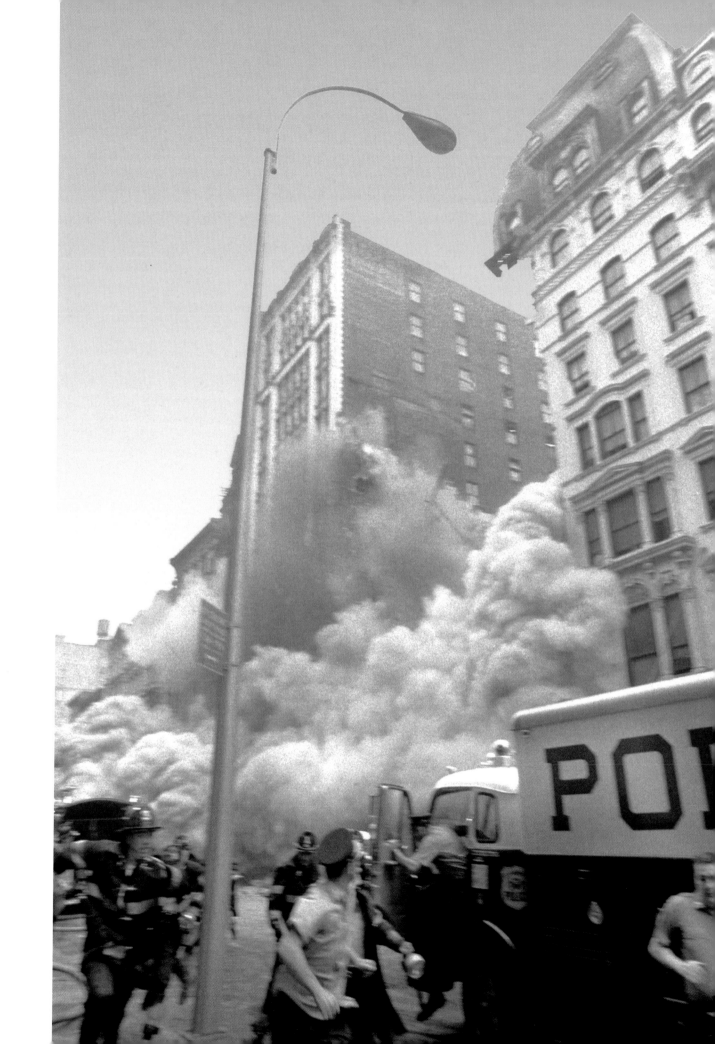

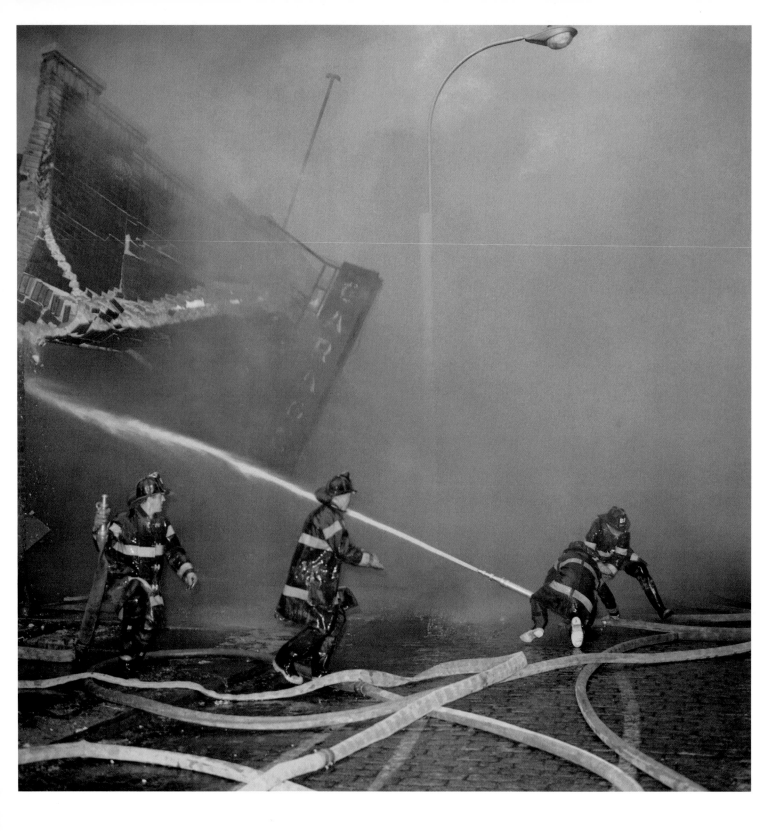

Above: Firemen abandon their
equipment and run for their
lives as the walls of a burning
garage at 2060 Bronx St., near
179th St., collapse behind
them. Firemen Walter Tully,
Carmine Croce, and Lawrence
McMahon were injured by the
flying debris. May 27, 1968

Opposite page: Firefighters
gently lower a litter bearing a
seriously injured comrade, one
of a dozen firemen hurt fighting
a three-alarm, mid-afternoon
store fire at 250 West 42nd St.
Nov. 16, 1975

Alan Aaronson

Jim Garrett

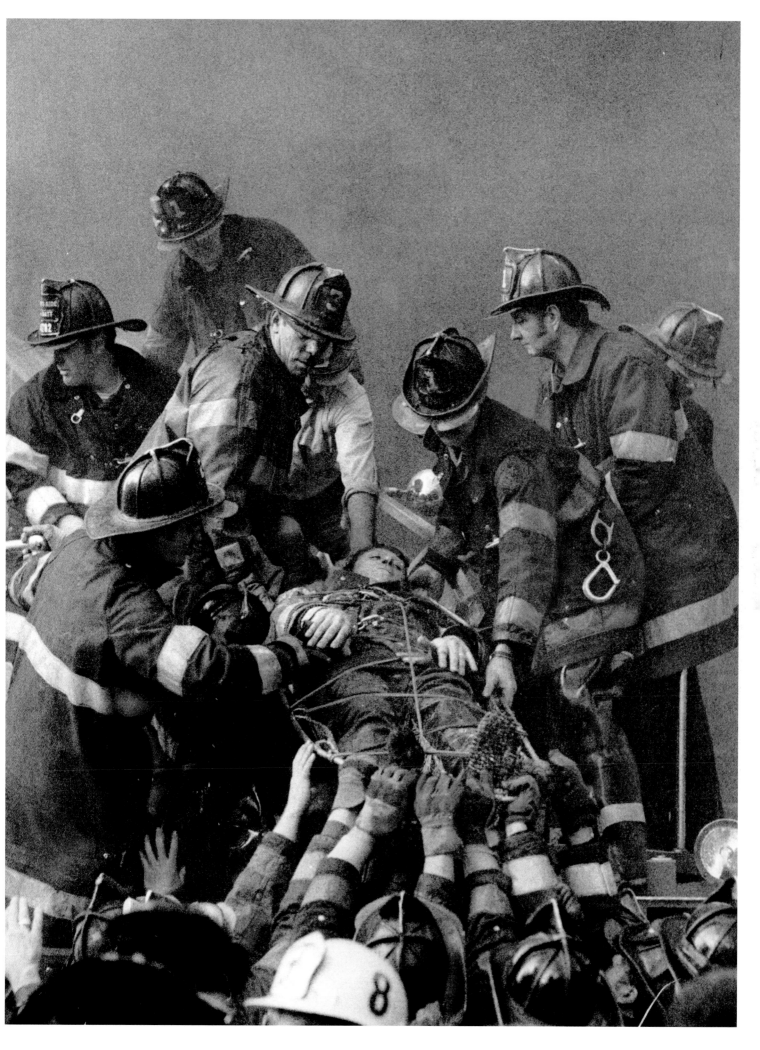

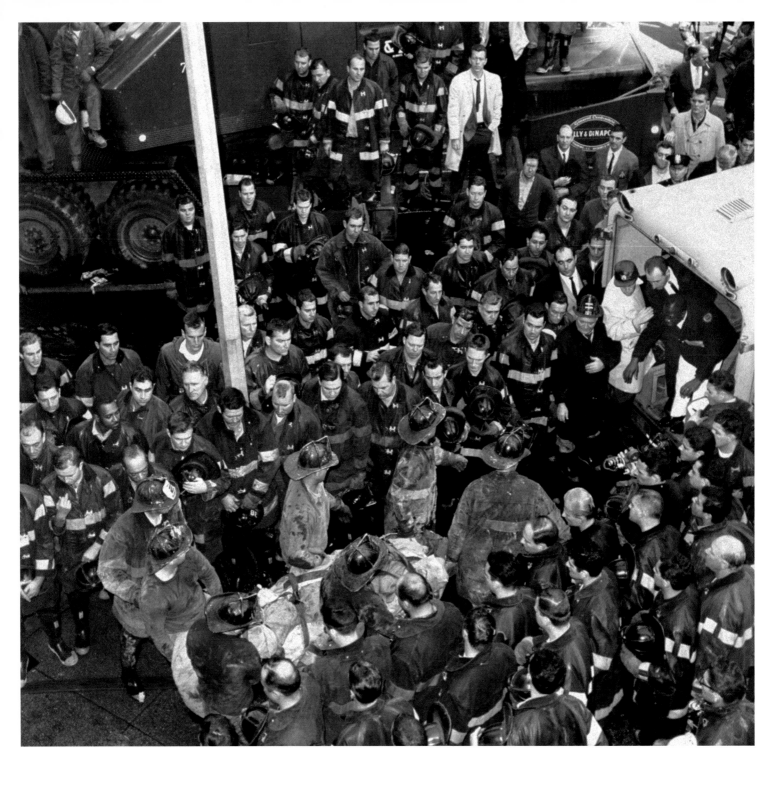

Firemen remove their helmets as one of twelve fallen comrades is carried to an ambulance from the rubble at 6 East 23rd St., after a five-alarm fire caused the ground floor to collapse. About 700 firefighters, including 300 off-duty volunteers, showed up to help find the men. After the last body was removed, Chief of Department John T. O'Hagen assembled the firefighters in nearby Madison Square Park, and said, "This was the saddest day in the 100-year history of the Fire Department. I know we all died a little in there." Oct. 18, 1966

94 **Tom Middlemiss**

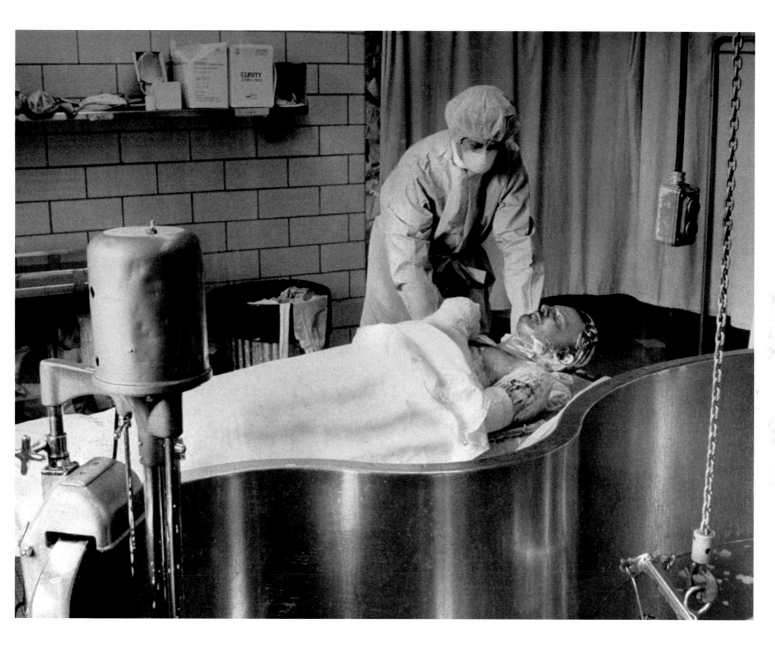

Dr. John Stein, chief of the Jacobi Hospital Burn
Unit, uses a special hydrotherapy bath to treat
Fireman Alfred J. Bold, 39, who was burned over
80% of his body ten days earlier when gasoline
fumes exploded in his Queens firehouse, 101st
St. and Jamaica Ave. Although last rites were
administered, Bold was quickly flown by heli-
copter from nearby Jamaica Hospital to Jacobi,
where the team of burn specialists started him
on the long and difficult road to recovery. Bold
spent two years in the hospital, eventually
regaining the use of his hands—which doctors
had wanted to amputate. He was confined to a
wheelchair for the rest of his life. May 24, 1974
Tom Cunningham

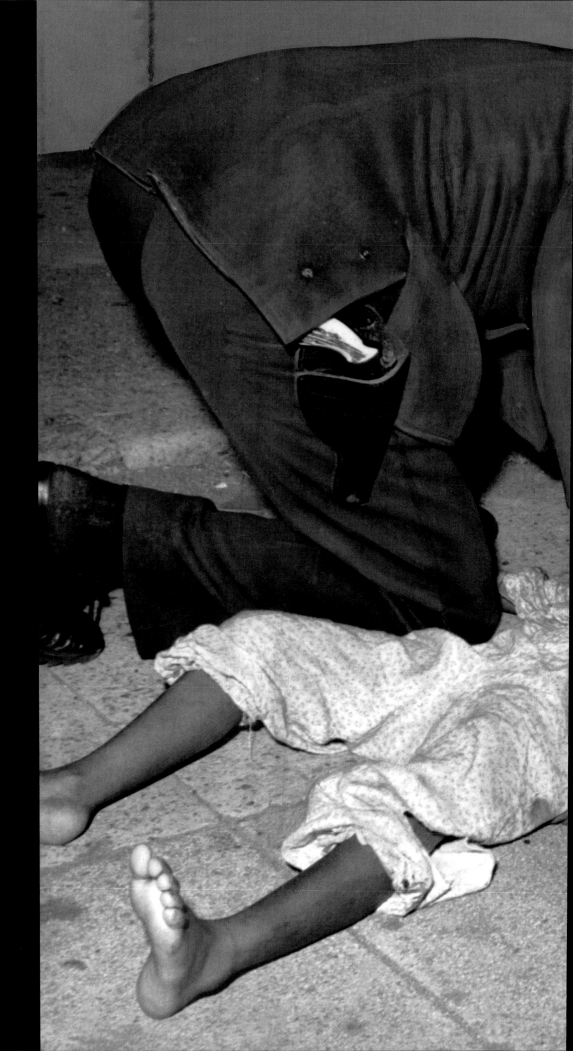

A policeman holds up a flashlight for a fireman as he performs mouth-to-mouth resuscitation on a child overcome by smoke from a fire at 508 Felix St., Brooklyn. Four adults and three children (one an infant) were felled by smoke when fire hit the four-story building. Quick work by the fireman revived all seven.
Mar. 9, 1962
James Colfield

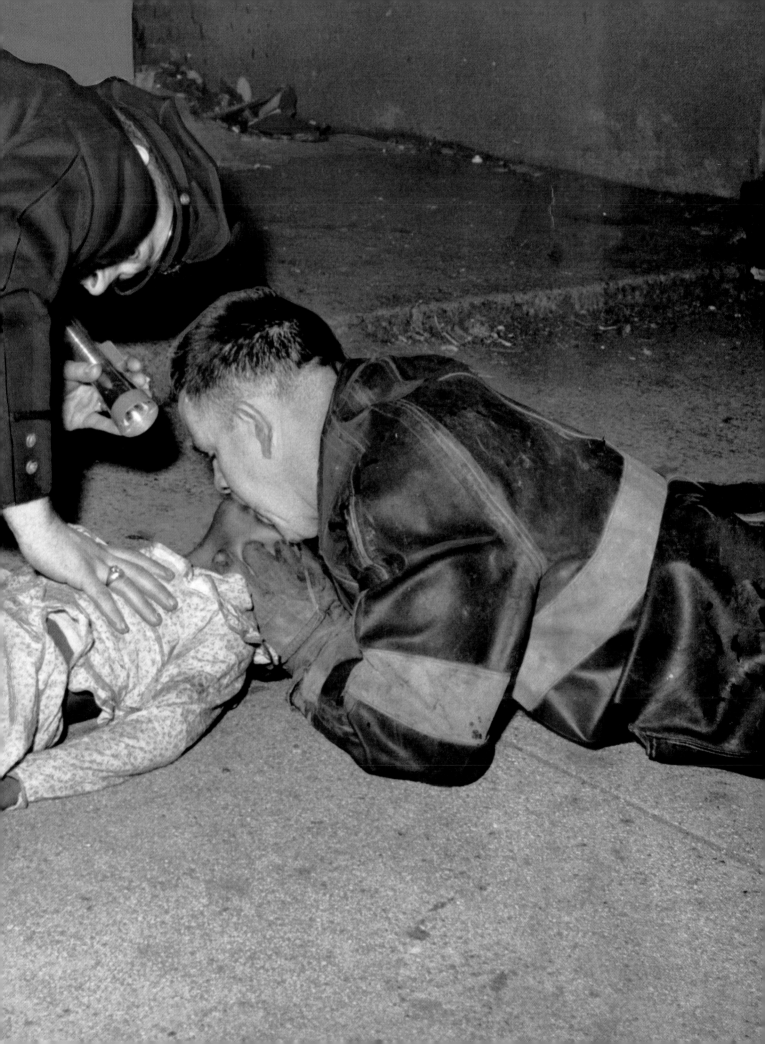

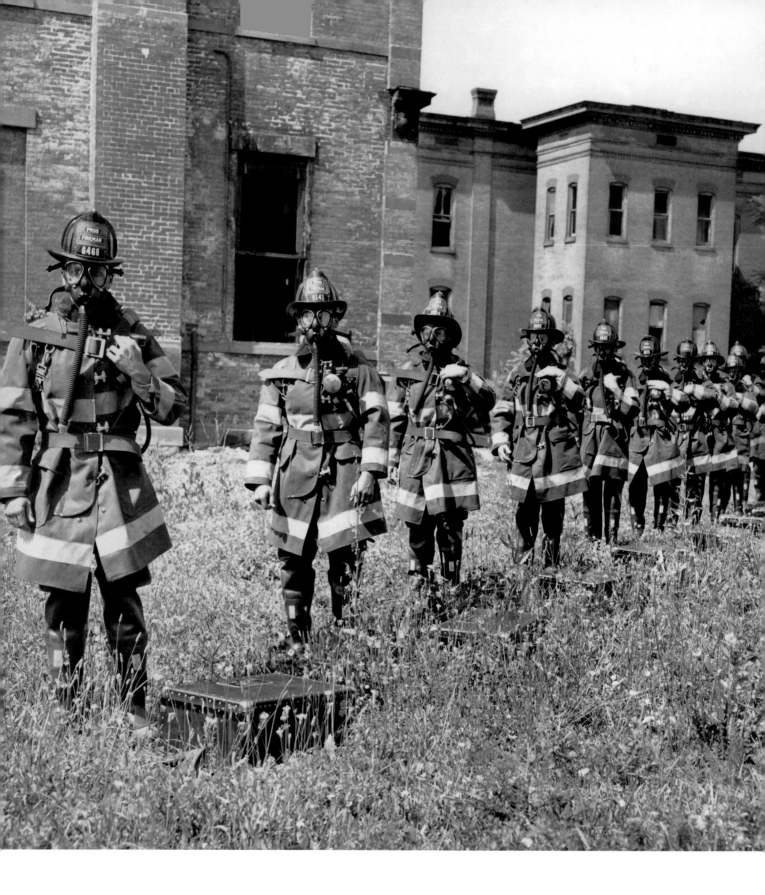

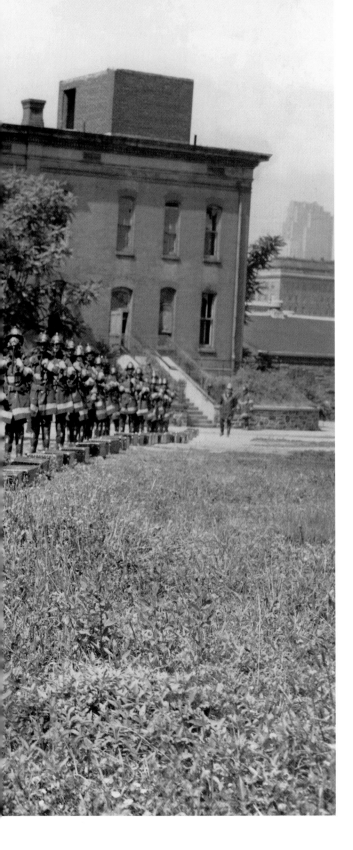

Wearing gas masks and portable carrying firefighting equipment, some of the 250 new probationary firemen line up for commencement exercises on Welfare Island after completing a training course. June 8, 1962
Bill Meurer

Below: Susan Smith, one of the two dozen trailblazing women taking the FDNY's applicant practice test on Ward's Island, hangs on to the chinning bar—but only for 50 seconds instead of the required two minutes. One of 500 candidates vying for new firefighting positions, she had better success in tests of endurance and agility than in those requiring brute strength. Women would not join the Fire Department until September 1982, when federal judge Charles P. Sifton ruled that the 1977 test was discriminatory. Four years later, Judge Sifton ordered the payment of two years of "lost" wages for the women who tried out in 1977 but were not accepted until five years later. Dec. 10, 1977
Jim Hughes

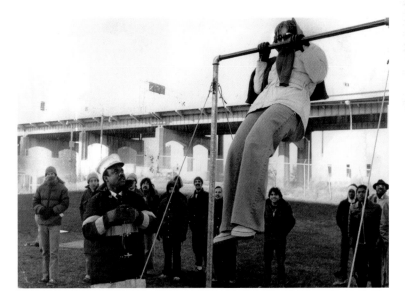

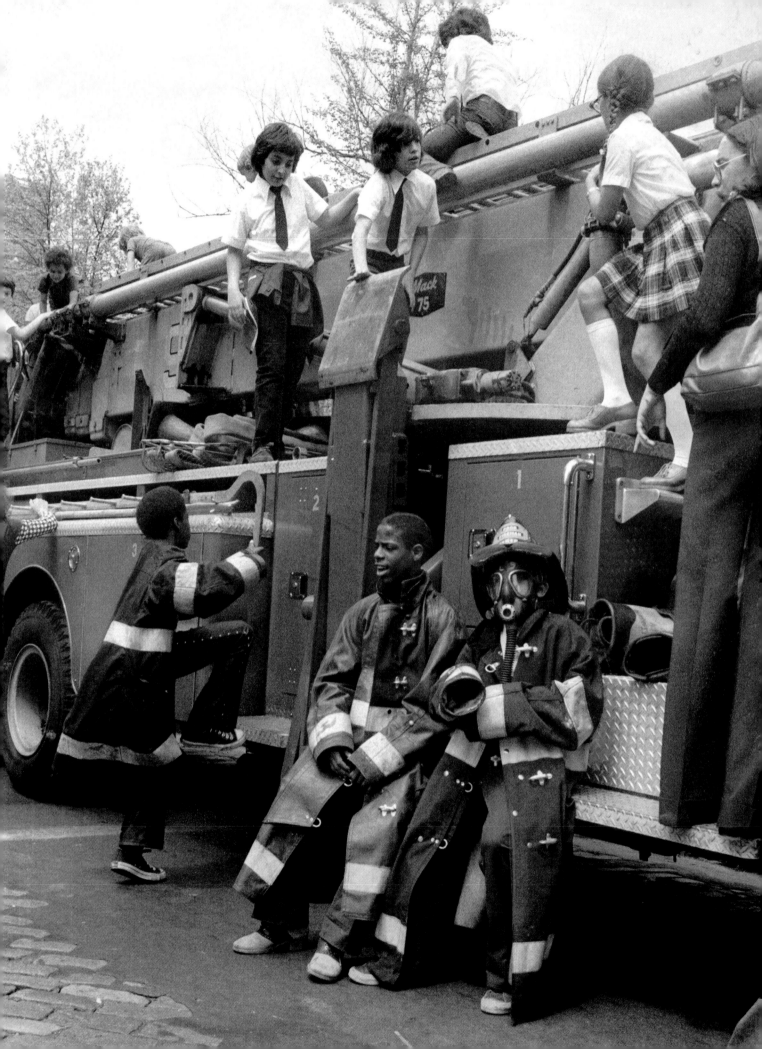

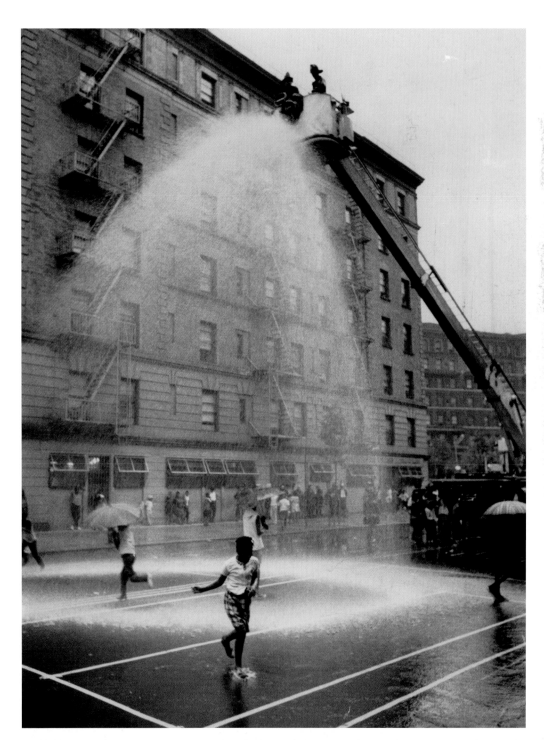

Opposite page: Kids swarm all over a ladder truck in Washington Square Park at the start of Operation LaGuardia, a program to acquaint youngsters with fire safety through fun visits to playgrounds. May 30, 1974
Anthony Casale

One of the city's two $60,000 ladder trucks showers the children of St. Nicholas Ave. between 117th and 118th St.s with kindness during the summer heat—a gift from Mayor John V. Lindsay. June 28, 1967
Hal Mathewson

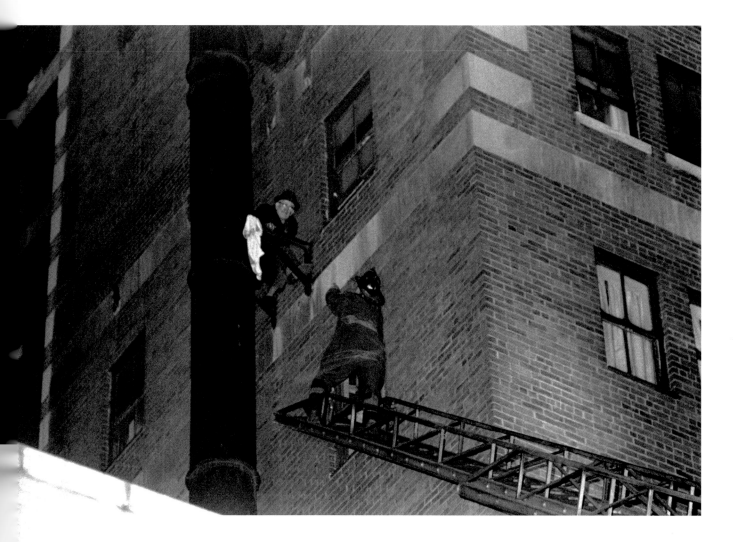

Above: Fireman John Metzger reaches out to Joseph Sands, 72, who clings for his life to a a vertical air duct support as fire destroys the sixth and seventh floors of the 1,490-room Sloane House YMCA, 356 West 34th St. In all, 40 residents were rescued from ledges and outdoor support structures. Sands later returned to the scene of his half-hour brush with death, saying, "I still don't know how I did it." Mar. 22, 1972
Alan Aaronson

Opposite page: A rope tied around his waist, Fireman John Driscoll is lowered by Fireman Ronald McGee from the roof of the posh Stanhope Hotel, 5th Ave. and 81st St., to calm panicked guests trapped temporarily on the 15th floor until other firemen arrived inside the building and rescued them. Oct. 14, 1971
Anthony Casale

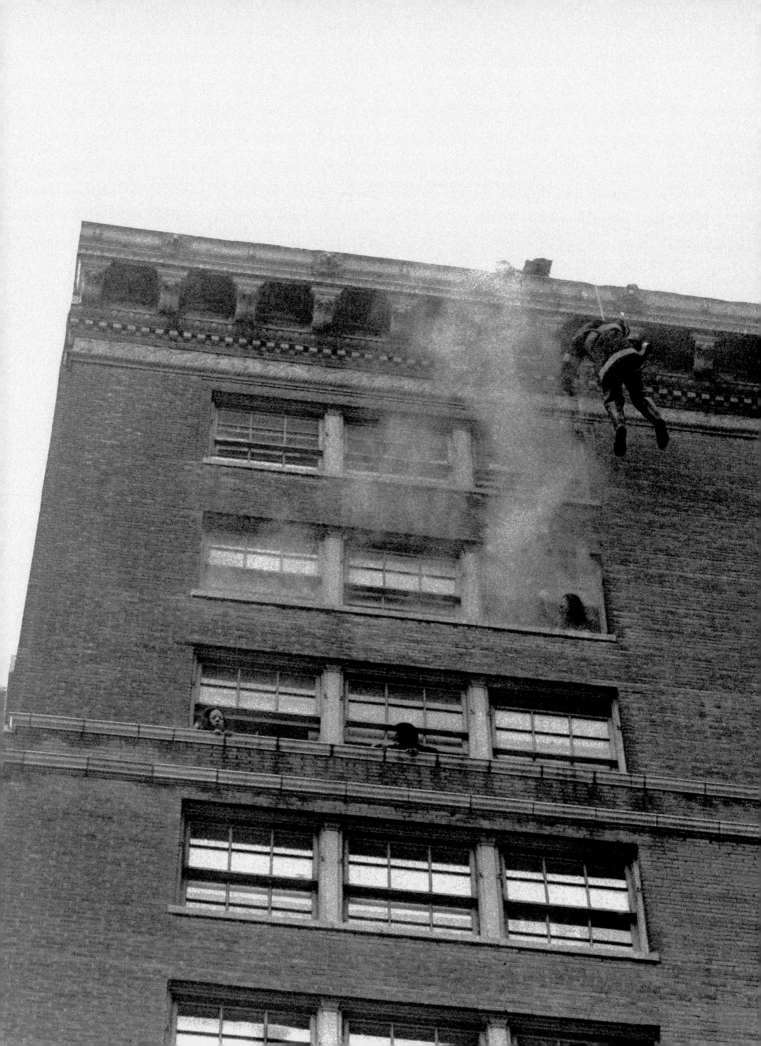

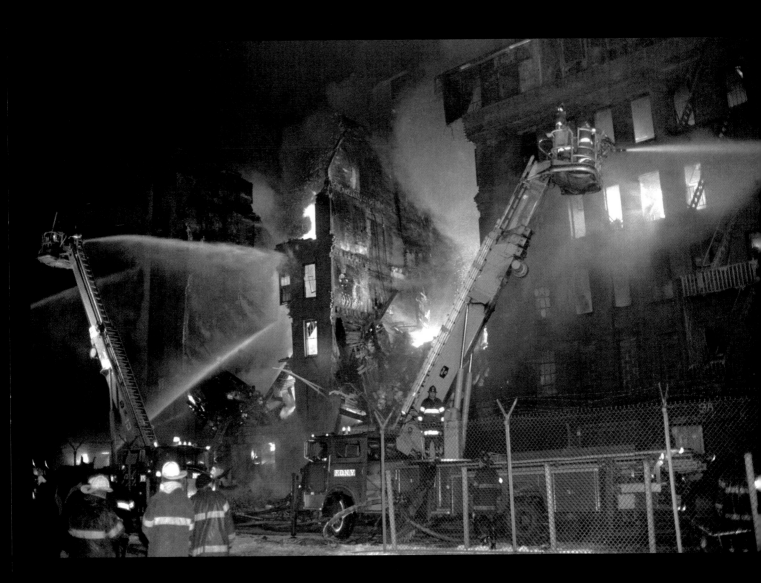

Icy winds gusting up to 30
mph fanned a seven-alarm
blaze that demolished a ware-
house complex on 12th Ave.
and 30th St. Firefighters
struggled through a long frigid
night before finally controlling
the blaze. About 300 firefight-
ers and 50 pieces of equip-
ment were brought into play.
Jan. 8, 1977
Charles Ruppman

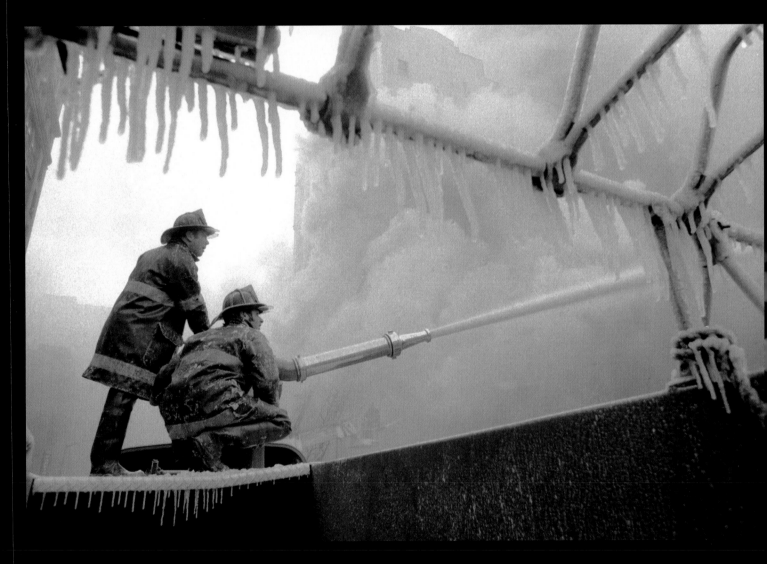

Ice forms on the deck of a
truck during a blaze which
broke out in a series of stores
at 168 West 23rd St., their
efforts hampered by the tem-
perature, hovering between
13 and 15 degrees. It took
125 firemen three hours to
control the four alarmer, but
only one was slightly injured
when a ceiling collapsed.
Jan. 19, 1970
Paul DeMaria

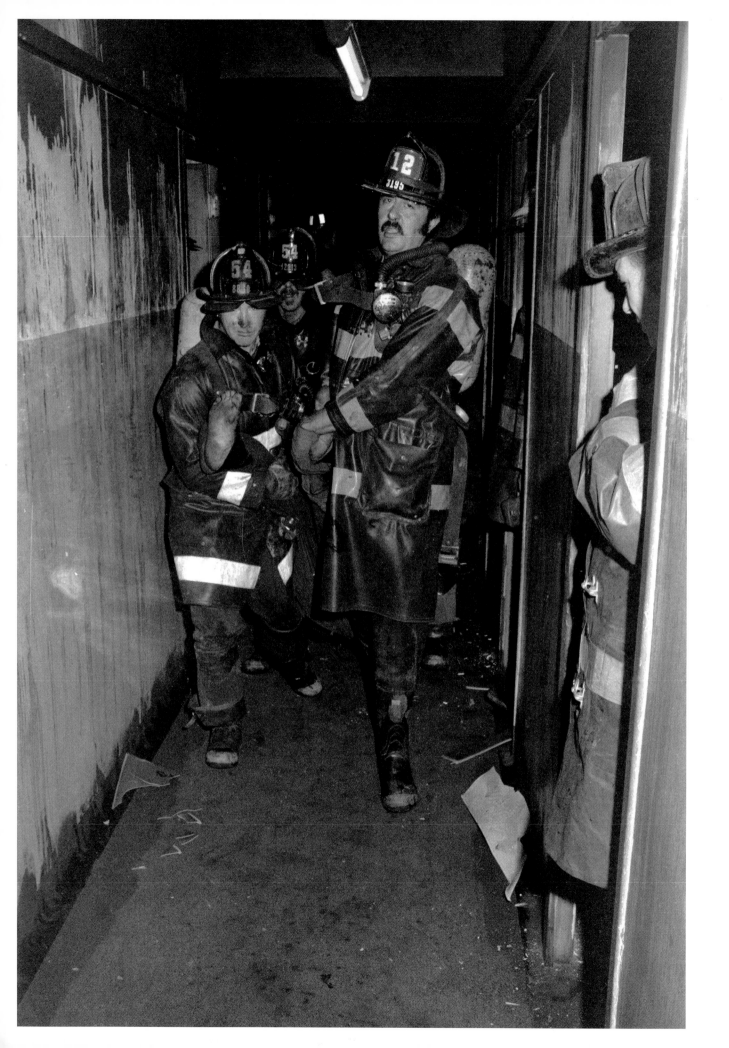

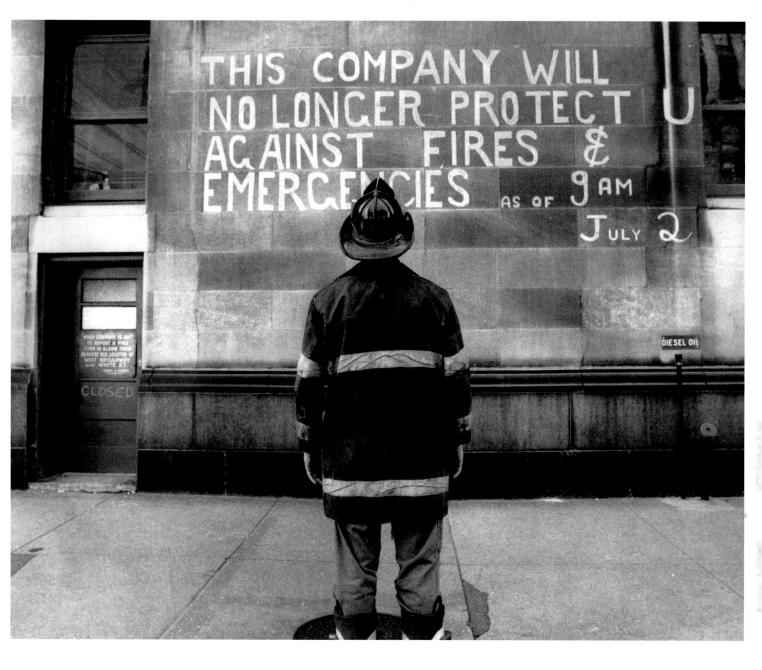

Opposite page: Firemen carry a seriously burned man down a fire-blackened hallway at the Sloane House YMCA. Four people died and about 100 were injured in the fire, which was blamed on a porter, accused of accidentally dropping a match onto some papers and then running away. Mar. 22, 1972
Anthony Pescatore

Above: A fireman stands outside the Lincoln Tower firehouse, home of Hook and Ladder Co. 8, one of 15 firehouses and 26 companies that the city ordered eliminated during a fiscal crisis, along with 19,000 scheduled layoffs of police, firemen, corrections officers, and sanitation workers. This triggered a three-day wildcat sanitation strike, joined the next day by a job action among many of the city's firemen: more than 350—ten times the normal number— called in sick. The state quickly gave Mayor Abraham Beame the authority to levy $330 million in new taxes; he quickly announced the rehiring of 750 firemen and thousands of other workers, and the return of 18 fire companies, including Hook and Ladder Co. 8. July 3, 1975
Clarence Davis

A FAMILY OF HEROES

They call themselves brothers. Theirs is a bond forged from living in close quarters, facing danger side by side, relying on each other in life-and-death moments. Theirs is a bond forged in fire, as they stand united to combat a force of nature.

Theirs is a camaraderie that goes beyond their football team or piper corps. They can be found repairing a house or raising money for a widow or a sick firefighter. Their selflessness has no boundaries. It takes them out of their neighborhoods to places as far away as Oklahoma City or the storm-wrecked Dominican Republic after Hurricane Georges, or the rubble of an earthquake in Puerto Rico—wherever they are needed. They give themselves to the public in myriad ways, from Little League to the National Guard, and as volunteer watchdogs in their neighborhoods.

They share a fearlessness that enables them to walk into a burning building. They also share a verve that comes from knowing how precious life is; it can end in a flash of flame.

They share grief, crying unabashedly at funerals. A 1995 photograph taken after Lieutenant John Clancy was killed in a crack-house fire shows the range of sentiments: his downcast comrades, heads bowed, lean against their rig where it is painted with the blithe nickname of their ladder company, "Cool Runnings" (page 142).

They share joy, too: holding a litter of Dalmatian pups and (page 58), or playing with the station's mascot after a call on a hot day (page 50).

They call themselves a family. Sons follow their fathers and siblings into the department, and many of them request to work in the same firehouses their dads worked. It's not rare to find three or even four generations of firefighting in one family.

Spouses and children get to know each other at picnics and bar mitzvahs and christenings, and are there for each other in times of need. When not with their own kids, you might find them with someone else's. A fatherless child will be spirited off to amusement parks and baseball games, and never be alone at a soccer match or school concert. There will always be a protective wing to shelter under.

Firefighters chosen as the Daily News Heroes of the Month are honored at ceremonies in the News' headquarters, and one can't avoid noticing the scope of their kinship. The entire firehouse—both the engine and ladder companies—would come to the News' offices to cheer, tease, and heckle the recipients. To a man, the hero would be red-faced with embarrassment, and would always thank everyone else; he'd never accept

Three year old Colin Jacob of Manhattan has the best seat in the house to watch

Sometimes the hero might say something poetic; more often just an awkward word of thanks. Often, he'd well up with tears, spouse and children and parents bursting with pride. And as the hero spoke, the guys in the back of the room fell silent, some with eyes moistening a little. Then they'd clap and hoot, sincerely happy for each other, and go out and party.

More than a dozen firefighters killed in the twin towers had been Daily News heroes. One, Matt Barnes of Ladder 25, was chosen for perching atop a 100-foot ladder and reaching out to take infant twins from their panicked mother as she thrust them onto the window ledge of her burning Manhattan apartment. "I'm in the spotlight, but a ton of other guys here who did a lot of fire duty, a lot of work, are getting pushed aside," Barnes said at the time. "I don't think it's fair I get all the credit."

Another, Michael Montesi, of Rescue 1 in Manhattan—also killed in the collapse of the twin towers—had been hailed for saving a man who had jumped into the Hudson River. "This was such a reward," said Montesi, in August 1999. "How many times we went out to no avail...after we put him in the ambulance, it was going through my mind that finally we made a difference."

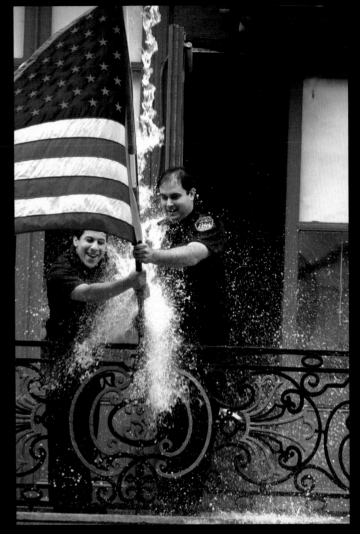

Probationary firefighters Mike Francese and Teddy Forlenza of Engine 33/ladder9 on Great Jones St. get a water bath from fellow firefighters. The ritual of lighthearted jokes on "probies" is a Firehouse tradition. **Mike Albans**

One visit to a firehouse and you feel like a friend of the family. Part college dorm, part barracks, part shrine, they are usually housed in antiquated buildings, with a banner proclaiming the company's motto or nickname inside. The members of Engine 255/Ladder 157 on Rogers Ave. in Brooklyn are "The Jolly Rogers," their patches showing a skull wearing a fire helmet. Engine 75/Ladder 33 in the Bronx is "Animal House." Ladder 132/Engine 280 in Brooklyn is known as "In the Eye of the Storm." The firefighters in the house that covers Ladder 15/Engine 4 in the Financial District called themselves the "Wall St. Bulls."

Boots and bunker pants shoved inside them stand ever ready to be jumped into. There's likely to be a mutt or a cat saved from a fire roaming around. You won't wait five minutes for a cup of coffee, and they'll urge you to stay for a meal of pasta or cold cuts, which invariably is interrupted by the alarm. Photos of fishing trips, promotion ceremonies, and weddings plaster the walls. Among them are portraits of the fallen.

After September 11, 76 of the 222 firehouses in the city added at least one face to their memorial walls. "We lost a lot of great guys, but there are still a lot of great guys left," said Mickey Conboy of Rescue 3 in the Bronx, which lost eight FDNY brothers that day.

"People rely on us and we rely on each other."

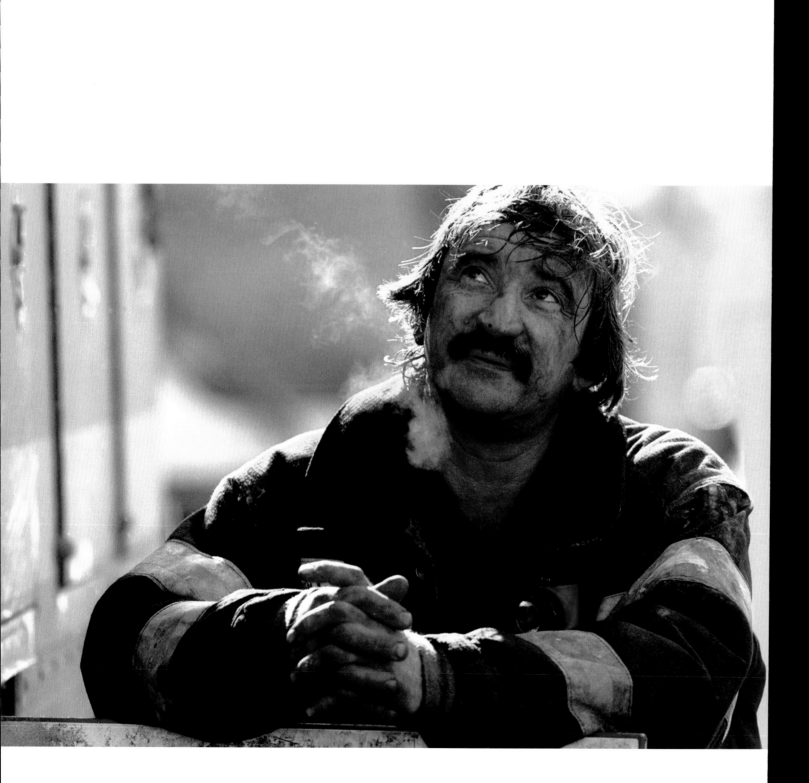

1980-2000

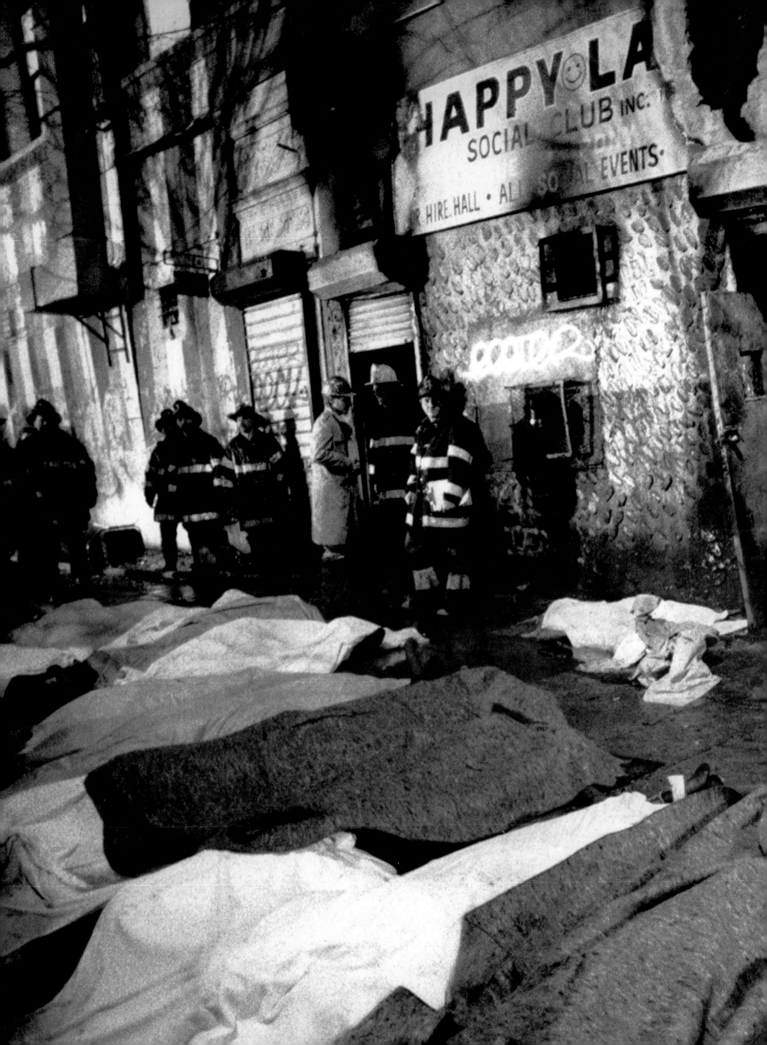

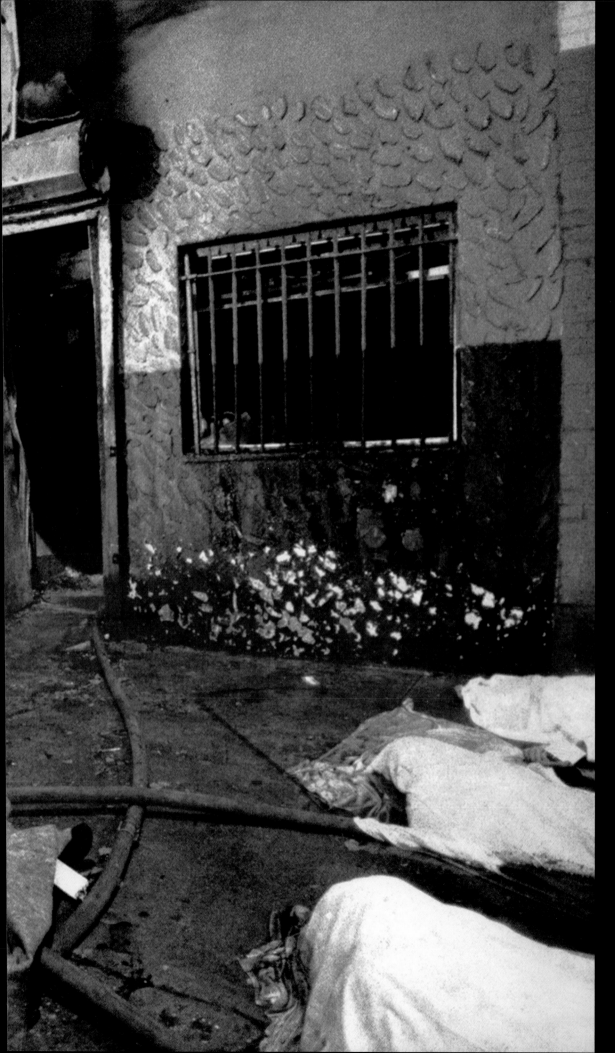

Previous page: Tony LaMagna
of Engine Co. 41, the first to
get to a trapped man, takes a
breather during a Bronx four-
alarm fire. Feb. 26, 1996
Mike Albans

Eighty-seven people cram-
med into the illegal Happy
Land Social Club in the
Bronx were asphyxiated or
burned to death within min-
utes in a flash fire deliberately
set by a man after a quarrel
in the club. Firefighters stand
by despondent as bodies are
brought into the street. It was
the worst fire in New York
since the Triangle Shirtwaist
Company fire in 1911, which
took 146 lives. Mar. 25, 1990
David Handschuh

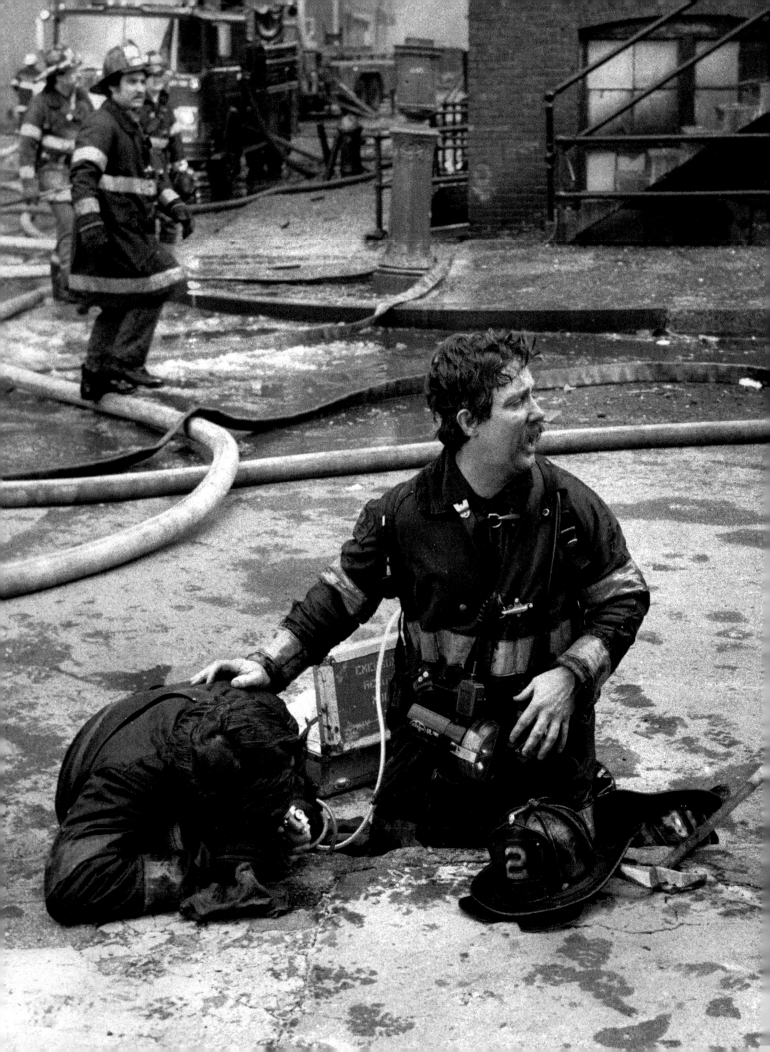

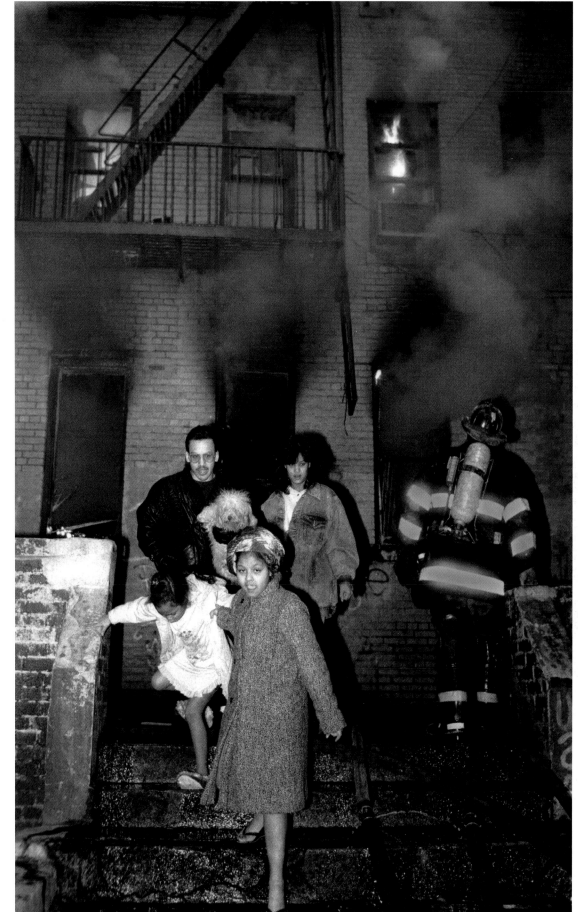

Opposite page: A firefighter shouts for help for his friend, Fireman Patrick Brown, whose throat was burned as he fought a factory blaze at 121 Plymouth St. in Brooklyn. Mar. 2, 1984
Charles Frattini

Residents flee into the street at Beech Terrace in the Bronx as firefighters rush into a four-alarm blaze, which left an estimated 50 families in the cold. Jan. 25, 1988
David Handschuh

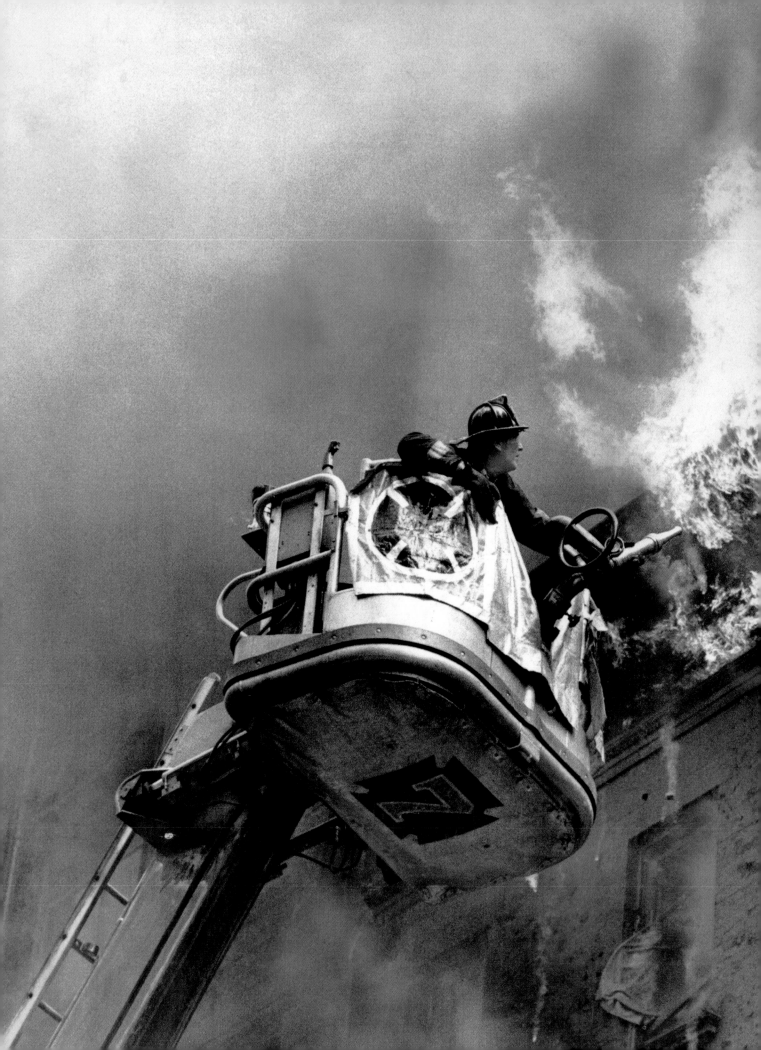

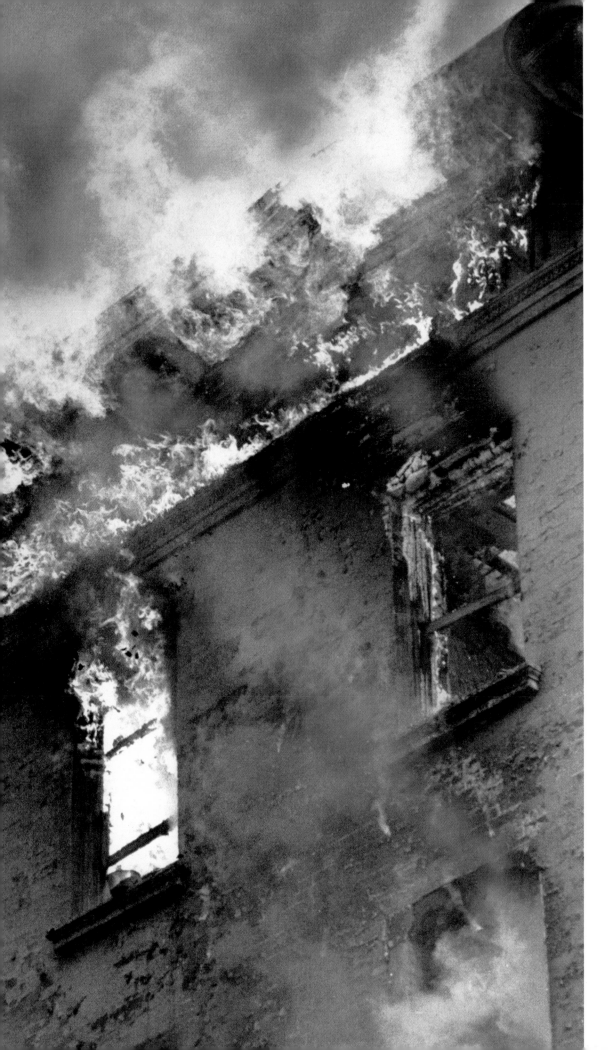

A fireman on an aerial ladder closes in on flames engulfing the top two floors of the five-story Elton Hotel, 101 East 26th St. Eighty occupants and three dogs were routed and one man was rescued as he hung by his fingers from the third-floor ledge. Sept. 28, 1981
Michael Lipack

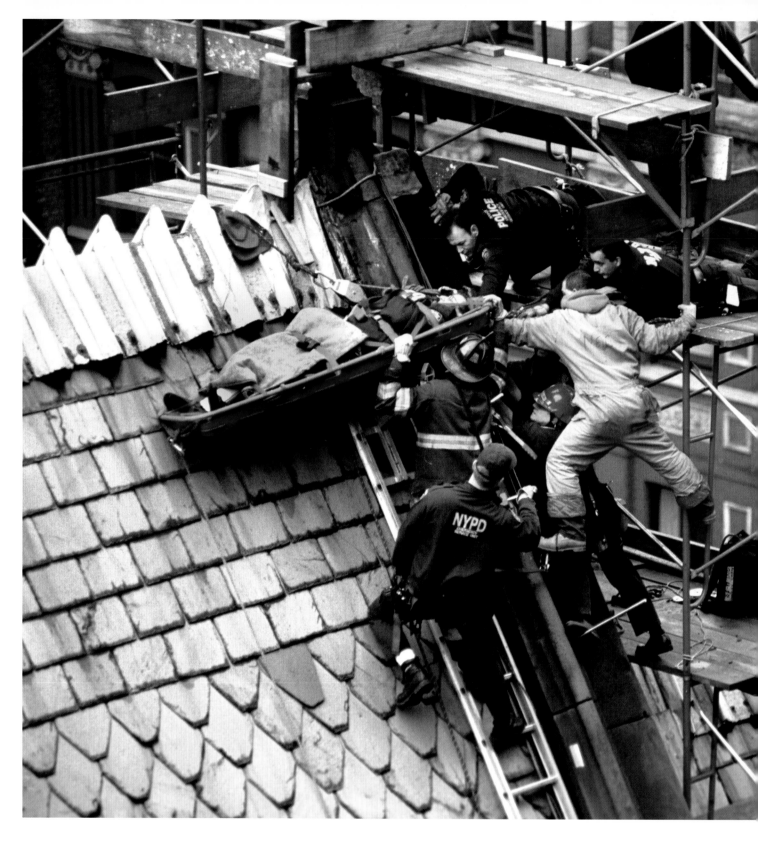

Rescue workers prepare to lower injured construction worker Donald Friedman in a body-length basket down the roof of the Serbian Orthodox Cathedral of Saint Sava on West 26th St. Friedman was trapped on the steeple after injuring his knee. Feb. 18, 1998
Susan Watts

Below: A firefighter from Rescue Squad 1 helps an elderly woman who was overcome from smoke at an all-hands fire at East 21st and Church Ave. in Brooklyn. Jan. 20, 1997
Mark Bonifacio

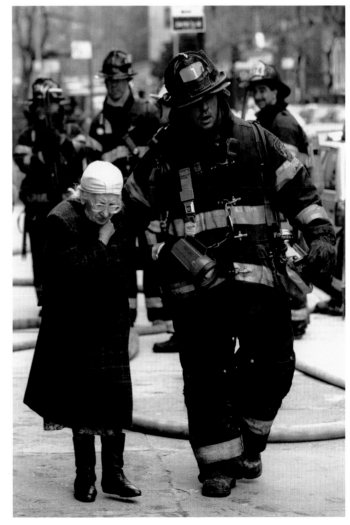

Fireman Ronald Bucca of
Rescue 1 ascends a rope dur-
ing an exercise after being
certified to return to full duty.
He was fully recovered from a
fractured back suffered one
year earlier in a five-story fall
while trying to rescue a col-
league trapped in a fire. Bucca
later became a Fire Marshal,
the only one of his rank killed
on Sept. 11; it was his last day
as a Fire Marshal—he had
requested a transfer back to
active duty, and was to report
the following day with Rescue
1, his old company, which lost
11 firefighters. Sept. 27, 1987
Thomas Monaster

Below: Kathy Van Wart has
her very own hero—husband
William, who was promoted to
lieutenant at a ceremony at
the Fire Academy on Randalls
Island. Apr. 12, 1989
David Handschuh

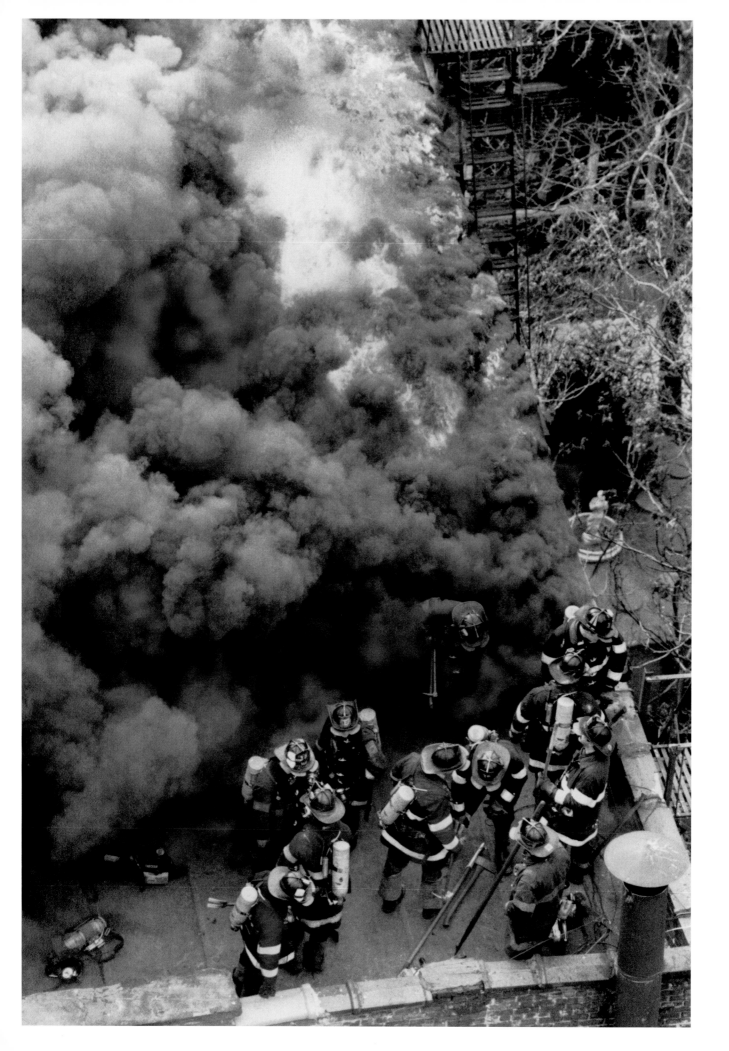

Opposite page: Firefighters huddle in one corner of the roof as thick smoke obscures the rest of the building at E. 32nd St. and 2nd Ave. The three-alarm fire, damaging two buildings, was blamed on a man who apparently fell asleep while smoking. Feb 14, 1982
Harry Hamburg

Above: Coated with ice from temperatures reaching 20 degrees below zero, a firefighter confers with his chief at the scene of a four-alarm fire in a city-owned apartment building at Franklin Ave. in Brooklyn. The fire left one woman dead, six injured, and 27 families homeless. Jan. 14, 1988
Paul DeMaria

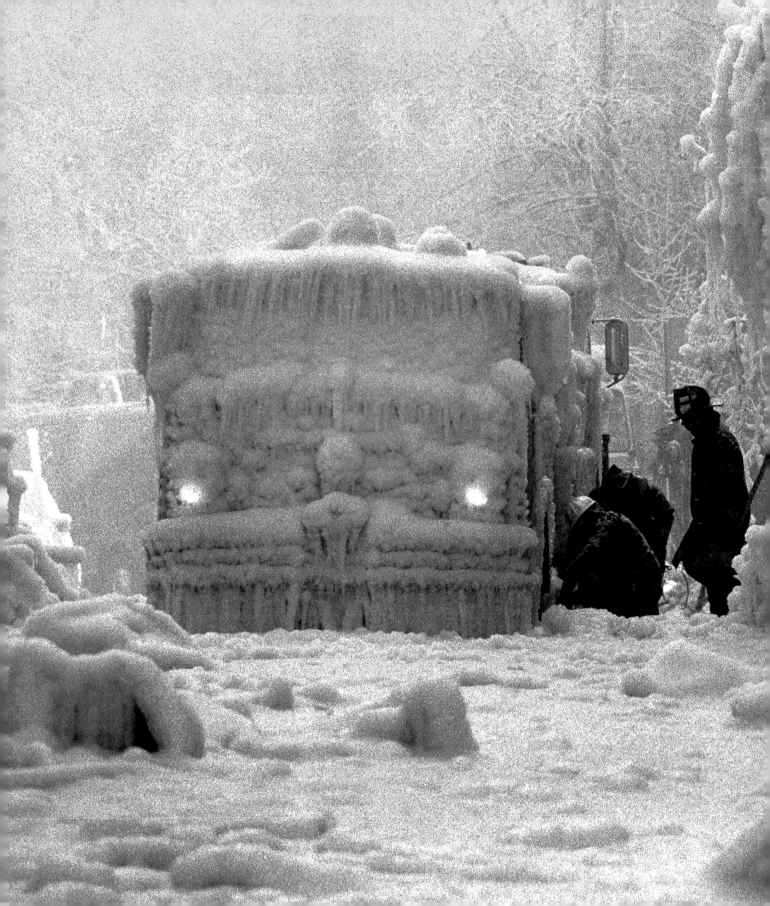

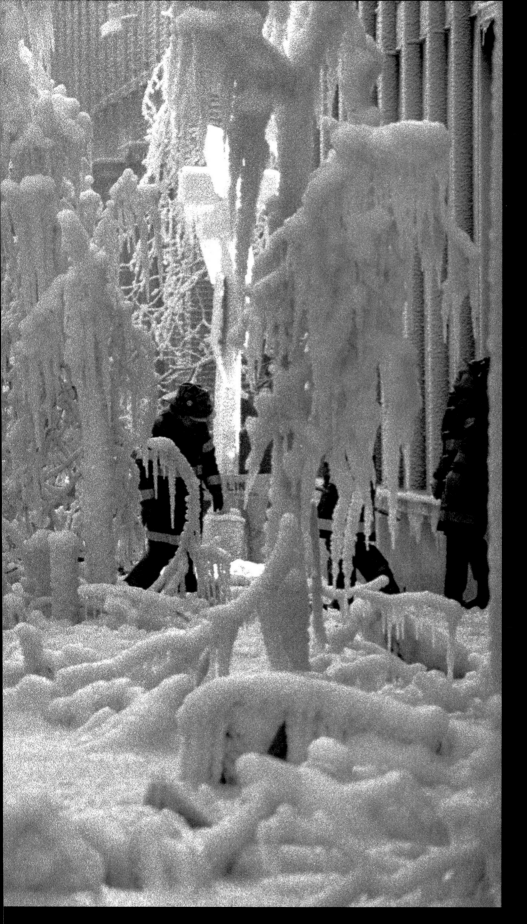

Engine 226 is frozen in place
after being soaked for hours,
with temperatures in the low
teens and winds up to 40
miles per hour, during the
battle to stop a five-alarm fire
in the Margaret Hotel, Orange
St. and Columbia Heights in
Brooklyn. The landmark hotel
was vacant and undergoing
renovations. Several floors
and part of a wall collapsed
onto two other fire trucks.

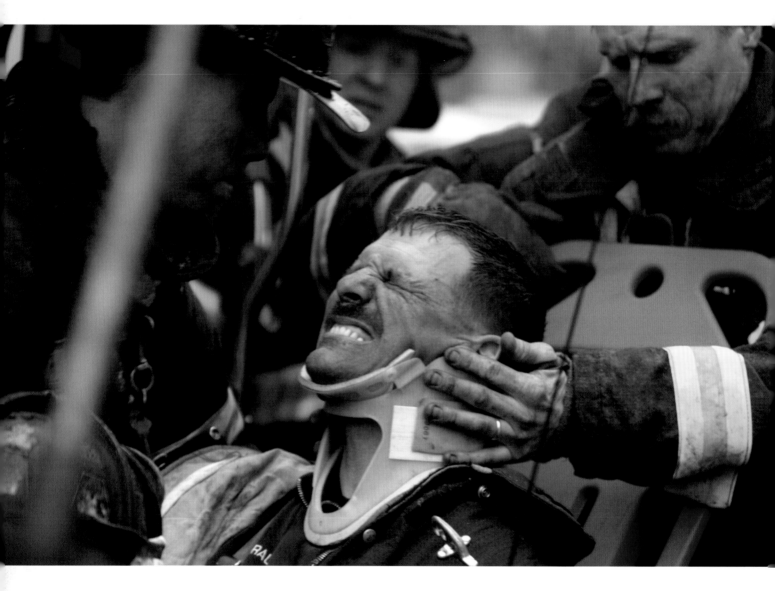

Above: Firefighter Kevin Reilly
is cared for by Lt. Tom
Donnelly (left) and firefighter
Lincoln Quappe, both of
Rescue 2. Reilly received
multiple injuries after taking a
nasty fall during a three-alarm
fire at 273 Evergreen Ave. in
the Bushwick section of
Brooklyn. Quappe later died
at the World Trade Center.
Feb. 25, 2001

Opposite page: Staggered by
the heat and smoke, Jeffrey
Johnston of Engine 48 in the
Bronx cools off in spray from
a hose at a three-alarm fire at
Webster Ave. and 197th St. in
the Bronx. June 20, 2000

Todd Maisel

David Handschuh

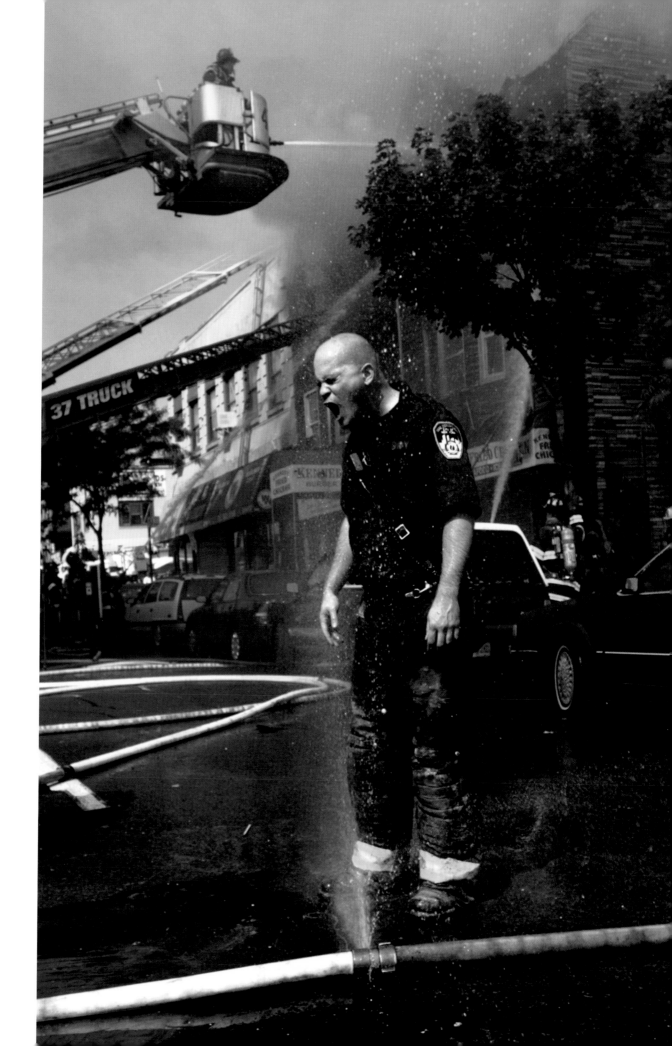

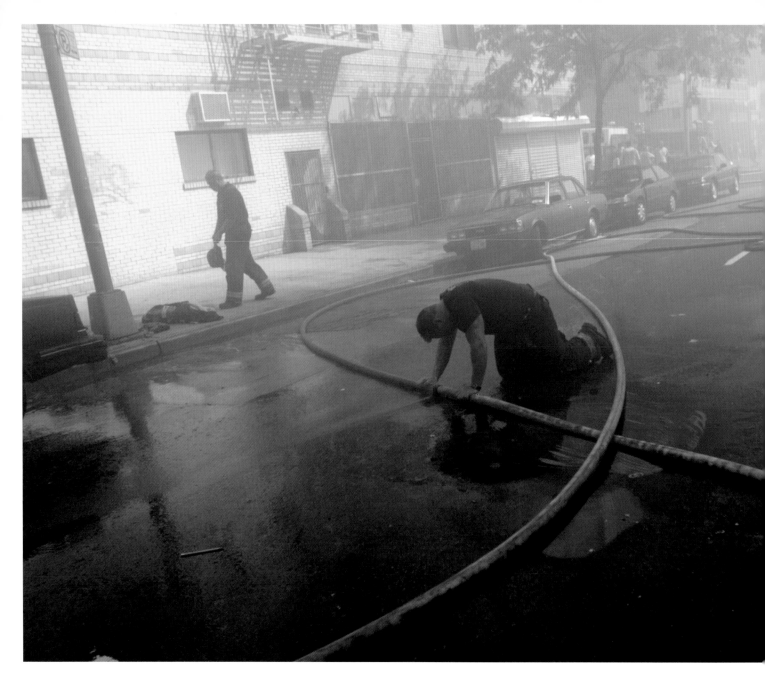

Above: Another firefighter at
the scene of the fire in the
Bronx (previous page) is
overcome from the heat and
smoke and finds relief from a
leak in a hose. June 20, 2000

David Handschuh

Opposite page: A lull after
the storm. After fighting a
three-alarm fire at the Mayfair
Hotel at 65th St. and Park
Ave., firemen were detained
for asbestos exposure testing
while a "Hazmat" team was
brought in. June 23, 1997

Linda Cataffo

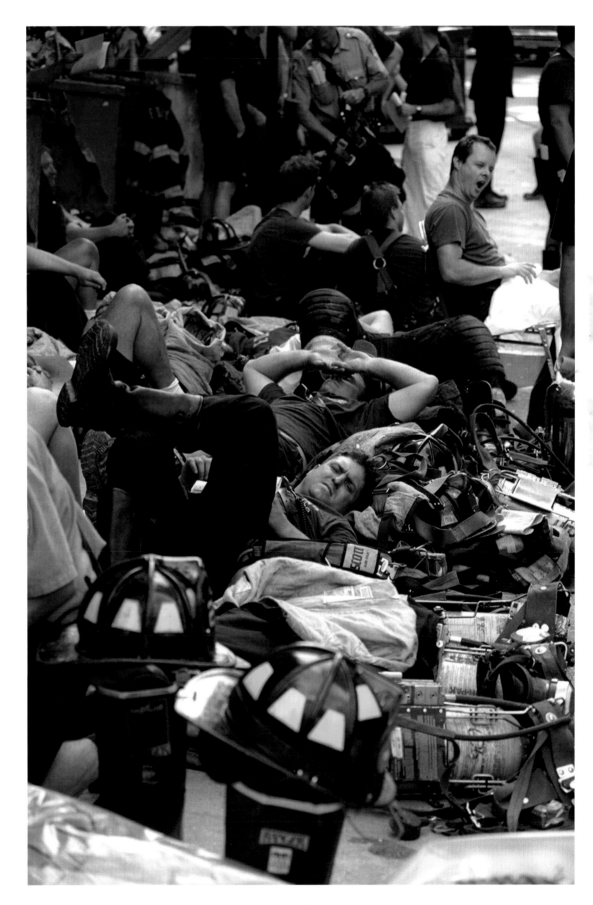

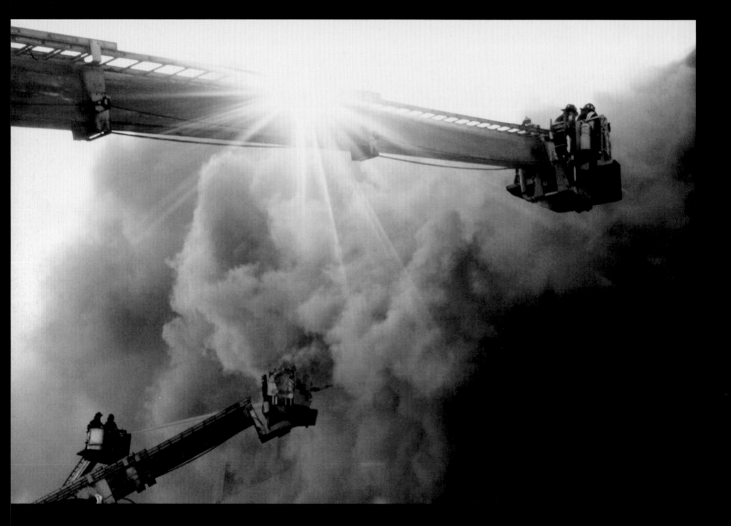

Two photographers captured
very different views of the
conflagration as a two-alarm
blaze raced through a factory
at 130 Third Avenue in
Brooklyn, injuring three fire-
fighters. Feb. 26,1999
Evy Mages (above)
Todd Maisel (opposite page)

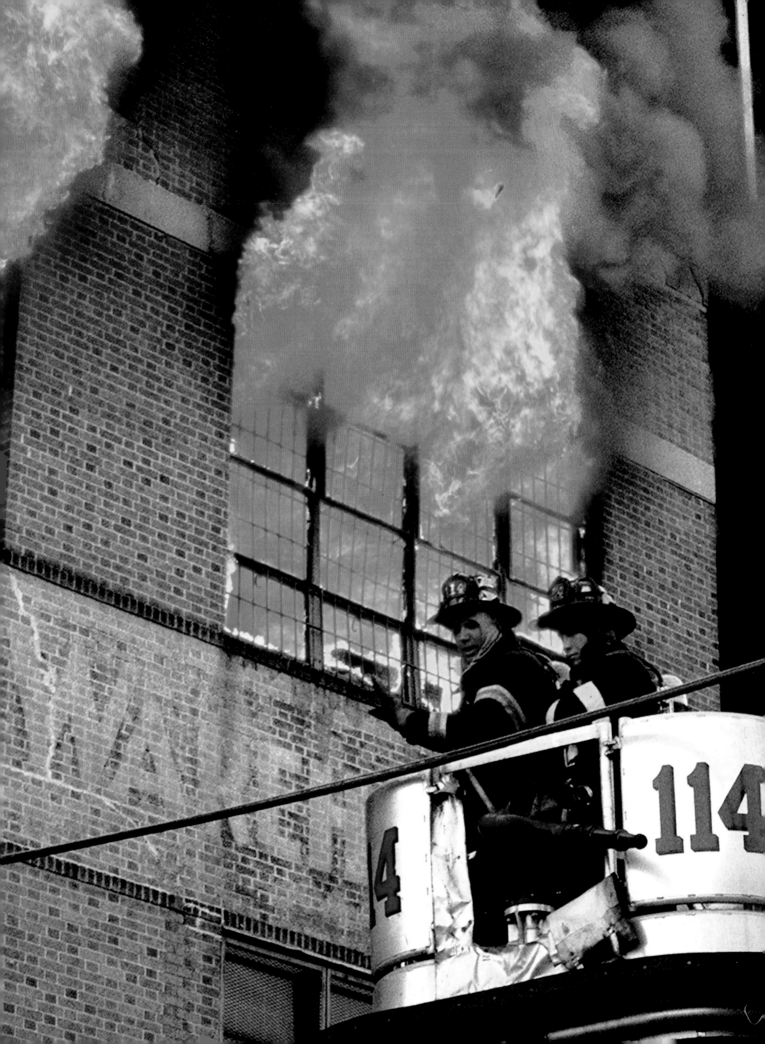

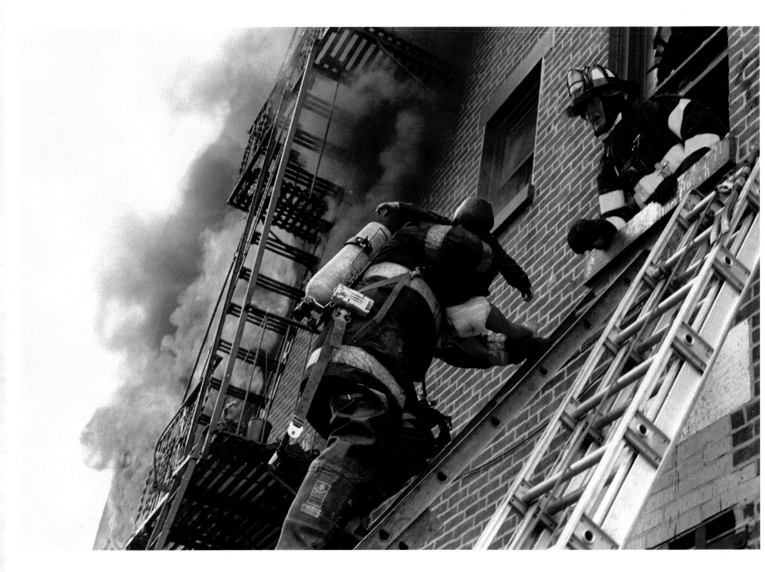

Above: Firefighters rescue Joey
Padilla, 2 years old, from a
burning apartment on Pioneer
St. in Red Hook, Brooklyn.
Padilla and his parents, older
sister, and grandmother were all
hospitalized for burns; his baby
sister, Sabrina, two months,
perished in the fire. More than
100 firefighters responded to
the the call; 11 were injured in
the blaze. May 18, 1993
Todd Maisel

Opposite page: Looking like the
evacuation of Noah's Ark, fire-
fighters rescue a woman, a dog,
and several cats from a fire at
1st Ave. and East 5th St. in the
East Village. May 14, 1994
Ken Murray

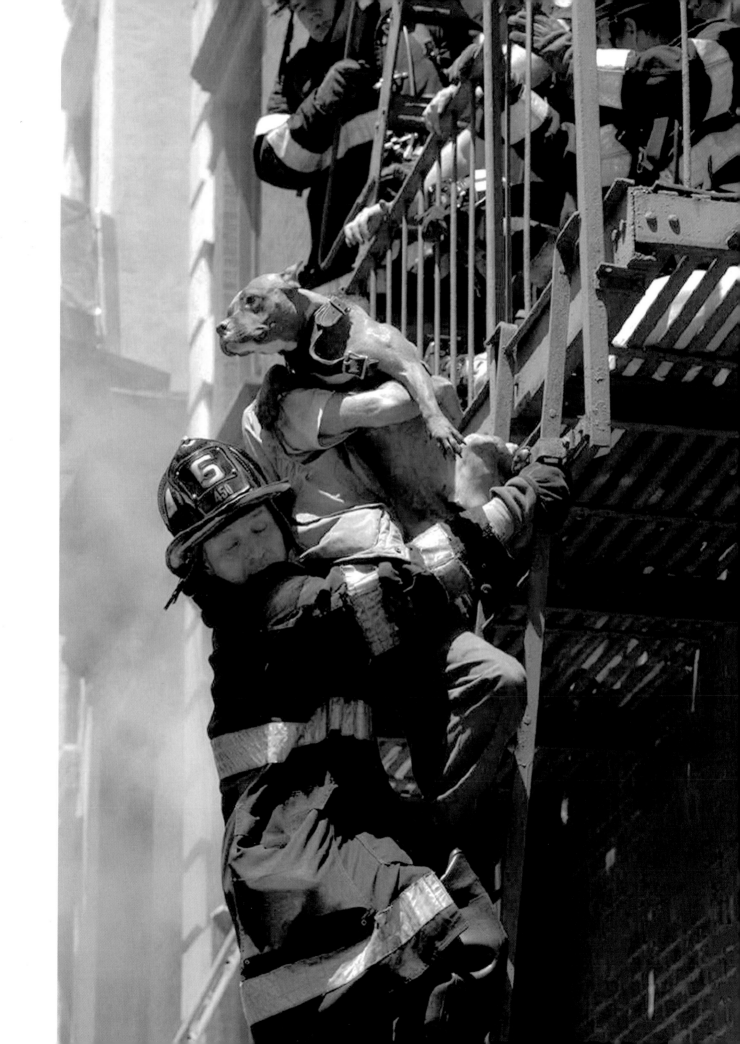

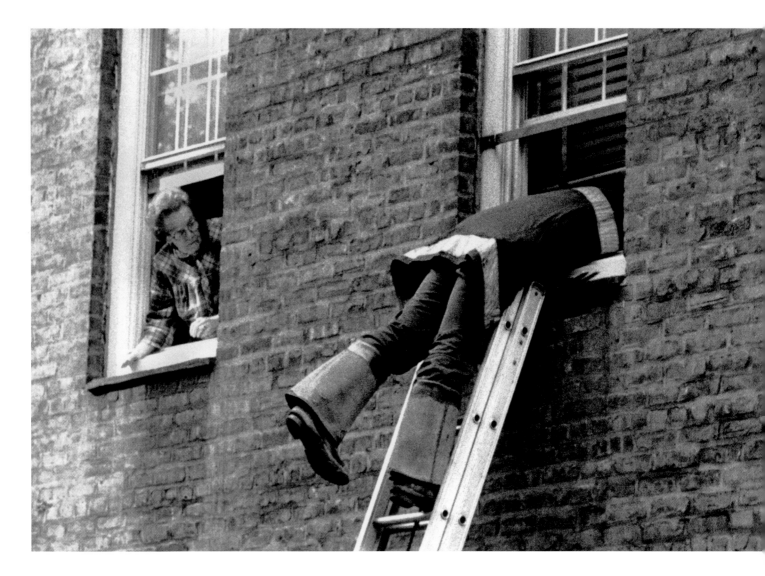

Opposite page: When the call
comes, they go. A firefighter
descends the pole as the
alarm signals at Engine
33/Ladder 9 firehouse on
Great Jones St. May 13,1996
Mike Albans

Above: Breaking and entering?
No, this fireman was merely
doing his duty by checking on
a gas stove that someone had
left on. Nov. 9, 1987
Mel Finkelstein

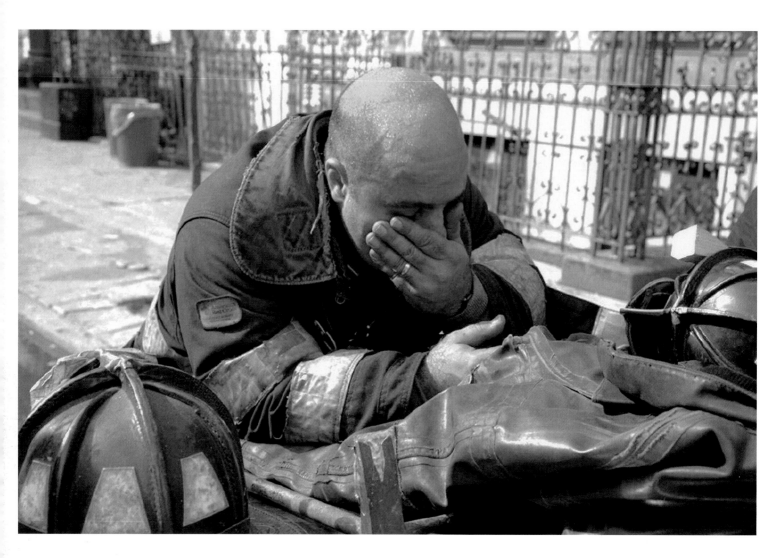

Above: Fireman Tom Zahralban grieves after the discovery of two little boys who died as a result of a refrigerator placed in front of a fire escape to keep out thieves; it also kept Lorel Pouncie, 8, and his brother Christian, 5, from escaping their bedroom when fire in the front room of their apartment at 465 East 140th St. in the Bronx blocked their only other exit. Three siblings, ages 6, 3, and 1, and their mother, Crystal Pouncie, 34, were all critically injured. May 3, 1994

Evy Mages

Opposite page: A small victim clings to the neck of a firefighter as he makes his way down the fire escape at 143rd St. and 7th Ave. July 20, 1987

David Handschuh

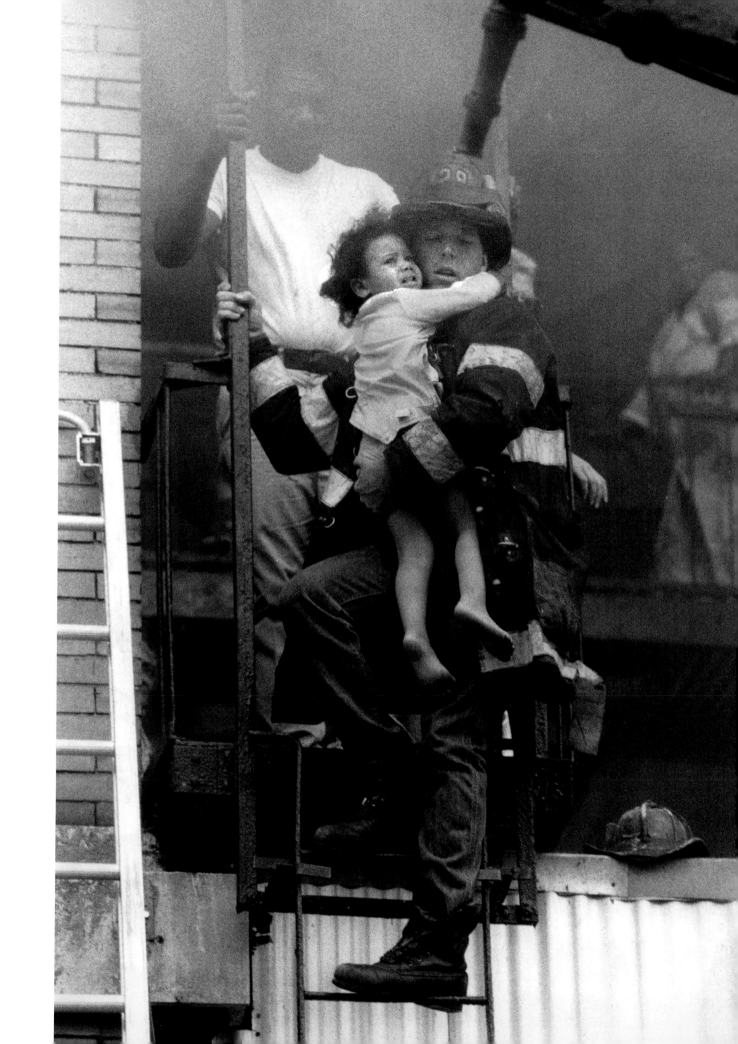

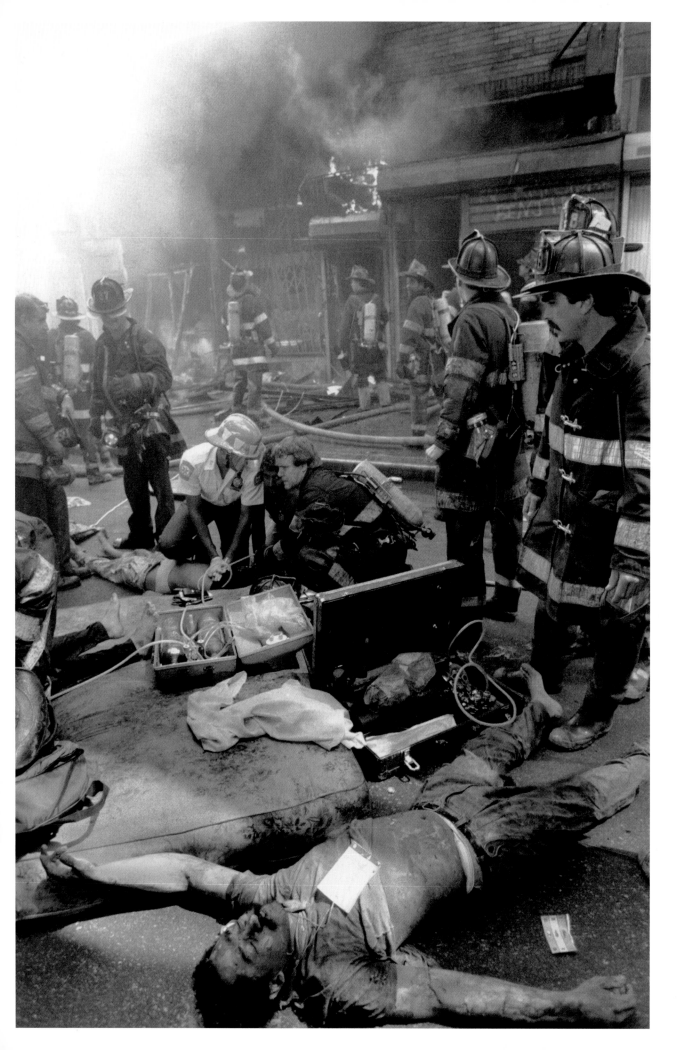

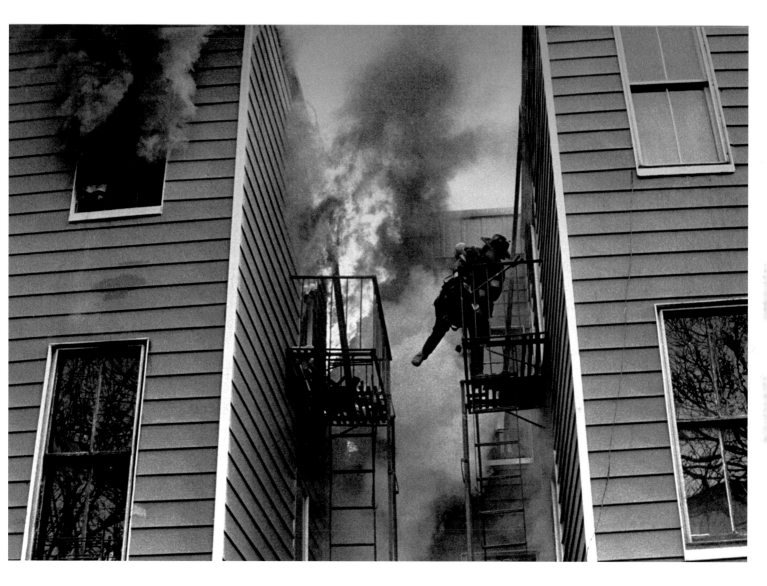

Opposite page: Firefighters and medics frantically work to save victims of the tragic fire at El Hoyo Social Club on Jerome Ave. in the Bronx. Survivors managed to break through a boarded-up door to an auto shop next door and through a gypsum wall into a courtyard to escape. Thirty-three people were injured in the blaze; seven died. Aug. 21, 1988
David Handschuh

Above: A firefighter tries to access one of five three-story buildings destroyed by a rapidly spreading fire at 1424 Flatbush Ave., Brooklyn. Diana Montanez, 8, who was deaf, and her half-sister, Lilly Rosario, 14, died in their third-floor apartment while desperately trying to open an illegal window gate. More than 60 people, half of them children, were left homeless in the eleven-degree cold. Dec. 27, 1989
Ken Murray

Below: Firefighters on an adjacent roof train water on a mostly vacant commercial building at 523-529 8th Ave. Eight of the more than 300 firefighters battling the six-alarm fire were hurt, and it took more than ten hours to bring the blaze under control. Mar. 1, 1996
Corey Sipkin

Opposite page: A firefighter tries to avoid being overcome by thick smoke at a three-alarm fire on North 6th St. in the Williamsburg section of Brooklyn. A worktable in a meatpacking warehouse collapsed, severing a gas line, whereupon a blowtorch ignited the gas. Two construction workers and four firefighters were injured. Jan. 24, 1997
Todd Maisel

Next page: Despondent firefighters from Ladder Co. 127 mourn the loss of Lt. John Clancy, 35, who entered a crack house at 97th Ave. and 150th St. in Jamaica, Queens, and fell through an apparent "booby trap"—a piece of linoleum placed over a large hole in the floor—set near a side door into the inferno in the basement. An arson suspect was arrested at the scene. Clancy left behind his wife, Dawn, who was six months pregnant with their first child. Dec. 31, 1995
Mike Albans

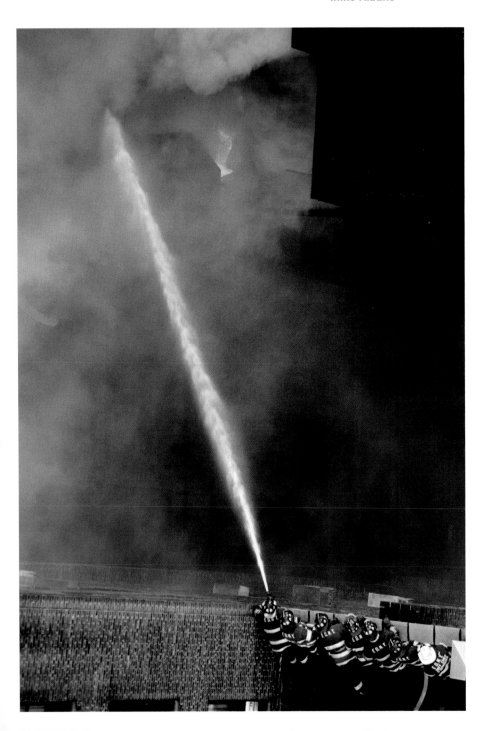

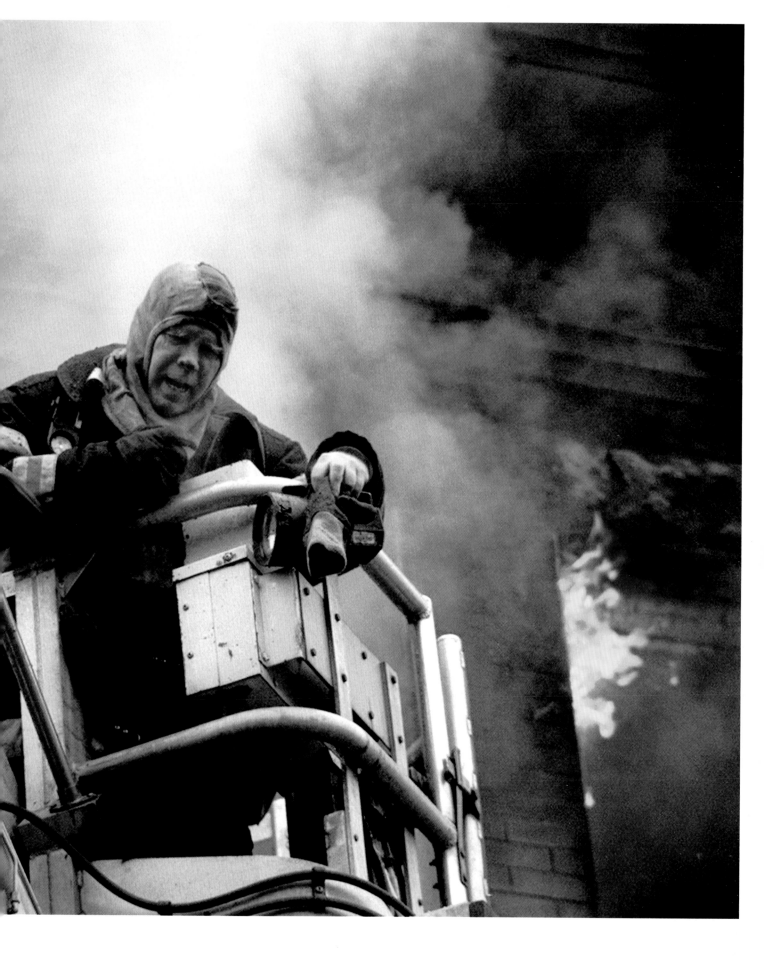

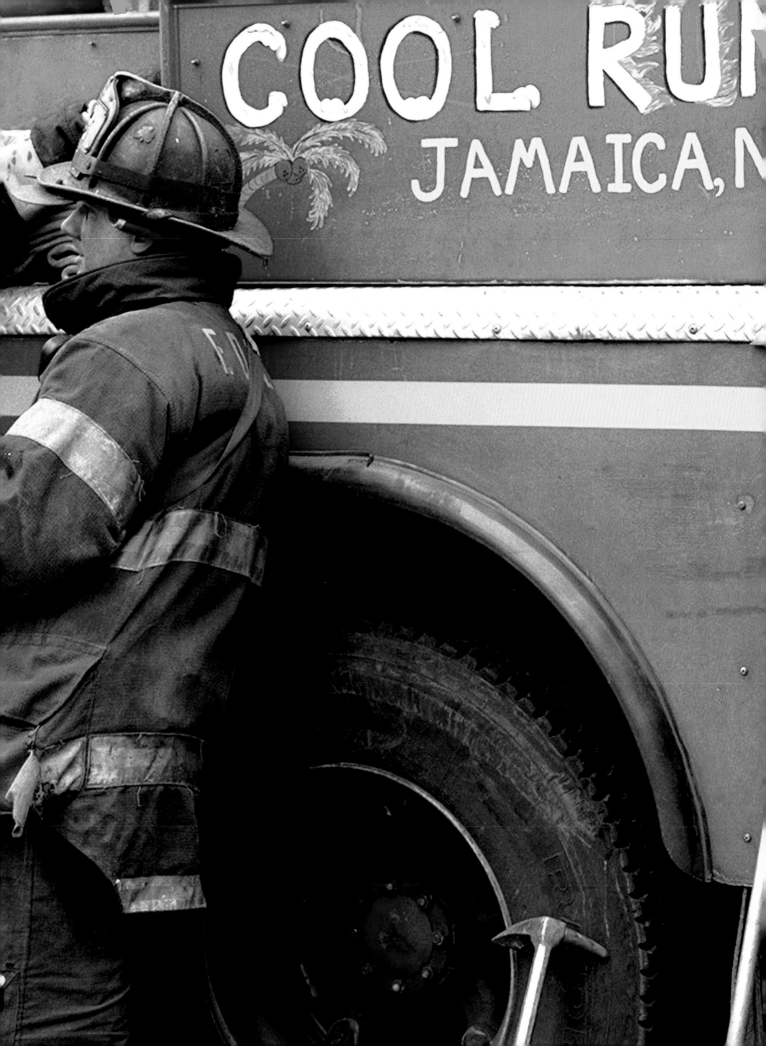

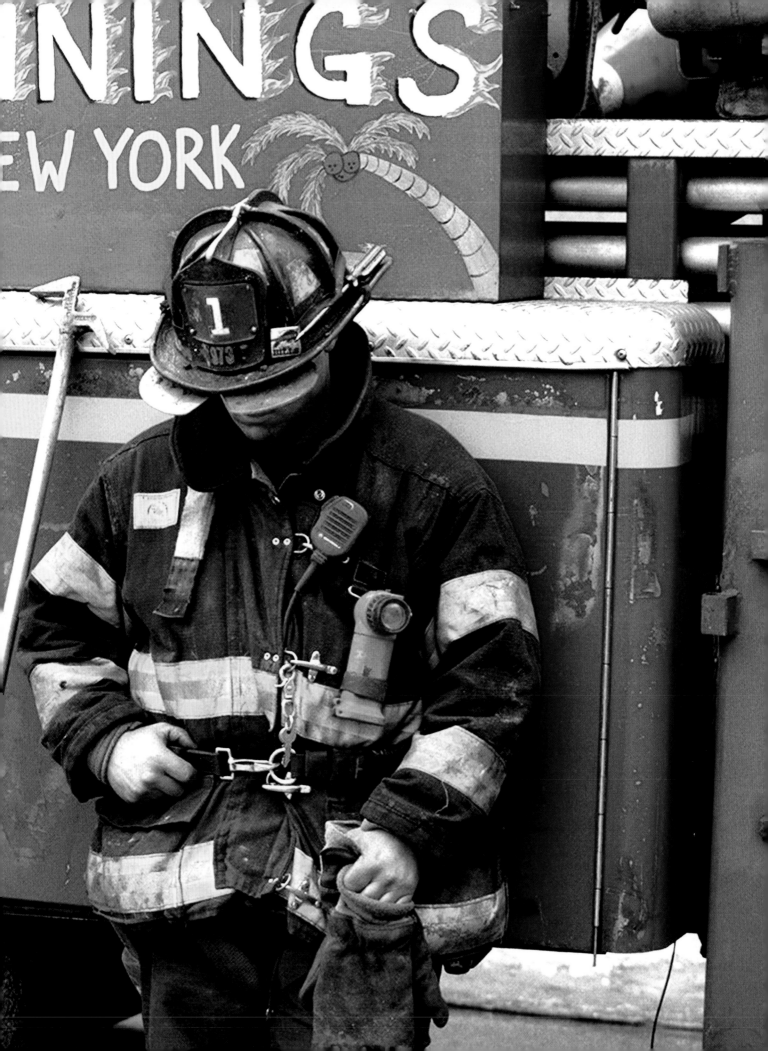

NEW YORK, SEPTEMBER 11

"I am of the opinion that my life belongs to the whole community, and as long as I live it is my privilege to do for it whatever I can. I want to be thoroughly used up when I die, for the harder I work, the more I live. I rejoice in life for its own sake. Life is no 'brief candle' to me. It is a sort of splendid torch which I have got hold of for the moment; and I want to make it burn as brightly as possible before handing it on to future generations."

–George Bernard Shaw, from the memorial card
for Firefighter Jeffrey Giordano of Ladder Co. 3.

On September 11, 2001, American Airlines Flight 11 was hijacked and deliberately steered into One World Trade Center at 8:47 a.m. A second hijacked plane, United Airlines Flight 175, smashed into Two World Trade Center at 9:03 a.m.

Both planes became terrorists' weapons in an attack on the splendid twin symbols of New York success, which that morning gleamed in the late summer sunshine and bustled with the city's best, brightest, and hardest working. As firefighters responded from all corners of the city, they knew it would be the largest fire operation in the history of the FDNY.

Rigs rode heavy; the attack had come right as the firefighters changed shifts, so double the number jumped on trucks and engines to speed to the twin towers. Even before the department issued a total recall of all firefighters to duty, many rushed down on their days off.

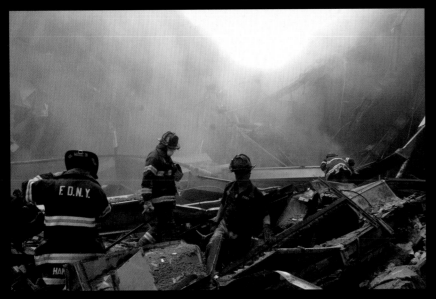

Bronx Firefighter Peter Bielfeld happened to be downtown when the first plane hit. He ran to Engine/Ladder 10 on Liberty Street and took someone else's turnout gear, leaving a note that said, "If I don't come back, please tell my wife and kids I love them."

He did not come back.

Daily News photographers raced to the scene. David Handschuh captured the second plane exploding in a fireball into the side of Tower 2, and Assistant Chief Gerard Barbara looking up at it. Barbara ran toward the tower, never to return.

Firefighters make their way slowly through the still-burning ashes of the World Trade Center in a desperate search for survivors. Sept. 11, 2001
Corey Sipkin

Then the inconceivable happened: the skyscrapers that had weathered a terrorist bombing in 1993 collapsed. Tower 2, the second one hit, went first, at 9:59 a.m., and thousands were killed in the cascading horror. News photographer Robert Rosamilio captured it plunging down, trailing smoke and raining steel beams. Shooter Susan Watts fled from the huge cloud of choking dust, then resumed photographing stunned, burnt, and bleeding office workers.

Frantic efforts to get everyone out of Tower 1 followed. The Fire Department documents that Captain Patrick Brown of Ladder 3 and his men reached at least the 35th floor of Tower 1, where Brown reported "numerous burn victims on the stairs." Witnesses from even higher floors who escaped recounted how they passed ascending firefighters while running down the stairwells. Tower 1 crashed down at 10:28 a.m.

Daily News photographer crime scene and fire veteran Todd Maisel, who counts many firefighters among his personal friends, said, "I wasn't even worried for my own life until I saw Danny Suhr get killed. He was the first to die of the firefighters. It was one of the most horrible scenes I've ever seen, it freaked me out and made me move back, it saved my life." Still shooting he came upon News photographer David Handschuh—thrown half a block by the force of the collapse, which shattered one of his legs—and helped rescue him.

Photographer Corey Sipkin, after escaping the collapse of the first tower, and then the second, recalls, "I remember thinking about what's important...It turned into a rescue effort, and that's what I tried to capture."

Veteran photographer Andrew Savulich captured the spontaneous gesture of determination and hope amid the ruins with his picture of Capt. Michael Dugan raising a ragged Stars and

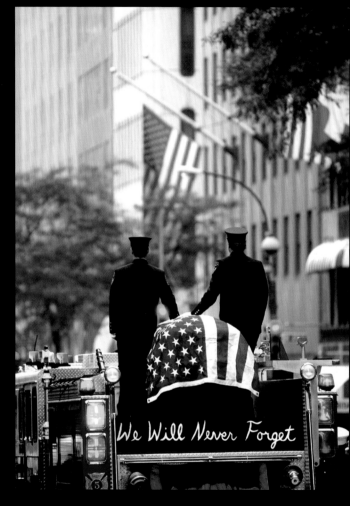

Funeral for Rescue Co. 1 Lieutenant Dennis Mojica at St. Patrick's Cathedral, killed in the World Trade Center attack. Mar. 4, 2002
Susan Watts

Stripes over the smoldering pile. It became a symbol for a nation stunned by the cruelty and senselessness of the attack on innocents.

Firefighters climbed the precarious, six-story-high pile of debris, and crawled through underground craters to rescue the injured. By the afternoon of September 12, they had pulled out the last of the living. Maisel and Sipkin bravely navigated the still-burning rubble with them, documenting the breadth of the destruction and the bravery of the rescue workers.

While the official death toll would not be known for months, all assumed it would be in the thousands. Mayor Rudolph Giuliani stated simply that whatever the number, it would be "more than any of us can bear."

Firefighters in Queens, the Bronx and outer Brooklyn who were ordered to stay put in their firehouses during the attacks cried as they watched the towers fall via television, knowing how many of their brethren were inside. Entire rescue squads and specialized units , top commanders of the Fire Department, firefighters from houses across the city, and the FDNY's disaster response expert were among those lost within those 100 minutes. The Fire Department's special operations units lost all 94 men who responded that day.

Among the dead were heroes who had made daring rescues or had pulled people from other disasters—people with irreplaceable experience "They've destroyed the heart and soul of the department," said one firefighter as he searched the ashes.

Never had the FDNY seen a disaster of this magnitude. As is their way, the firefighters refused to give up hope, refused to refer to their colleagues as dead.

"There ain't no 'death toll,'" a department spokesman said on September 12. "They're unaccounted for."

Legendary figures in the FDNY died instantly or were among the missing.

People like the Rev. Mychal Judge, a Franciscan priest and revered Fire Department chaplain.

First Deputy Fire Commissioner William Feehan, himself a four-decade institution, and Chief of Department Peter Ganci, with 30 years in the department, were lost. Newly promoted Capt. Timothy Stackpole, who had recently returned to the job after recovering from a fall into a flaming Brooklyn basement four years ago, died, leaving behind his wife and five children. More than 600 children were left fatherless on September 11.

Six probationary firefighters were lost, a month before graduating from the Fire Academy. Theirs was the first class of recruits to rotate through firehouses while still in training. Six chairs would be left empty at the graduation ceremony.

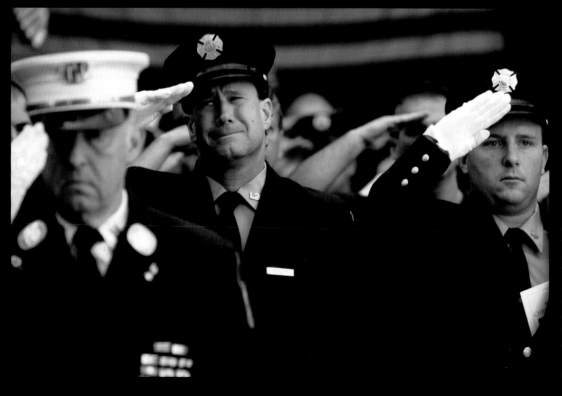

Holding back the tears, firefighters give a final salute to their beloved colleague, the Rev. Mychal Judge, during his funeral at St. Francis of Assisi Church on West 31st St. Judge, a Fire Department chaplain, died while administering last rights to a firefighter on September 11. Nov. 15, 2001
Linda Rosier

So began the torturous search at the overwhelming, gray ash-coated pile of crushed steel and concrete. There were fathers digging for their sons, sons for their fathers, brothers digging for brothers. After spotting a Rescue 3 helmet, Firefighter Danny Foley dug for his brother, Tom, a member of the elite squad, and found his body.

Daily News "Hero of the Month" Capt. Fred Ill, who had crawled under a Manhattan subway train to save a man whose legs were severed, was in there, and his son Fred, a rookie fireman, searched for him. Capt. Ill's body was recovered.

Chief Raymond Downey—the most decorated officer in the department to perish that day—had assisted in the Oklahoma City bombing and other terrorist and natural disasters. He was identified through DNA reports after eight long months of searching by his son, Capt. Raymond Downey, Jr. Retired Fire Captain John Vigiano searched for his only children, John, a firefighter, and Joseph, an Emergency Service cop. He was only able to carry out Joseph's body.

Frustration and grief forced firefighters to their knees and made them weep.

Three hundred forty-three.

There is a protocol followed when a firefighter dies. The funeral is a ritual of tears and tradition, kilts, bagpipes, and slowly rolling fire rig used as a caisson for the coffin. Thousands of white-gloved firefighters salute.

Daily News photographers attended the funerals, poignantly capturing widows and children in their grief, allowing all of us to share in the mourning. For many of the them, there could not be a funeral because there was no coffin; there was no body, or even a remnant of a body.

Autumn and winter dissolved into a blur of heavy-hearted memorial services, replete with displays of photographs and empty uniforms, coming as many as seven a day. Brothers in firefighting arrived in droves from all over the country to attend. Many had been here already, to assist in the rescue and recovery.

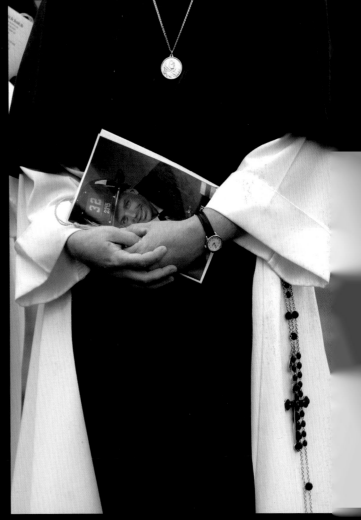

A Sisters of Life nun holds funeral program with firefighter Michael Lynch's picture during his funeral at St. Francis de Chantal Parish in Throgs Neck. Lynch, of Engine Co. 32, was killed in the World Trade Center attack, leaving behind a fiancé Stephanie Luccioni and parents Jack and Kathleen. Dec. 7, 2001
Susan Watts

By springtime, two heaps of dirt were all that was once the quarter-mile-high twin towers. Up until the last day of the recovery effort, firefighters used fine rakes to comb out thin layers, still hoping to find some tangible evidence of their brothers and the other civilian victims.

Spray-painted all over the wooden barricade encircling this hallowed place, site of the greatest tragedy of this country's modern era, now known as Ground Zero, was the mantra of the New

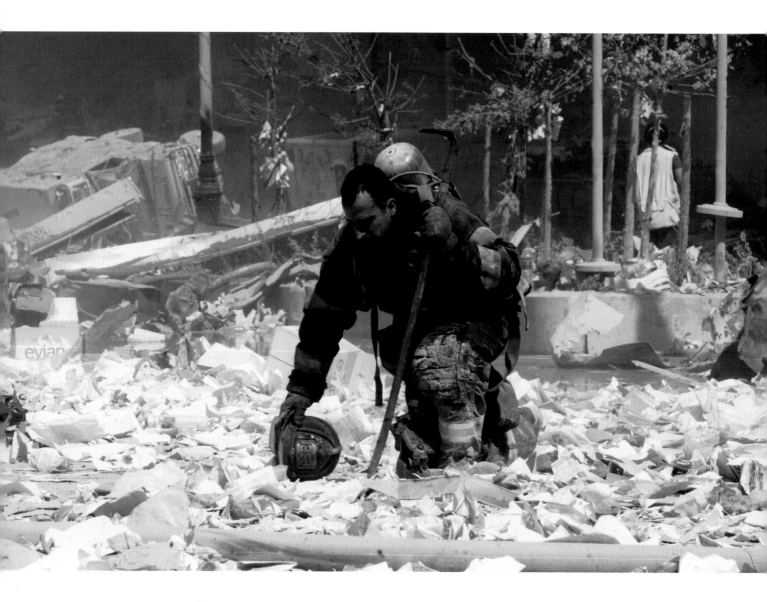

September 11

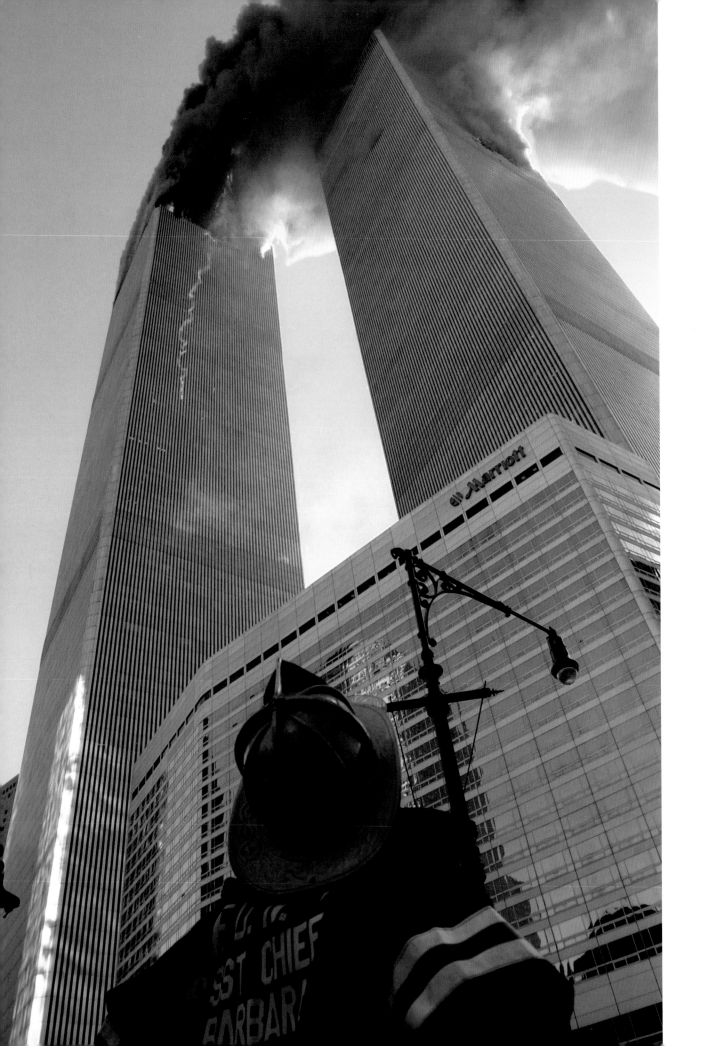

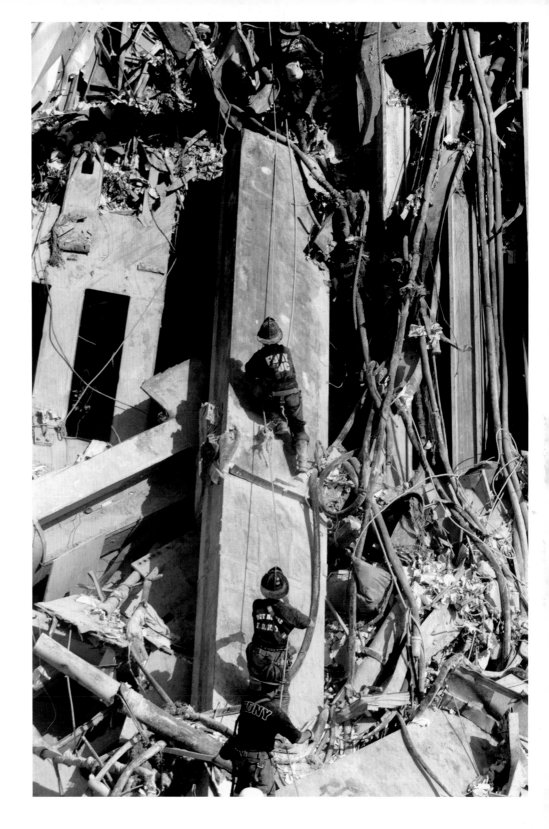

Previous page: Firefighter Kevin Kubler of Engine 288 kneels in the rubble and debris of the World Trade Center. Sept. 11, 2001
Todd Maisel

Opposite page: After the second plane hit, Assistant Chief Gerald A. Barbara looks up at the burning towers. Moments later he would go in, never to return. Barbara, 53, was citywide tour commander and a 30-year veteran of the department.
Sept. 11, 2001
David Handschuh

Right: Firefighters scale the mass of wreckage as the search goes on for victims.
Sept. 11, 2001
Corey Sipkin

Next page: Firefighters begin the impossible task of looking for survivors as fires still raged in the wasteland that was the World Trade Center.
Sept. 11, 2001
Todd Maisel

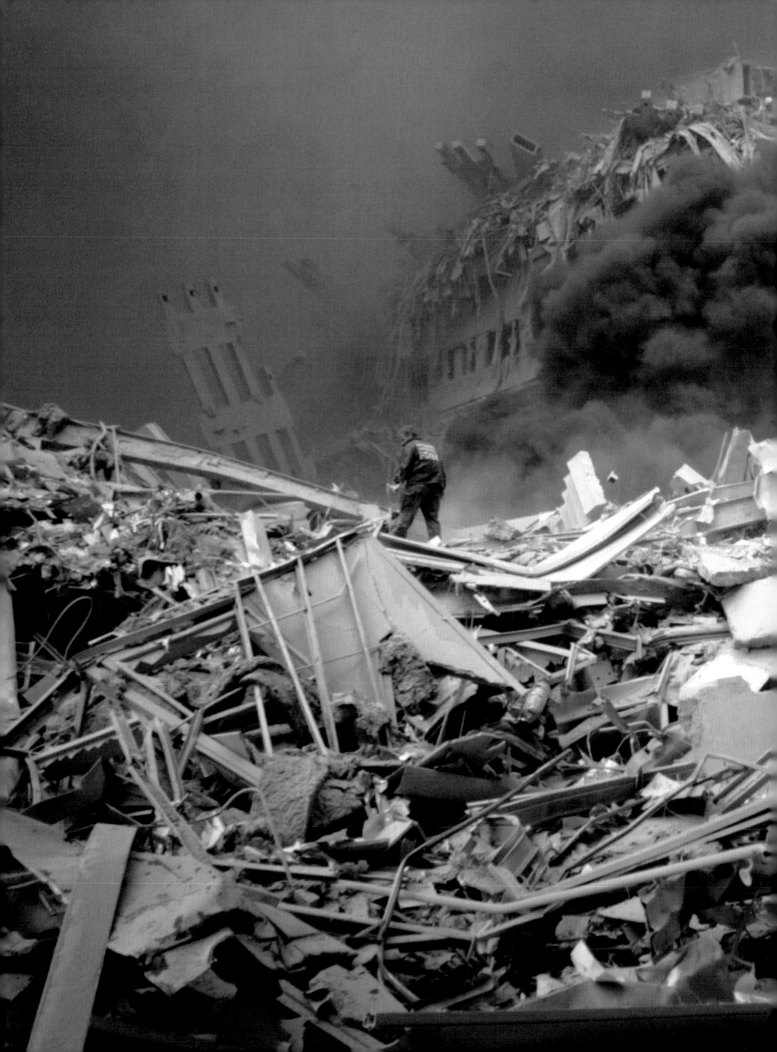

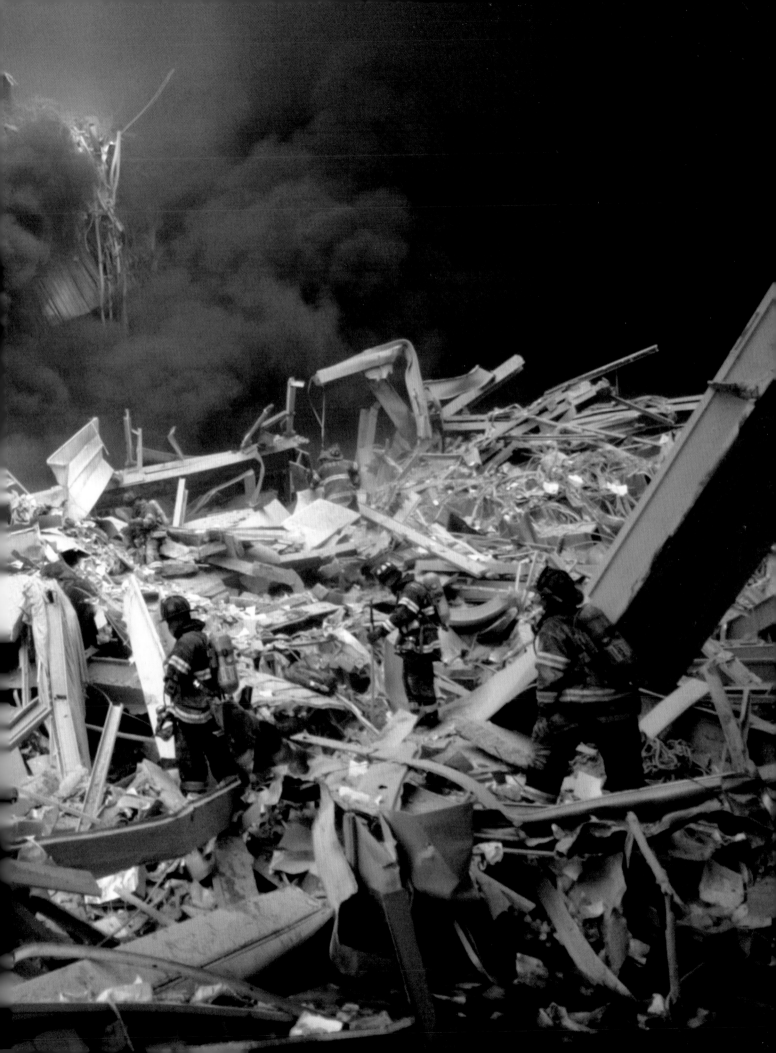

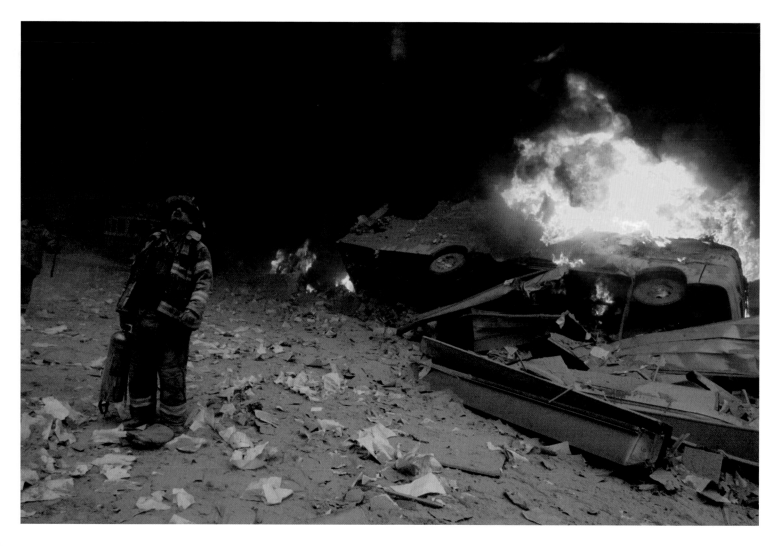

Firefighter William Roberts of
Ladder 113—all of whom
survived the attacks—looks
skyward in grief and despair
as he stands in the ashes of
World Trade Center during
the desperate search for sur-
vivors. Sept. 11, 2001

Todd Maisel

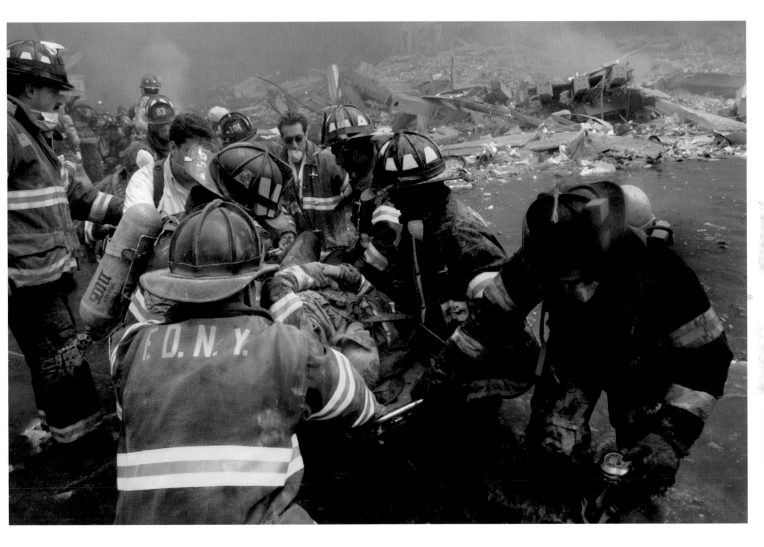

Firefighters rescue their
brother Armando Reno, one
of the few who survived the
World Trade Center attack.
Sept. 11, 2001
Todd Maisel

155

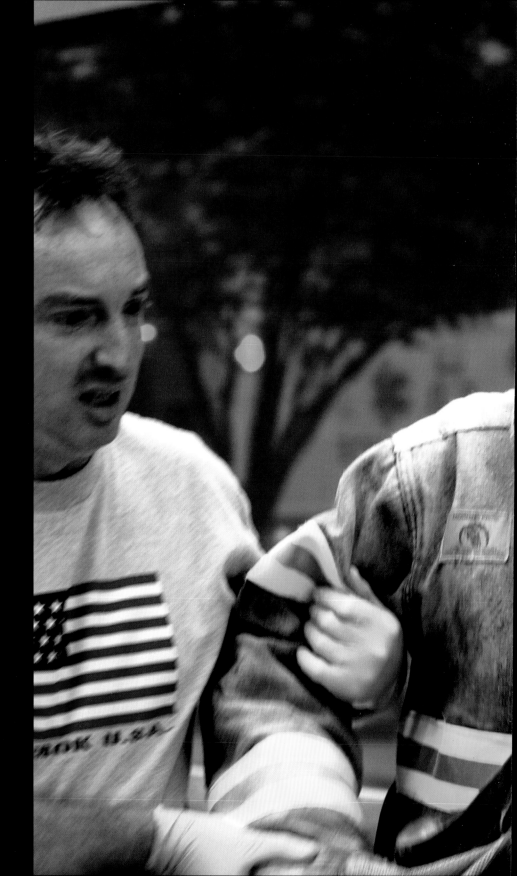

Firefighter covered with
ash being aided right
after the first tower's
collapse. Sept. 11, 2001
Tom Monaster

Next page: Exhausted
firemen take a much
needed rest on
Broadway during the

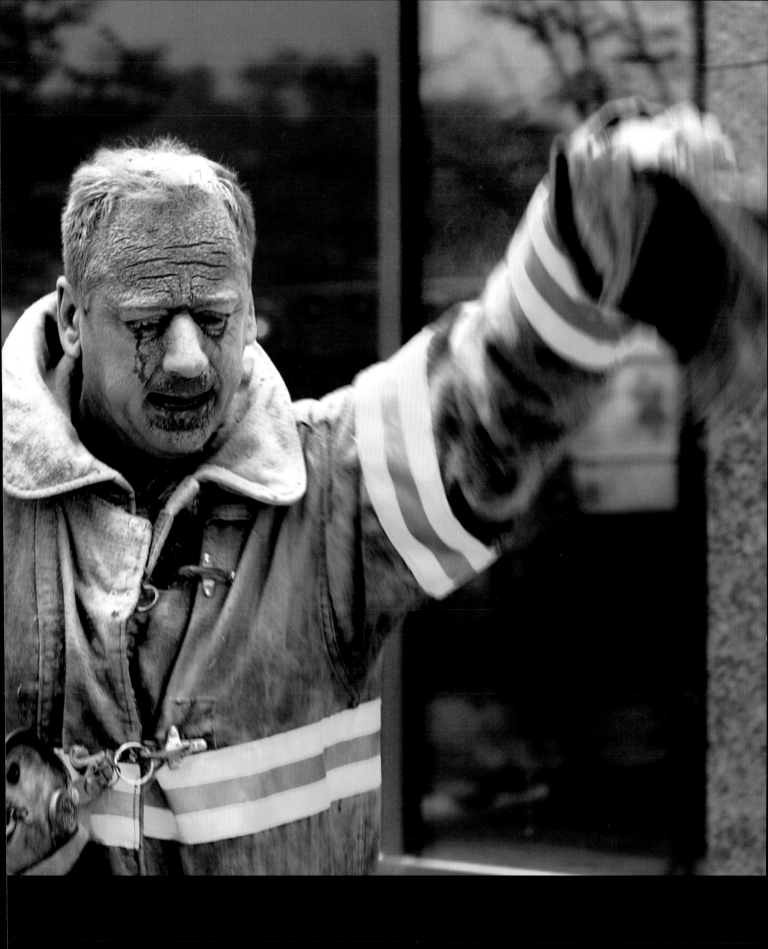

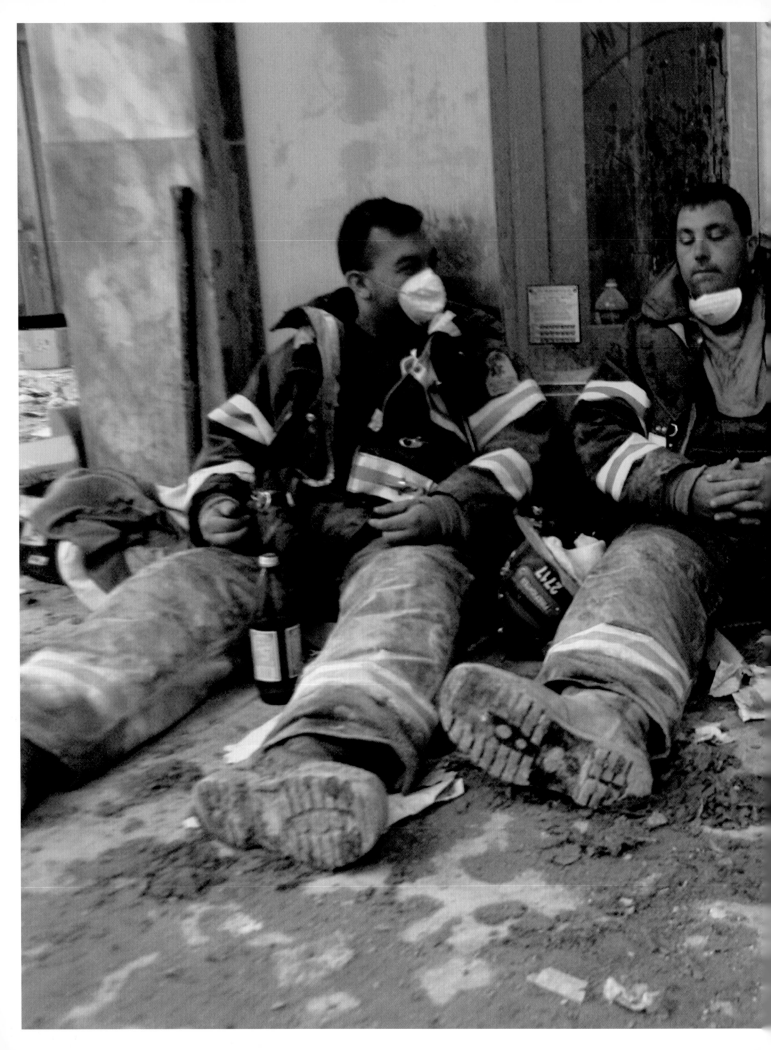

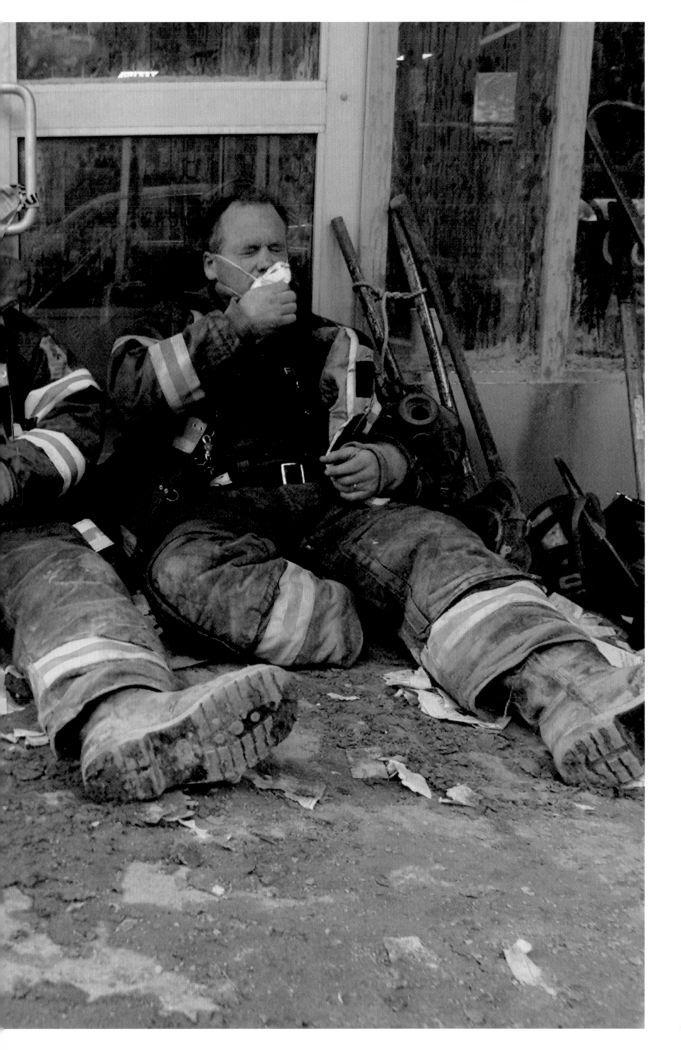

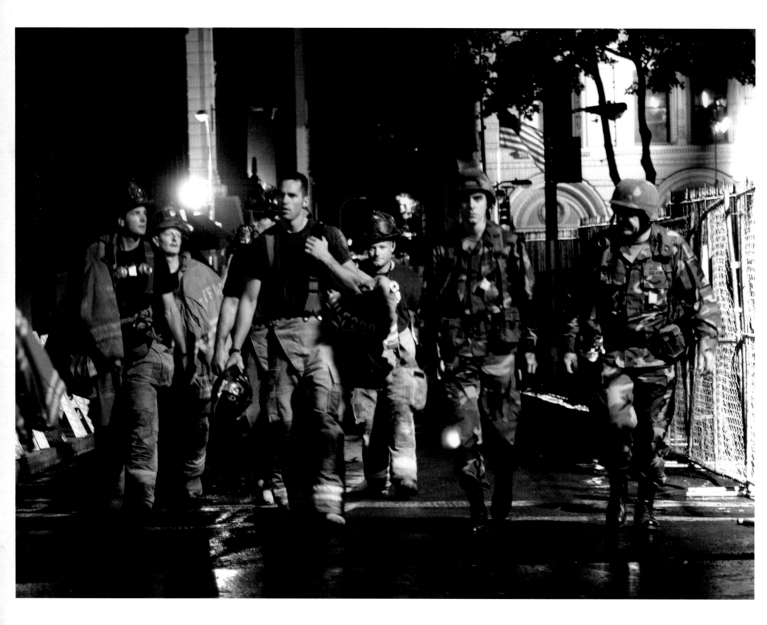

Above: Firefighters, flanked by the National Guard, trudge off the pile as night falls at Ground Zero. Their effort, and that of other rescue workers and volunteers, would keep them coming back until May of 2002, when the recovery effort was officially ended. Sept. 17, 2001

160 **Corey Sipkin**

Opposite page: Sally Suarez comforts her son Christian, 6, as her other son Jose, 10, daughter Jocelyn, 14, and sister Annette mourn during the funeral service for her husband, Firefighter Benjamin Suarez, at the Church of Saint John the Baptist in midtown Manhattan. Suarez, of Brooklyn's Ladder Co. 21, was killed on September 11. He also left behind another daughter, Angela. Nov. 2, 2001

Susan Watts

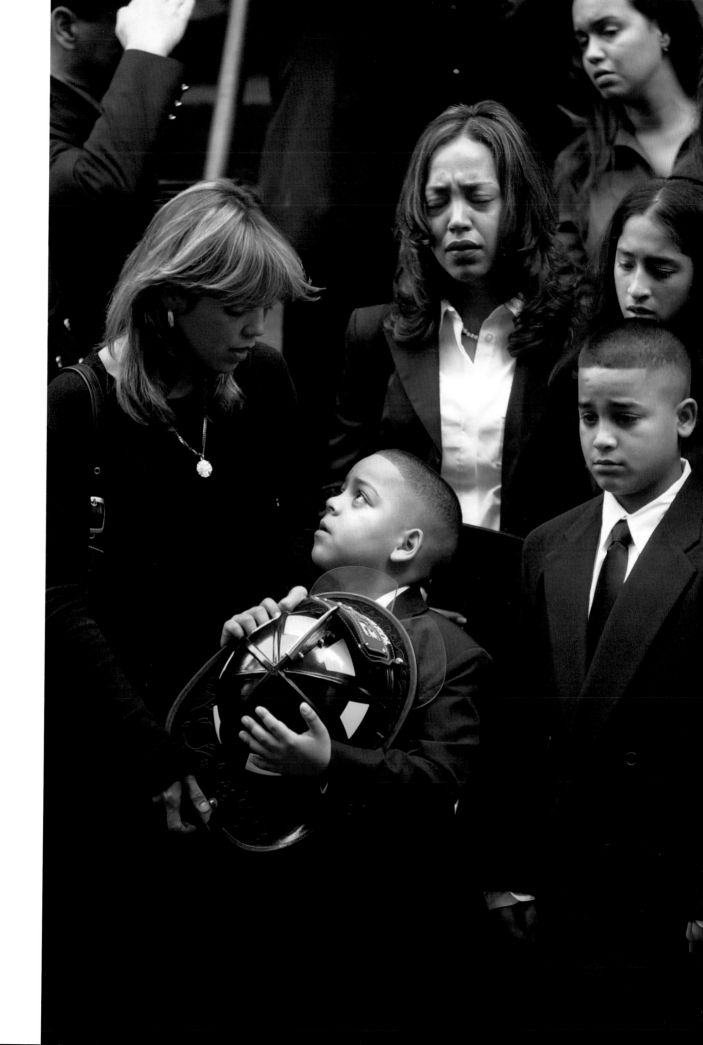

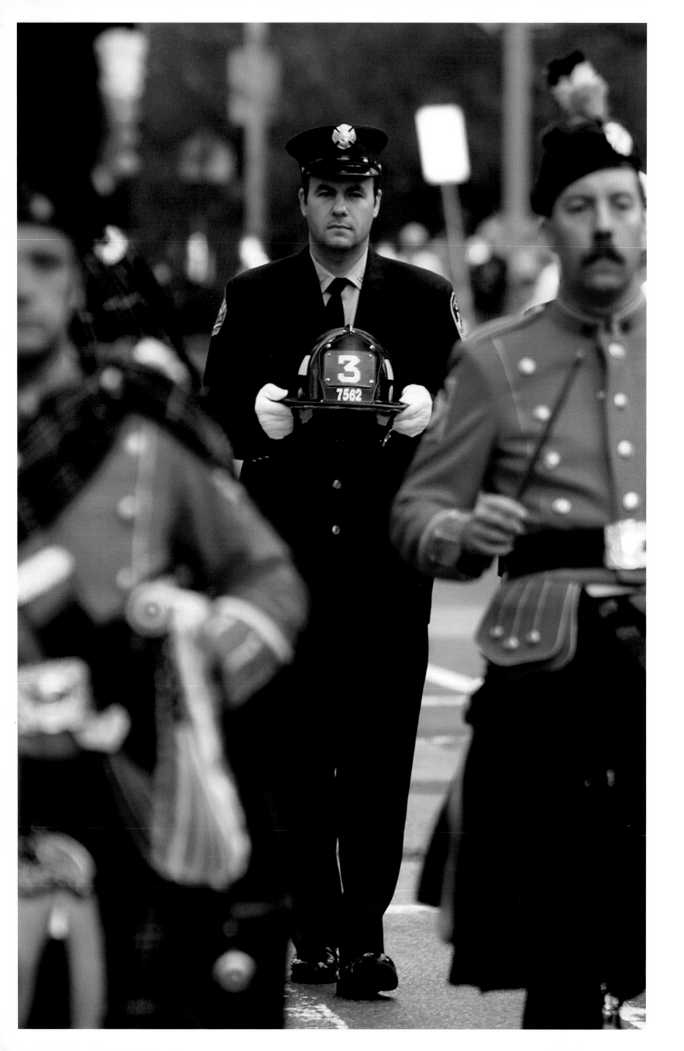

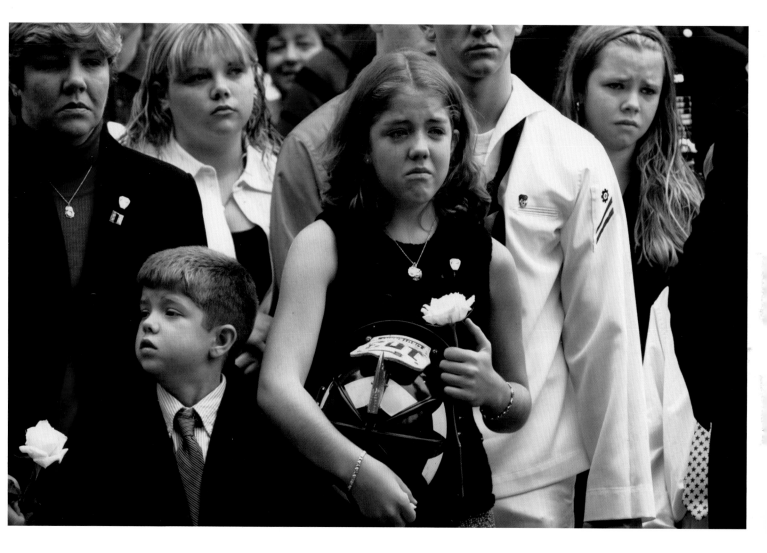

Opposite page: A firefighter from Ladder Co. 3 holds the fire helmet of fallen Firefighter Michael Carroll before presenting it to his widow, Nancy, during a memorial service at Saint Ignatius Loyola Church on Park Avenue. Carroll, 39, a 15-year Fire Department veteran, worked with Ladder Co. 3. Killed in the attack on the World Trade Center, he left behind his wife, son Brendan, 8, and daughter Olivia, 3. Oct. 20, 2001
Mike Albans

Above: The family of Fire Capt. Timothy Stackpole—wife Tara, and three of his five children, son Kevin (in sailor uniform), 18, son Terrence, 6, and daughter Kaitlyn, 15, holding her father's helmet (sons Brian, 10, and Brendan, 9, are standing outside the frame)—mourn during his funeral at Good Shepherd Catholic Church in Marine Park, Brooklyn. Stackpole had just returned to active duty in March with Ladder 103 after recuperating from being badly burned in a five-alarm fire in 1998. He had just finished his shift on the morning of September 11 when the call came. Sept. 24, 2001
Todd Maisel

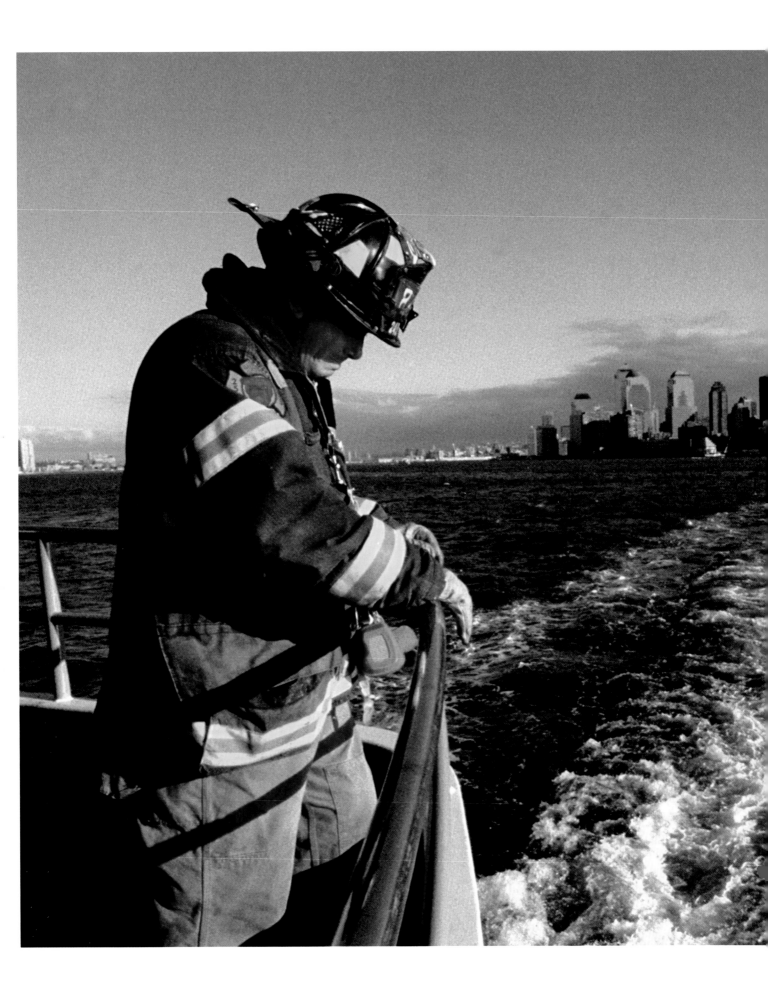

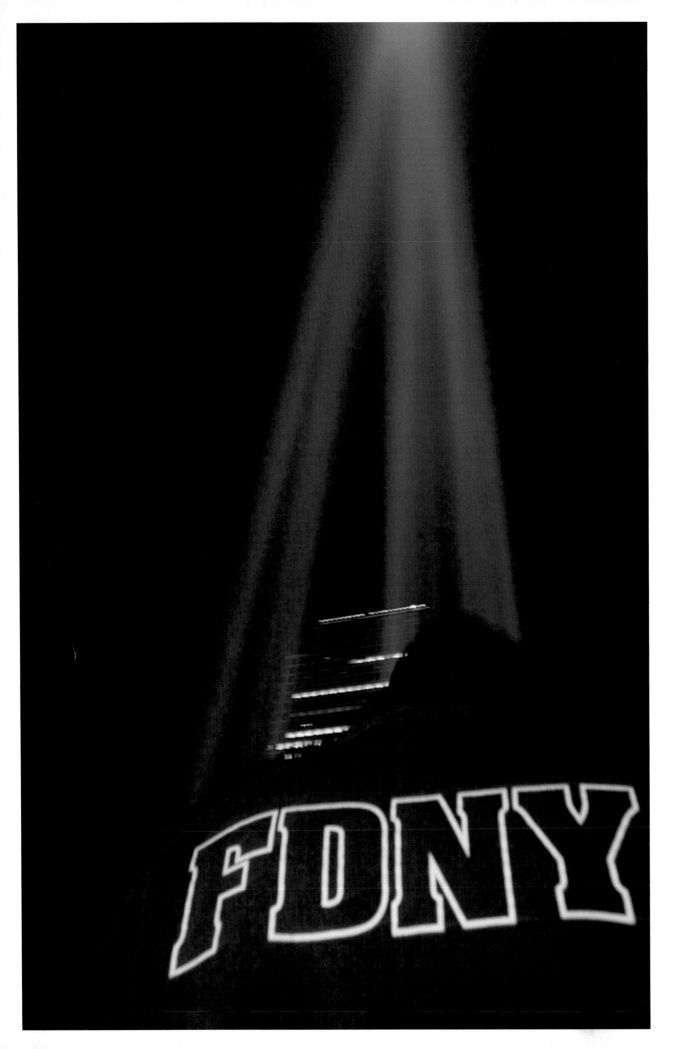

ACKNOWLEDGMENTS

The book you have in your hands was made possible by a process unique to the Daily News. We are the only newspaper in the world to have converted our entire photo archive into digital images that can be searched and accessed electronically by anyone on the Internet. DailyNewsPix.com is the largest online searchable photo database in the world, consisting of more than two and a half million digital files of current as well as historic images—edited from the more than six million prints and negatives in the Daily News picture library.

The era of the tabloid newspaper, distinguished by the prominent role played by photographs, began in 1919 with the founding of the New York Daily News. The News' picture collection represents an important piece of modern photojournalistic history, documenting the birth of tabloid photography with its reliance on dynamic images meant to grab the attention and imagination of busy city readers. Everything from entertainment to politics, disasters to celebrations, criminals to heroes, has been photographed by News photographers. The Daily News Photo Archive is the best visual history of 20th-century-New York in existence. This unique resource can be viewed at http://www.dailynewspix.com.

—Eric Meskauskas
Director of Photography, Daily News

Thanks to the many hands and hearts that helped make this book: To Eric Meskauskas, the director of photography at the News, for his encouragement and devotion to photography. To Mike Lipack, the deputy director of photography. To the people at powerHouse Books: Kiki Bauer, for designing a book with great sensitivity and elegance, Daniel Power, publisher, Craig Cohen, associate publisher, and Porochista Khakpour, associate editor. To Richard Slovak for skilled research and caption writing. To Lee Sprecace Clark, who headed the News' production team of Raymond Cruz, Sarah Feinsmith, Claus Gugleberger, Lawrence Lai, Ann Marie Linden, and Rita Robinson. To Gardy Delatour, Angela Troisi, and Andre Martinez. Faigi Rosenthal and Peter Edelmen in the News Library. And most importantly, my wonderful family for their love, understanding, and support.

—Shawn O'Sullivan

Many thanks to Bill Boyle, Daily News managing editor, for his skillful and heartfelt editing of the essays. Special thanks to my husband, Edward Fay, and our daughters, Tara and Alannah, for their loving encouragement.

—Patrice O'Shaughnessy

Previous page: New York City firefighter Ron Parker of Ladder 84 rides the Liberty Island ferry to the Statue of Liberty in New York harbor, reopened to the public for the first time since the attacks on the World Trade Center.
Dec. 20, 2001
Keith Bedford

Opposite page: "The Tribute in Light" beams into the sky from Ground Zero, a temporary memorial to the victims of the September 11 attacks commemorating the six-month anniversary. The twin towers of light shown nightly for six weeks afterward.
Apr. 13, 2002
James Keivom

New York's Bravest
Eight Decades of Photographs from the Daily News

Published in the United States by powerHouse Books,
a division of powerHouse Cultural Entertainment, Inc.
180 Varick Street, Suite 1302, New York, NY 10014-4606
telephone 212 604 9074, fax 212 366 5247, e-mail: bravest@powerHouseBooks.com
web site: www.powerHouseBooks.com

First edition, 2002

Library of Congress Cataloging-in-Publication Data:

New York's bravest : eight decades of photographs from the Daily News /
edited by Shawn O'Sullivan ; texts by Patrice O'Shaughnessy.
 p. cm.
 ISBN 1-57687-158-4
 1. New York (N.Y.). Fire Dept.--Pictorial works. 2. Fire extinction--New York
(State)--New York--Pictorial works. 3. Daily news (New York, N.Y. : 1920) I.
O'Sullivan, Shawn. II. O'Shaughnessy, Patrice.

TH95905.N5 N48 2002
363.37'09747'10222--dc21

 2002068429

Hardcover ISBN 1-57687-158-4

Separations, printing, and binding by Artegrafica, Verona

Captions by Richard Slovak

A portion of the proceeds of this book will be donated to the New York Firefighter's Burn Center Foundation.
Started in 1975 by members of the FDNY, and run by volunteers, the center provides much-needed funds for research,
care, equipment, and a children's camp for the Burn Center at New York-Presbyterian Hospital.

A complete catalog of powerHouse Books and Limited Editions is available upon request;
please call, write, or brave our web site.

10 9 8 7 6 5 4 3 2 1

Printed and bound in Italy

Book design by Kiki Bauer